". . . I am very pleased to see this *Field Guide* appear and hope that it is the first in a series of books that make the results of Alex's extensive and systematic surveys of rock art sites and literature available to scholars and the general public. The *Field Guide* is an ambitious, wide-ranging, yet properly cautious attempt to begin to define recurrent rock art elements in the Greater Southwest and to assemble published accounts of possible interpretations of these elements."
—*William D. Lipe*
Professor of Anthropology, Washington State University, and
Director of Research, Crow Canyon Archaeological Center

"This *Field Guide* provides an interesting and innovative approach to the classification of rock art features of the Greater Southwest, and it will benefit both the novice and the professional . . . [it] may well help to standardize names and meanings applied to rock art features derived from professional reports . . . it is an important contribution to the field of rock art."
—*Albert H. Schroeder*
Archaeologist and author

"This is an invaluable guide to a cultural treasure we must learn to understand if we are to conserve it for future generations. As a scholar, I found the *Field Guide* very exciting for its demonstration of highly suggestive clusterings of meanings in petroglyphs, recurring over wide areas of the West and northern Mexico."
—*Alfonzo Ortiz*
Native American scholar, teacher, and author

"I applaud and salute author Alex Patterson on his work and his broad spectrum of information. This is a worthy collection and a book that is needed in every library across the land. I await his next endeavor!"
—*Teresa Pijoan*
Mythologist, Pueblo storyteller, and author

A FIELD GUIDE TO
ROCK ART
SYMBOLS
Of the Greater Southwest

ALEX PATTERSON

Johnson Books: Boulder

To Mary McPherson Patterson

Roommate, friend, bedroll warmer, map and proofreader, rock art finder, plant lady, keeper of the "nice," mother of four, grandmother of two, and loving wife of thirty-seven years.

Cover photograph by Mary Patterson: Near Petrified National Park, Arizona. At the winter solstice sunrise, the shadow of a rock pinnacle across the canyon passes directly through the concentric circles at the top of this panel. Note the damage by vandalism at center right.
Cover design by Robert Schram
Text design by Wynne McPherson Patterson and Allen Moore III

9

Library of Congress Cataloging-in-Publication Data

A Field guide to rock art symbols of the greater Southwest / [compiled by] Alex Patterson.
 p. cm.
 Includes bibliographical references (p.) and index.
 ISBN 1-55566-091-6
 1. Indians of North America—Southwest, New—Antiquities—Guidebooks. 2. Rock paintings—Southwest, New—Guidebooks.
3. Southwest, New—Antiquities—Guidebook. I. Patterson, Alex.
E78.S7F54 1992
979'.01—dc20 92-883
 CIP

Printed in the United States of America by
Johnson Printing Company
1880 South 57th Court
Boulder, Colorado 80304

CONTENTS

ACKNOWLEDGMENTS

Thanks go to all those who gave us a smile and a helping hand on our journey:

Brian Amme, Alex and Patti Apostolides, Jim and Nan Bain, Margery Torrey Barber, Con and Dawn Bergland, Nancy Bernard, Natasha Bonilla, Frank and A.J. Bock, Nina Bowen, Jerry and Jean Brody, John Burke, Ernest and Ellie Carter, Jim and Peggy Chapin, John Chavez, Sally Cole, James Crocker, Jay and Helen Crotty, Debra Dandridge, Burnie Davidson, Mary Davies, Dale Davison, John DeLong, Ron Eisman, Red and Virginia Ellison, Barry and Rene Fell, Roland Force, Jolynn Fox, Fred Frampton, Tom and Maureen Freestone, Phil Garn, Bill Gibson, Jeff Grathwohl, Campbell and Lou Grant, John Greer, Sally Hadlock, Ken Hedges, Bruce Henderson, Rebecca Herr, Tom Hoskinson, Bill Hyder, Leigh Jenkins, John and Ed, Bobby Jones, Boma Johnson, Tim and Siste Kearns, John King, Smokey Knolton, Jan Lawson, Clifton Aubrey Lawson, Bill Lipe, Walter Lorenzut, Bill and Muffy Lynch, Ekkehart Malotki, LeVan Martineau, Bob and Margery McBride, Jack and Pat McCreery, Michael McNierney, Allen Moore III, Marty Mulligan, Dan Murphy, Barbara Johnson Mussil, Remy and Margaret Nadeau, Joy Nevin, Alfonso Ortiz, Dave Parker, Alex and Carol Patterson III, Jill Patterson, Jim Patterson, Joan Patterson, Wynne Patterson, Rafaela Peralta, Peter Pilles, Pat and Dennise Rabideau, Gus and Leslie Rathe, Carol Patterson Rudolph, Cliff Ryal, Darryl Sanders, Curt and Polly Schaafsma, Albert H. Schroeder, Morgan and Babbie Smith, Doug Schwartz, Shurban, Don Simonis, Bob Staffanson, Larry Starr, Steve Stoney, Stuart Streuver, Gary Stumpf, Laine Thom, Bill Thompson, Mary Ellen Toner, Richard Townsend, Wilson Turner, Teresa Pijoan, John and Laura Holt Vavluska, Henry Wallace, Jesse and Judith Warner, Don Weaver, Lee Young. Profound apologies for any misspellings, mistakes, omissions, etc.

FOREWORD

After completing a successful career in the business world, Alex Patterson has dedicated himself to learning as much as he can about American Indian rock art in western North America. Several years ago I had the pleasure of taking Alex and Mary Patterson on their first visit to an important rock art site in Grand Gulch, in southeastern Utah. During the trip, Alex expressed trepidation about publishing some of his studies; I encouraged him to "just do it." Consequently, I am very pleased to see this *Field Guide* appear and hope that it is the first in a series of books that make the results of Alex's extensive and systematic surveys of rock art sites and literature available to scholars and the general public.

The Field Guide is an ambitious, wide-ranging, yet properly cautious attempt to begin to define recurrent rock art elements in the Greater Southwest and to assemble published accounts of possible interpretations of these elements. For the student and incipient scholar, it is a useful introduction to the vast and scattered literature on rock art interpretation in this large area. For the rock art viewer, it will promote intelligent reflection on the endlessly fascinating question of how (and if) human minds can communicate across barriers erected by time and cultural difference.

—William D. Lipe, April 1992
Professor of Anthropology, Washington State University
Director of Research, Crow Canyon Archaeological Center

This *Field Guide* provides an interesting and innovative approach to the classification of rock art features of the Greater Southwest, and it will benefit both the novice and the professional. The author combed the literature on the Southwest for rock art illustrations and names or meanings applied to each of the depictions in the reports. The results are assembled and well illustrated in this guide under three major divisions: humanlike, animallike, and abstract—with representations or meanings as given by the authors of the reports.

A separate section of the guide lists the ascribed meanings alphabetically along with a description of the symbol or feature. This is followed by a section that lists the symbols alphabetically with their attached ascribed meanings as given in the original sources. The author has been careful not to inject his personal interpretations of the subjects. The general locale of each site involved is

provided on a state map, but in order to protect the sites, the maps in no way reveal precise locations; yet they will make distribution studies possible.

This guide may well help to standardize names and meanings applied to rock art features derived from professional reports. It may also provide a base for further refinements in classification. It is an important contribution to the field of rock art and provides a lengthy bibliography for reference needs.

—*Albert H. Schroeder*, March 23, 1992
Archaeologist and author

INTRODUCTION

What started as a nostalgic trip to my boyhood home of deserts, canyons, cactus, and sagebrush led to a love affair with the ancients.

In 1984 my wife, Mary, and I visited the ruins at Bandelier, Chaco Canyon, Canyon de Chelly, Betatakin, and Kiet Siel. It was a wonderful trip, and we were excited by what we saw. But somehow the ruins, interesting as they are, seemed sterile. We were looking at long-vacated apartments, shrouded in silence. But these sites often had some rock art. It was the one element that seemed truly valid.

Then we saw the rock art at Three Rivers State Park in southern New Mexico. There were thousands of engravings—petroglyphs—on two miles of basalt rocks. The pictures appeared to represent birds, animals, fish, people, hands, feet, abstract designs, and fantastic beings. We were fascinated. These engravings were exactly as the ancient artist had drawn them many centuries ago. We felt we were looking directly into the minds of these ancient people.

But what did all these pictures, these symbols, mean? Like most newcomers to rock art, we wanted to know what they meant. What was the message that the ancients had so carefully placed on the rocks long ago?

We soon found out that there are precious few answers. The park rangers we talked to were interested but could not help much. The libraries and bookstores had books on rock art, but they were mostly beautiful photographs, with seldom a reference to meaning. We even managed to talk to an archaeologist occasionally and soon found that they too, with rare exceptions, had few clues to the meaning of rock art. More importantly they were not studying the question.

This seemed strange as we came to the realization that there were thousands of rock art sites in the Southwest. No one knows the exact number. One researcher claims that there are 7,564 rock art sites "known to exist" in Utah alone (Manning 1990:148). Arizona and California are probably not far behind Utah, with New Mexico, Nevada, and Colorado with lesser quantities.

As we began our own study in depth, we were elated to find that there was in years past and is today a small group of authors studying the question of meaning and reporting their findings in published works. Driven by a desire to understand these communications on the rocks, we undertook a literature search of the rock art writings of archaeologists, anthropologists, researchers, Native American informants, and other writers—all published over the last 125 years. We began compiling quotations and illustrations

directly from their works, noting the general location of the rock art sites to which they referred.

We chose to extend our study to cover an area greater than the usual southwestern states—Arizona, New Mexico Utah, and Colorado—to include quotations relating to Nevada, California, Texas, Wyoming, northern Mexico and occasionally elsewhere.

It was this gathering of ideas that grew into the *Field Guide*. It is our hope that visitors to rock art sites may enrich their experience by reading these selections and scanning the illustrations.

The Meaning of Rock Art

Have we found the real meaning of the rock art symbols cited in this book? Do the quotations and illustrations we have selected really define the meaning of this rock art? The answer, sadly, is no. There is no proof that any of these meanings are correct. It is not possible to define a symbol, as you would a word in *Webster's Dictionary*. These quotations are only the meaning these selected writers believed was the right meaning when they wrote the original book or article—and it usually pertained only to a particular panel in a particular location.

We have gathered together these commentaries on the symbols and labeled each grouping with an "Ascribed Meaning." This is a word or phrase that in our opinion most closely summarizes the commentaries on the symbol meanings cited. Frequently the commentaries do not express an opinion on the meaning, and we have chosen a simple descriptive word or phrase as the "Ascribed Meaning." The book is arranged alphabetically by these "Ascribed Meanings," and an index is provided.

With each "Ascribed Meaning" we have shown a "Symbol Description" also. It describes what you actually see on the rocks in terms of lines, circles, spirals, dots, anthropomorphs, quadrupeds, etc. These "Symbol Descriptions" are in turn arranged in an alphabetic index, so that the reader can determine if a particular design of lines, circles, dots, seen on the rocks has an "Ascribed Meaning(s)" attached to it in the *Field Guide*.

Note that the cited commentaries give the reader a selection of opinions as to the possible meaning(s) of a rock art symbol. At times one opinion may conflict with a second opinion. The second opinion may relate to some other location, maybe far removed from the first. Another culture may have been in place at the second location, and its meaning for this symbol may be sharply different than that of the original culture.

There is evidence that some symbols have more than one meaning, even in a single culture. Lumholtz in his study of the Huichol Indians in western Mexico (Lumholtz 1900:223) found that the equilateral cross represented the four quarters of the world, the morning star preceding the rising sun, the heart (when enclosed in a circle), and sparks from a fire.

Dating Rock Art

There is, as yet, no generally accepted, precise method of dating rock art, but the following techniques can give an approximation of the age of rock art:

Degree of Repatination. Most petroglyphs are engraved on cliffs or rocks that are covered, or "patinated," with a coat of "desert varnish." Desert varnish is a thin layer of brown or bluish black material that is believed to be the residue of bodies of dead bacteria which have been impregnated with iron and manganese salts leached from the rock itself over an untold number of years. By cutting through the desert varnish the artist exposes the lighter rock underneath, thus creating the picture. As soon as the petroglyph is made, the desert varnish begins to form again, very slowly, in the lines of the petroglyph. Over time these lines become "repatinated" with this new varnish, until they approach the color of the original desert varnish—the darker the lines, the older the petroglyph. Degree of repatination is only a gross way of measuring the relative age of a petroglyph. Patination itself seems to vary substantially from rock to rock, place to place: it seems to depend upon many factors—for example, type of rock, direction of exposure, rainfall, geographical location, etc.

Association with Ruins. On occasion we find rock art in or adjacent to ruins. The ruins may be dated by conventional methods that archaeologists all agree are acceptable, such as carbon dating. If the rock art is closely associated with a dated ruin, we may make the assumption that the rock art was made by the people who inhabited the ruin. This is not absolute proof, by any means. However, it seems to be accepted as a fair indication of the age of the rock art.

Rock Art Style (*See also* Rock Art Style below). Over the years archaeologists and researchers have identified numerous "rock art styles" for petroglyphs and pictographs. Usually when a rock art style is postulated, it is suggested that that style belongs to a particu-

lar culture or subculture that produced the rock art. Through archaeological excavations, carbon dating, or other means, that culture has been dated to a particular period in the past. Thus, if a panel of rock art can be linked to a particular style of rock art, you have some evidence that the time period attributed to the rock art style can also be attributed to your panel.

High Technology Dating. Very sophisticated techniques of dating rock art are being developed and tried experimentally by a few scientists. One of these pioneers is Ronald I. Dorn of Arizona State University who has been developing a technique called cation-ratio dating. Beginning with the rock varnish itself, "cation-ratio dating uses the ratio of ($K+Ca/Ti$) to establish a relative sequence of ages in a given area, that can be calibrated by numerical dating methods such as radiocarbon" (Dorn 1990:1). Once this key curve is established, readings for individual petroglyphs from the same area can be plotted on this key curve and approximate dates obtained. Dorn also works in radiocarbon dating, using "accelerator mass spectrometry (AMS) to date organic matter collected underneath the varnish and encapsulated after the varnish starts to grow" (*op. cit.*: 1).

Rock Art Style

Rock art style is a basic concept with which every person attempting to understand rock art should be acquainted. In essence, style refers to the overall impression that the panel of rock art makes on the viewer. It begins with the inventory of elements used. Are they mostly abstract designs or are there humanlike or animallike symbols involved? Second, it includes the way the symbols are expressed: Are the humanlike symbols mere stick figures, or do they have bodies with interior designs and heads with faces, horns, or other appendages? Third, how do these symbols relate to each other in the general pattern?

An analogy is style as expressed by various artists in their paintings. For example, the French Impressionists of the late nineteenth and early twentieth centuries have styles very different from those of the Surrealists of the twentieth century. Rock art styles can be examined in much the same way as any art style.

Researchers have ascribed certain rock art styles to given cultures, based on such factors as geographic locations of the rock art and the other indicators of the culture, i.e. ruins, pottery, etc. It is generally agreed that the culture of a people determines the meaning of their symbols.

We recommend the discussion of style in Schaafsma's *Indian Rock Art of the Southwest* (1980:8-24), particularly her summary of the different rock art styles, their cultural affiliations, and approximate dates.

Authors Cited

We have quoted from almost 150 authors in this book. Their reputations for reliability vary. For example, there are indications that much of what Frank Waters wrote about rock art in the *Book of the Hopi*—helped by his Hopi informant Oswald White Bear Fredericks—may be suspect. In fact, we have had difficulty locating the rock art named in some of his very general references. The story goes that Fredericks occasionally made up things, and Waters did not fully check this material. Despite this, we have chosen to include some of Waters' writings on the meaning of rock art, as we feel that, on balance, the *Book of the Hopi* is a remarkable telling of the story of the Hopi people.

The early archaeologists, ethnologists, and researchers—Fewkes, Colton, Cushing, Stephen, Mallery, Lumholtz, Stevenson, to name a few—are quoted with confidence. For the most part these men and women, working around the turn of the century, were in direct contact with the Native Americans of that era. The full impact of white culture had not yet been felt. Quotations from more recent researchers—Schaafsma, Grant, Young, Cole, Hedges, for example—are also confidently presented. Schaafsma has produced a thoughtful and perceptive body of work, particularly in her *Indian Rock Art of the Southwest* (1980). Hedges' writings on shamanism and rock art seem very astute. And the value of all these authors' works is beyond question.

Artists have been attracted to rock art. Schaafsma herself has shown considerable talent in art. Campbell Grant was already well into a career as a respected artist when he became intrigued with rock art. Grant did the necessary research to produce several well-received studies such as *Rock Drawings of the Coso Range* (1968 with Baird and Pringle) and *Canyon de Chelly—Its People and Rock Art* (1978). Agnes Sims, now deceased, received considerable recognition as an artist in her hometown of Santa Fe and produced several interesting works on rock art.

Rock Art Site Manners

How do you behave at a rock art site? First make sure you are welcome. Do not enter any land without the owner's permission. Sec-

ondly, act as if you were visiting both a museum and a place of worship. The rock engravings or paintings are as unique as any art object you find in a museum and, once defaced or destroyed, cannot be replaced. Since some experts believe that rock art often had religious meaning, you may be visiting the outdoor place of worship of a vanished people.

Most importantly, do not touch or walk on the rock art. You may deface the images or leave oils that may defeat some future dating process. Do not move the rocks or disturb the site in any way. Leave the plant material as you found it.

Contemplate the writings and enjoy the surroundings. Most sites are nestled in beautiful scenery, often with superb views. You are where the ancients wrote a message for all to see, maybe even their gods and ancestors. Ponder the symbols and what others have written about them.

To some Native American people rock art is very special. The anthropologist M. Jane Young describes an elderly religious leader of the Zuni people, visiting a local rock art site. He spent three hours, mostly in silence, looking at the symbols. Often he approached a figure and gently traced its outline with his fingertips (touching permitted here—the original artist was undoubtedly his ancestor). Finally the elderly man said, "I don't know what it means, but I know it is important" (Young 1985:42).

We agree with the Zuni religious leader—the rock art of the Southwest is important. We have a duty to preserve these intriguing symbols for future generations to see and ponder. Who knows what they say? We should encourage their study. With patient research, our grandchildren and their grandchildren may be able to read, understand, and profit by these messages from the ancients. We believe this is a worthwhile goal.

How to Use the Field Guide

The *Field Guide* is designed to permit the study of symbols at the rock art site. One aid in this study is a section called "Finders." These consist of little duplicates of the illustrations in the text, gathered together in three sections entitled "Humanlike," "Animallike," and "Abstract" and arranged alphabetically by "Ascribed Meaning" of the symbol.

When using the *Guide* in the field, please follow these steps with the Finders:

1. Pick a symbol on the rocks you would like to know more about.

2. Decide whether the symbol is more like a human being or "Human-like" (an anthropomorph), more like an animal or "Animallike" (a zoomorph), or is neither and thus can be considered as "Abstract."

3. Select the appropriate section of the Finders—either "Human-like" (an anthropomorph), "Animallike" (a zoomorph), or "Abstract."

4. Scan through the Finders in the appropriate section until you locate the Finder that most closely matches your chosen symbol. Peruse the quotations and full-size illustrations of the symbol.

If you do not find your symbol in the Finder sections, you might try the alphabetical index by Symbol Descriptions. For example, if you decide a symbol is "Humanlike" (an anthropomorph) and has two projections from the top of the head, turn to the alphabetical index by Symbol Description.

Find the listings for "Anthropomorph" and under it the category for "with horns or special headdress." You will be referred to "Shaman" and "Headdress," which are the Ascribed Meanings for an anthropomorph with projections from its head.

FINDER: HUMANLIKE

Arrow

Arrow

Arrow

Atlatl

Beans

Bird-Headed
Humans

Bird-Headed
Humans

Birthing

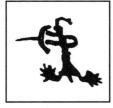

Birthing

Blanket Design

Blanket Design

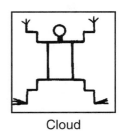

Bow

Bow

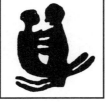

Bullroarer

Butterfly

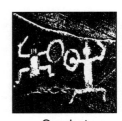

Cloud

Cloud

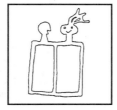

Coitus

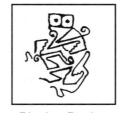

Coitus

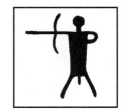

Combat

1

FINDER: HUMANLIKE

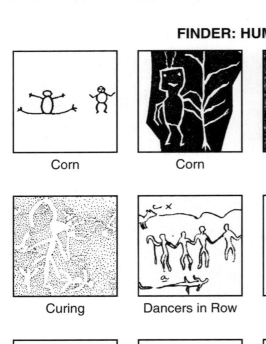

Corn

Corn

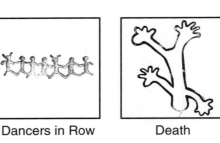

Crook

Curing

Curing

Dancers in Row

Dancers in Row

Death

Death

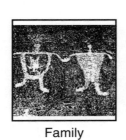

Death

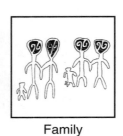

Dragonfly

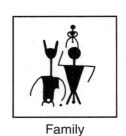

Ear Extensions

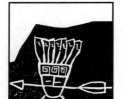

Ear Extensions

Family

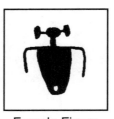

Family

Family

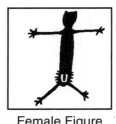

Family

Feather

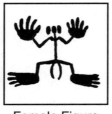

Female Figure

Female Figure

Female Figure

FINDER: HUMANLIKE

Flute Player

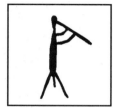

Flute Player or
Kokopelli

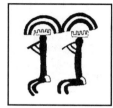

Flute Player or
Kokopelli

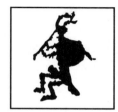

Flute Player or
Kokopelli

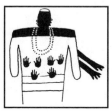

Footprints

Footprints

God of Death

God of Death

God of Death

God of Death

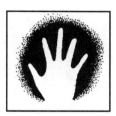

Handprint

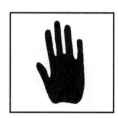

Handprint

Handprint

Handprint

Headdress or
Shaman

Headdress or
Shaman

Headdress or
Shaman

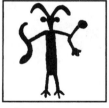

Headdress or
Shaman

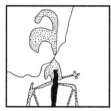

Headdress or
Shaman

Headdress or
Warriors

FINDER: HUMANLIKE

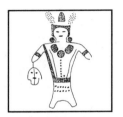

Head Hunting

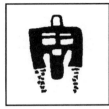

Head Hunting

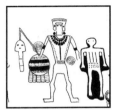

Head Hunting

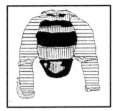

Head Hunting or
Masks

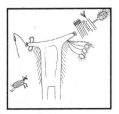

Headless

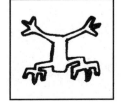

Headless

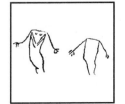

Headless

Headless

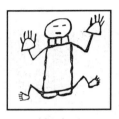

Hocker

Hocker

Horns

Horns

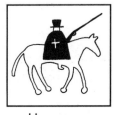

Horsemen

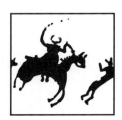

Horsemen

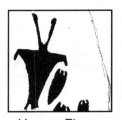

Human Figure

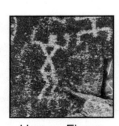

Human Figure

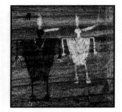

Human Figure

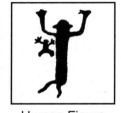

Human Figure

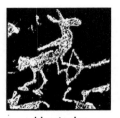

Hunter's
Disguise

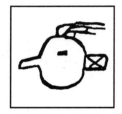

Katcina–Ahole

4

FINDER: HUMANLIKE

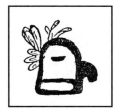

Katcina–Ahole

Katcina–
Cha'veyo

Katcina–
Cholawitze

Katcina–Cloud

Katcina–Deer

Katcina–Dumas
or Tumash

Katcina–Hehea

Katcina–
Hemis or Tableta

Katcina–
Mudhead Clowns

Katcina–
Mudhead Clowns

Katcina–
Planet or Star

Katcina–
Sayathlia

Katcina–
Sayathlia

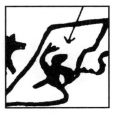

Katcina–
Sayathlia

Katcina–Shalako

Katcina–Shalako

Katcina Clan

Mirror Image

Mirror Image

Mother of
Animals

5

FINDER: HUMANLIKE

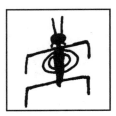

Mother of
Animals

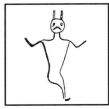

Mother of
Animals

Mother of
Animals

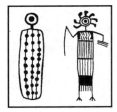

Patterned Body
Anthropomorphs

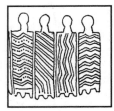

Patterned Body
Anthropomorphs

Phallic Figure

Phallic Figure

Phosphenes

Power Lines

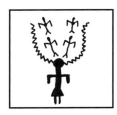

Power Lines or
Spirit Helpers

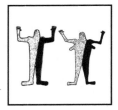

Praying Person

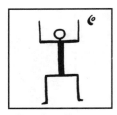

Praying Person

Pregnancy

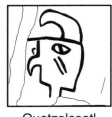

Quetzalcoatl

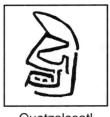

Quetzalcoatl

Rain God

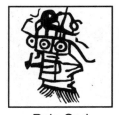

Rain God

Rain God

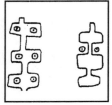

Rain God

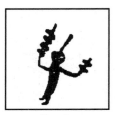

Rattle

FINDER: HUMANLIKE

Rattle

Runner

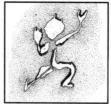

Runner

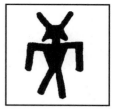

Shaman

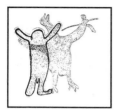

Shaman

Shields

Shields

Shields

Snakes

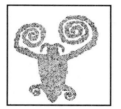

Spirals

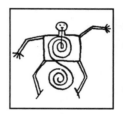

Spirals

Spirits

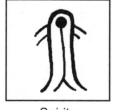

Spirits

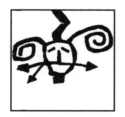

Swallower

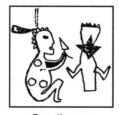

Swallower

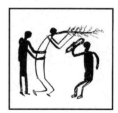

Swallower

Swallower

Twin War Gods

Twin War Gods

Warriors or
Four Circles

FINDER: HUMANLIKE

Warriors

Warriors

Waving Man

Waving Man

Weeping Eye

Weeping Eye

X-Ray Style

8

FINDER: ANIMALLIKE

Arrow or
Mountain Sheep

Badger

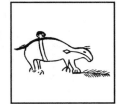

Badger

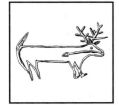

Breath

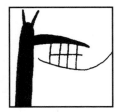

Coyote, Dog,
or Wolf

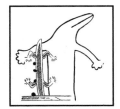

Coyote, Dog,
or Wolf

Coyote, Dog,
or Wolf

Coyote, Dog,
or Wolf

Corn

Crane or Heron

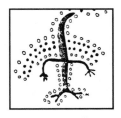

Datura or Dot

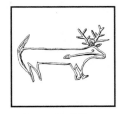

Deer or Elk or
Heart Line

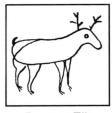

Deer or Elk

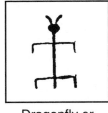

Dragonfly or
Water Skate

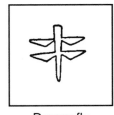

Dragonfly

Dragonfly

Eagle

Eagle

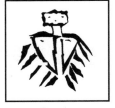

Eagle

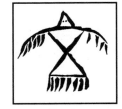

Eagle

9

FINDER: ANIMALLIKE

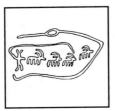

Enclosures

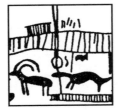

Enclosures

Enclosures

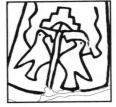

Facing Birds

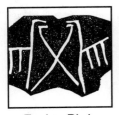

Facing Birds

Fish

Fish

Fish

Fish

Frog

Frog

Frog

Heart Line

Horns

Hunting

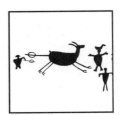

Hunting

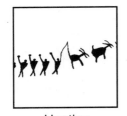

Hunting

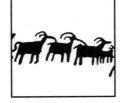

Kinship Lines

Kwataka

Kwataka

FINDER: ANIMALLIKE

Lightning or
Snakes

Mastadon

Mountain Lion

Mountain Lion

Mountain Sheep

Mountain Sheep

Parrot

Parrot

Parrot

Plumed Serpent

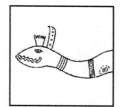

Plumed Serpent

Plumed Serpent

Praying Man

Pregnancy

Rabbit

Rabbit

Rabbit

Rabbit

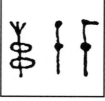

Red Ant

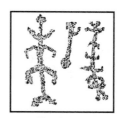

Red Ant

11

FINDER: ANIMALLIKE

 River

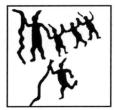 Snakes

 Snakes

 Snakes

 Speech

 Spider or Spider Web

 Spider or Spider Web

 Spider or Spider Web

 Spirits

 Spirit Helper

 Spirit Helper

 Thunderbird

 Thunderbird

 Turkey or Bird-Headed Human

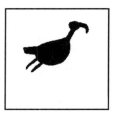 Turkey

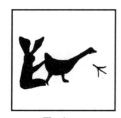 Turkey

 Two-Headed

 Water Skate

 Water Skate

 X-Incurved

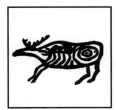

X-Ray Style

X-Ray Style

FINDER: ABSTRACT

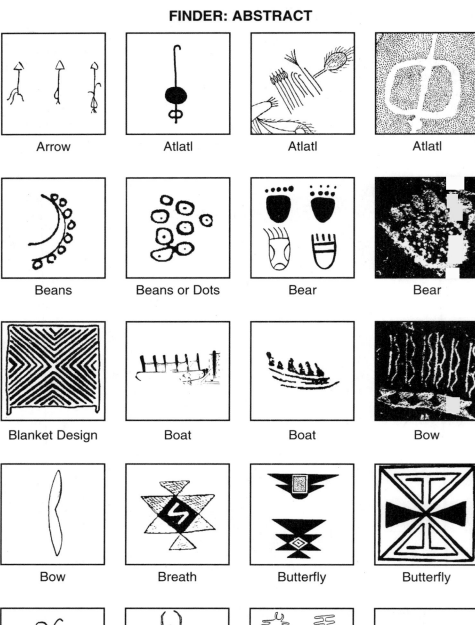

Arrow	Atlatl	Atlatl	Atlatl
Beans	Beans or Dots	Bear	Bear
Blanket Design	Boat	Boat	Bow
Bow	Breath	Butterfly	Butterfly
Butterfly	Centipede	Centipede	Centipede

FINDER: ABSTRACT

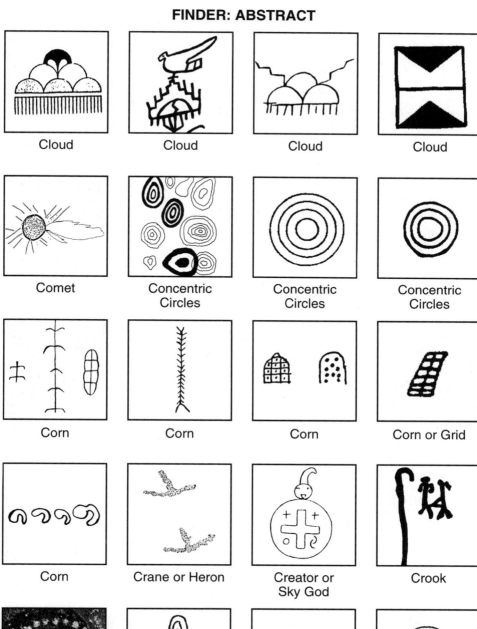

Cloud	Cloud	Cloud	Cloud
Comet	Concentric Circles	Concentric Circles	Concentric Circles
Corn	Corn	Corn	Corn or Grid
Corn	Crane or Heron	Creator or Sky God	Crook
Cross	Cross or Quetzalcoatl	Cross	Cross

15

FINDER: ABSTRACT

Cross

Datura or Sun

Deer or Elk

Deer or Elk

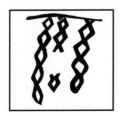

Diamond Chain
or Snakes

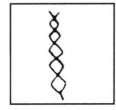

Diamond Chain
or Squash

Dots

Dumbbell

Dumbbell

Emergence

Emergence

Emergence

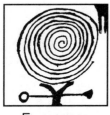

Emergence

Enclosures

Enclosures

Feather

Female Figure
or Vulva

Female Figure

Four Circles

Four Circles

16

Four Circles

Four Circles

Friendship

Friendship or Water

Grid

Grid

Grid

Grid

Hourglass or Masks

Hourglass or Twin War Gods

Hourglass or Twin War Gods

Irrigation

Irrigation or Map

Katcina Clan

Lightning

Lightning

Map

Map

Masks

Maze

Maze

Maze

Medicine Bag

Medicine Bag

Migrations

Migrations or
Spirals

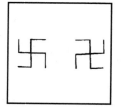

Migrations

Moon

Moon

Moon

Moon

Phosphenes

Pit & Groove

Planetarium

Pottery or Textile
Designs

Pottery or Textile
Designs

Pottery or Textile
Designs

Rain

Rain

Rainbow

FINDER: ABSTRACT

Rainbow

Rainbow

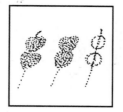
Rattle

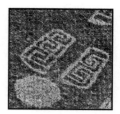
Sandals

Sandals

Shell

Shell

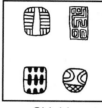
Shields

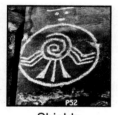
Shields

Shrine

Sipapu

Sipapu

Solstice

Speech

Spider or
Spider Web

Spirals or
Phosphenes

Squash or
Squash Blossom

Squash or
Squash Blossom

Squash or
Squash Blossom

Staff or Crook

19

FINDER: ABSTRACT

Staff or Crook

Staff or Crook

Staff or Crook

Star

Star

Star

Star

Star

Sun

Sun

Sun

Sun

Sun

Sun or Cross

Supernova

Supernova

Supernova

Supernova

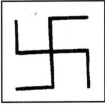

Swastika

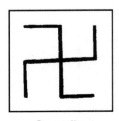

Swastika

FINDER: ABSTRACT

Swastika

T-Shaped

Tablet

Tablet

Tablet

Tablet

Vulva

Vulva

Vulva

Water

Water

Water Gourd

Water Gourd

Water Gourd
(double)

Water Gourd
(double)

Weeping Eye

Whirlwind

Whirlwind

X-Incurved

X-Incurved

21

ALPHBETICAL INDEX OF ASCRIBED MEANING OF ROCK ART SYMBOLS, PLUS RELATED SYMBOL DESCRIPTION

ASCRIBED MEANING	SYMBOL DESCRIPTION
Arrow	• Arrow.
Atlatl or Spear Thrower	• Line through circle. • Line with hook at one end. • Line through circle(s), often with hook at one end and loop(s) at other.
Badger	• Small quadruped with claws. • Paw print with claws.
Beans (*see also* Diamond Chain)	• Circle with dot. • Line with hook.
Bear	• Large quadruped with claws. • Paw print with claws. • Paw print with dots for toes and claws.
Bird-Headed Humans	• Anthropomorph with bird in place of head or on top of head.
Birthing (*see also* Two-Headed)	• Anthropomorph with small figure between legs or adjacent to main figure.
Blanket Designs (*see also* Pottery or Textile Designs)	• Rectangle or square with interior design, often with "tassels" at corners.
Boat	• Horizontal banana-shape with multiple vertical lines extending from top side.
Born-for-water (*see* Twin War Gods)	
Bow	• Bow.
Bow Tie (*see* X-Incurved)	
Breath (*see also* Heart Line)	• Line(s) from mouth to chest, ending in heart-shaped object. • "S" sign in center of figure.
Bullroarer or Rhombus or Whizzer	• Vertical rectangle with design.
Butterfly	• Butterfly. • Nested or connected multiple triangles.
Canoe (*see* Boat)	
Centipede or One-Pole Ladder	• Vertical line bisected by many short lines; may have head, horns at top, legs at bottom.

ASCRIBED MEANING	SYMBOL DESCRIPTION
Cloud	• Horizontal line with stacked inverted half-circles or step pyramid above; may have vertical lines descending below (rain).
Coitus	• Two anthropomorphs or zoo-morphs connected at genital areas.
Combat	• Anthropomorphs displaying weapons toward each other.
Comet	• Circle(s) with rays and long tail.
Concentric Circles	• Concentric circles.
Corn (see also Dots and Fish)	• Vertical line bisected by many lines which may slant downward. • Oval bisected by vertical and horizontal lines; may have dots within these lines. • Anthropomorph with extended arms and legs.
Coyote, Dog, or Wolf	• Quadruped with small ears and tail, often near game animals. • Head of zoomorph with ears and long snout.
Crane or Heron	• Bird with long legs. • Three-pronged bird track.
Creator or Sky God	• Head with one horn. • Circle with cross.
Crook	• Line with hook at one end, often held by anthropomorph.
Cross (see also Stars, Creator God, and Quetzalcoatl)	• Equilateral stick cross, often outlined; may be double or multiple. • Stick cross within circle. • Fat or "red cross." • "Maltese cross."
Curing	• Anthropomorph holding C- or U-shaped object near another figure.
Cyclone (see Whirlwind)	
Dancers in Row	• Row of anthropomorphs, often holding hands.
Datura or Jimson Weed (see also Dots and Phosphenes)	• Dots surrounding or adjacent to figure(s). • Mandela-like circular designs.
Death (see also Headless and Curing)	• Upside down anthropomorph. • Horizontal anthropomorph. • Headless anthropomorph.

ASCRIBED MEANING	SYMBOL DESCRIPTION
Deer or Elk	• Quadruped with antlers. • Hoof print with two parallel V-shaped or one U-shaped mark(s), often with two dots at open end.
Diamond Chain	• Diamond chain.
Dots (*see also* Datura, Enclosure, and Phosphenes)	• Dots surrounding or adjacent to figure. • Dots alone. • Dot in center of circle.
Dragonfly	• Vertical line with dot head at top, bisected by two (at times one), horizontal parallel line(s).
Dumbbell	• Two circles connected with line(s); may be embellished with designs.
Eagle (*see also* Thunderbird)	• Standing bird in profile. • Bird facing front, wings spread, feathers prominent.
Ear Extensions	• Front facing anthropomorph with extension from left (usually) ear, ending in arc or balloon.
Earth Altar Woman (*see* Mother of Animals and Hocker)	
Emergence (*see also* Sipapu)	• Spiral. • Double-linked spiral.
Enclosures (*see also* Dots and Hunting)	• U-shaped line (or dots) with game animals entering or within. • Vertical lines like a picket fence with game animals nearby.
Equinox (*see* Solstice or Equinox)	
Facing Birds	• Two birds in profile facing each other.
Family	• Two anthropomorphs—male and female—together, occasionally with smaller figure.
Feather	• Extended oval or rectangular object(s) above head of anthropomorph. • Same shape with step design in end.
Female Figure (*see also* Vulva)	• Anthropomorph with filled-in circles on both sides of head. • Anthropomorph with down-turned "U" or vulva shape between legs.

ASCRIBED MEANING	SYMBOL DESCRIPTION
Fish	• Fish.
Flute Player or Kokopelli	• Anthropomorph in profile with line from mouth and arms holding this line, often with hump on back and ithyphallic.
Footprints (*see also* Sandals)	• Footprints of bare human foot.
Four Circles (*see also* Warriors)	• Four small circles, in a cross design; may be connected with lines or separated by stick cross.
Friendship (*see also* Swastika and Water)	• Interlocking "U"s or "C"s.
Frog, Lizard or Toad	• Zoomorph with tail, arms upraised and bent at elbow, legs spread and bent at knees, often with circular body.
God of Death or Metamorphosis (Maasaw)	• Anthropomorph with "pumpkin" head, round eyes and mouth. • Head of anthropomorph in profile with large forehead ("pac-man").
Goggle-eyed Figure (*see* Rain God)	
Grid (*see also* Enclosures and Phosphenes)	• Abstract design of horizontal and vertical lines, usually enclosed.
Handprints (*see also* Twin War Gods)	• Print of human hand.
Headdress (*see also* Shaman and Tableta, Tablet, and Tabla)	• Headdress of anthropomorph; often includes horns, feathers, and other materials.
Head Hunting	• Anthropomorphs carrying human heads, often suspended from line. • Head of anthropomorph alone, occasionally with loop on top.
Headless (*see also* Death)	• Anthropomorph headless.
Heart Line (*see also* Breath and X-Ray Style)	• Line(s) from mouth to chest, ending in heart-shaped object.
Hocker or Receptive Female	• Female anthropomorph with legs spread and bent at knees, often showing vulva.
Horns	• Horns on the head of anthropomorph or zoomorph.
Horsemen	• Quadruped with anthropomorph on its back.

ASCRIBED MEANING	SYMBOL DESCRIPTION
Hourglass	• Hourglass.
Human Figure	• Anthropomorph.
Hunter's Disguise	• Anthropomorph wearing animal head, usually carrying weapons near game animals.
Hunting	• Anthropomorphs with weapons near game animals which are often impaled.
Irrigation	• Complex designs with water and plant symbols.
Katcina Clan	• Masks, various. • Line bisected by "V"s (spruce bough).
Katcina–Ahole	• Mask, with feathers on top and a snout.
Katcina–Cha'veyo	• Mask, with big ears and top feathers; may have snout with teeth.
Katcina–Cholawitze or Kokosori	• Mask, black with spots and big ears. • Anthropomorph with big ears and feather; may carry spruce bough and weapon.
Katcina–Cloud (*see also* Cloud)	• Mask or anthropomorph with cloud symbol on head.
Katcina–Clowns (*see* Katcina–Mudhead Clowns)	
Katcina–Deer or Sowiñu	• Mask, with deer horns on top; may have snout with teeth.
Katcina–Dumas or Tumash	• Mask with triangle in the center of the face and wing-like "ears."
Katcina–Kokosori (*see* Katcina Cholawitze)	
Katcina–Hehea	• Mask or face design, with toothed mouth at 45-degree angle.
Katcina–Hemis	• Mask with stepped pyramid on top.
Katcina–Mudhead Clowns	• Head of anthropomorph with knobs on sides or top of head.
Katcina–Planet or Star	• Mask with star in the middle of face or stars as eyes.

ASCRIBED MEANING	SYMBOL DESCRIPTION
Katcina–Sayathlia, Tungwup, Hu, Hututu, or Whipper	• Mask with two large horns, round eyes, and toothed mouth. • Anthropomorph with arm raised, holding stick or whip.
Katcina–Shalako	• Mask with large snout, horns and feathers. • Mask as above on top of extended body.
Jimson Weed (*see* Datura or Jimson Weed)	
Kinship Lines (*see also* Power Lines)	• Wavy lines connecting zoomorphs and other figures.
Kokopelli (*see* Flute Player)	
Kwataka or Qaletaqa or Kwa'toko	• Large unreal bird.
Lightning (*see also* Snakes)	• Wiggly line, with or without head at one end.
Lightning Snakes (*see* Lightning and Snakes)	
Lizard (*see* Frog, Lizard or Toad)	
Maasaw (*see* God of Death or Metamorphosis)	
Maps	• Curvilinear meanders.
Masks (*see also* Katcinas)	• Masks.
Mastodon and Mammoth	• Heavy-bodied quadruped with raised trunk.
Maze	• Circular or rectangular design of nested lines.
Medicine Bag	• Trapezoidal design suspended from a bar. • Oval with dots or rays suspended from an anthropomorph.
Meeting (*see* Dumbbell)	
Migrations (*see also* Spirals and Swastika)	• Curvilinear meander. • Double-linked spirals. •Swastika, with arms pointing clockwise or counter-clockwise.
Mirror Images	• Anthropomorphic or abstract designs that look similar viewed normally or upside down.
Monster Slayer (*see* Bow and Twin War Gods)	

ASCRIBED MEANING	SYMBOL DESCRIPTION
Moon	• Crescent. • Half or full circle with dot. • Complete circle filled in.
Morning Star (*see* Cross, Stars, and Quetzalcoatl)	
Mother of Animals (*see also* Hocker and Water Skate)	• Hocker, with filled-in circle on each side of body. • Water Skate, with two concentric circles overlaying body.
Mountain Lion	• Quadruped with ball-like feet, short ears, long tail, often doubled-back over body or extended up or down.
Mountain Sheep (*see also* Coyote)	• Quadruped with one or two horns curving back over body. • Quadruped with horns spreading left and right.
One-Pole Ladder (*see* Centipede or One-Pole Ladder)	
Parrot	• Bird in profile, with curved beak and triangular body, often with long tail.
Patterned Body Anthropomorphs	• Anthropomorphs with complex designs on body.
Phallic Figure (*see also* Flute Player)	• Anthropomorph with phallus. • Three connected down-pointing triangles.
Phosphenes (*see also* Concentric Circles and Grid)	• Patterns of dots, checkerboards, grids, circles, crosses, spirals, parallel lines, etc., sometimes seen with the eyes closed.
Pit and Groove	• Multiple pits on rock surface; may include grooves among the pits.
Planetarium (*see also* Stars)	• Crosses, usually painted, of varying sizes, on the roof of cave or shelter.
Plumed Serpent (*see also* Quetzalcoatl, Cross and Star)	• Snake with plume on head or may have human-like head with tall hat.
Pottery or Textile Designs (*see also* Blanket Designs)	• Complex designs, usually seen on pottery or textiles.
Power Lines (*see also* Kinship Lines)	• Wavy lines, emanating from anthropomorph, often connecting with other figures.

28

ASCRIBED MEANING	SYMBOL DESCRIPTION
Praying Person	• Anthropomorph with both hands upraised.
Pregnancy (*see also* Birthing)	• Anthropomorph or zoomorph with small figure within body.
Quetzalcoatl (*see also* Plumed Serpent, Cross and Stars)	• Single- or double-outlined cross. • Snake with head plume. • Human head with tall hat; may have snake body.
Rabbit	• Quadruped with long ears.
Rain	• Horizontal line with vertical lines descending from it.
Rainbow	• Arc of parallel lines, with ends pointing down. • Horizontal rectangle enclosing short vertical lines.
Rain God or Tlaloc	• Goggle-eyed anthropomorph, often with design on body. • Vertical design of connected rectangles, often with "eyes."
Rattle	• Vertical line bisected with line(s) or oval(s), usually carried by an anthropomorph. • Single or double oval on stick.
Rattlesnake (*see* Snakes and Diamond Chain)	
Red Ant	• Vertical line with dot head and dot body. • Vertical line with "V" at top and circles below.
Rhombus (*see* Bullroarer)	
River (*see also* Snakes and Maps)	• Meandering line in complex design. • Snake-like figure, possibly with head.
Roadrunner (*see* X-Incurved)	
Runner	• Anthropomorph running.
Sandals (*see also* Footprints)	• Foot-shaped designs, often with left and right shown; some have interior patterns.
Seedpods (*see* Diamond Chain)	
Settlements (*see* Concentric Circles)	
Scalps (*see* Hourglass)	

ASCRIBED MEANING	SYMBOL DESCRIPTION
Shaman (*see also* Bird-Headed Humans, Curing, and Patterned Body Anthropomorphs)	• Anthropomorphs with horns or special headdresses.
Shell	• Vertical lines enclosed in oval frame. • Spirals.
Shield	• Circle or oval, with interior design, often with head, legs, and spear shown around edge. • Design in circle, oval, square or rectangle.
Shrine	• Rectangles with interior designs.
Sickness (*see* Curing)	
Sipapu or Sipapuni (*see* Shrine, Spirals, and Emergence)	• Double-linked spirals. • Rectangle with interior design.
Skeletons (*see* X-Ray Style)	
Sky God (*see* Creator God)	
Snakes (*see also* Lightning, River and Diamond Chain)	• Wiggly lines, with or without head at one end.
Solstice or Equinox	• Spirals. • Concentric circles.
Spaniards (*see* Horsemen)	
Spear (*see* Arrow)	
Spear Thrower (*see* Atlatl)	
Speech	• Anthropomorph, zoomorph or abstract design, with shape, often comma-like, exiting from mouth or associated with it.
Spider and Spider Web	• Zoomorph with circular body and multiple legs. • Design with radial spokes, connected around circumference.
Spirals (*see also* Emergence, Migrations, Whirlwind, and Solstice)	• Spirals.
Spirits	• Unusual life forms.
Spirit Helpers	• Small zoomorphs near anthropomorph, often at head and shoulders.
Spread-Legged Figure (*see* Hocker or Receptive Female)	

ASCRIBED MEANING	SYMBOL DESCRIPTION
Squash and Squash Blossom	• Ship's wheel design. • Open flower in profile. • Dots. • String of connected circles.
Staff (*see also* Crook)	• Long line, with object or curve at one end, often carried by anthropomorph.
Stars (*see also* Cross, Planetaria, and Quetzalcoatl)	• Four isoceles triangles joined at bases to form star. • Equilateral cross, often outlined. • Dots.
Storyteller (*see* Waving Man)	
Sun (*see also* Concentric Circles, Pit, and Solstice)	• Circle with rays. • Concentric circles, often with dot in center. • Circle with face or designs. • Circle with cross and rays. • Pit.
Supernova	• Crescent with circle or star.
Swallower	• Anthropomorph swallowing arrow, stick or bough.
Swastika (*see also* Friendship and Migrations)	• Swastika, with arms pointing either clockwise or counter-clockwise.
T-Shaped	• T-shaped.
Tablet, Tableta, or Tabla	• Stepped-pyramid design worn on top of the head or mask. • Rectangular design on wooden board used by shaman.
Thunderbird (*see also* Eagle)	• Flying bird, wings outstretched, feathers often prominent.
Tlaloc (*see* Rain God)	
Turkey	• Bird in profile, with drooping nose. • Three-toed footprint of bird.
Twin War Gods (*see also* Bow, Hourglass, and Handprint)	• Two small anthropomorphs, without facial features, but with "pony tails." • Two parallel lines, often on cheeks of anthropomorph. • Bow and hourglass. • Red hand.
Two-Headed (*see also* Birthing)	• Zoomorph with head at both ends.
Venus (*see* Cross, Stars, and Quetzalcoatl)	
Vulva	• Oval or triangle vertically bisected by line.

ASCRIBED MEANING	SYMBOL DESCRIPTION
Warriors (*see also* Combat and Four Circles)	• Anthropomorphs with shields, weapons, and possibly helmets.
Water (*see also* Friendship)	• Horizontal wavy lines. • Interlocking "U"s or "C"s. • Spirals.
Water Gourd	• Round object, enclosed in a carrying net, often carried by anthropomorph. • Double-round objects connected one to the other.
Water Skate	• Zoomorph with dot head and horns; arms and legs bent down at elbows and knees; also has tail.
Waving Person	• Anthropomorph with one hand upraised.
Weeping Eye	• Anthropomorph with slant lines descending from eyes.
Whirlwind (*see also* Breath, Spirals, and Swastika)	• Spirals. • Anthropomorph with spirals attached or within.
Whizzer (*see* Bullroarer)	
Wolf (*see* Coyote, Dog, or Wolf)	
X-Incurved	• "X" shape with tips curved in.
X-Ray Style (*see also* Heart Line)	• Anthropomorph with bones and internal organs showing.

ALPHABETICAL INDEX BY SYMBOL DESCRIPTION, PLUS RELATED ASCRIBED MEANING

SYMBOL DESCRIPTION	ASCRIBED MEANING

Anthropomorph

with **big ears and feather:** may carry **spruce bough and weapon**	Katcina–Cholawitze
with **bird in place of head** or on top of head	Bird-Headed Human
with filled-in **circles or ovals attached to both sides of head**	Female Figure
carrying human head(s), often suspended from line	Head Hunting
with **cloud symbol on head**	Katcina-Cloud
with **complex designs on body**	Patterned Body Anthropomorph
front facing, with extension from ear usually his left, ending in arc or balloon	Ear Extension
with **extended arms and legs**	Corn
with **eyes that have slant lines below**	Weeping Eye
female, horned, with arms and legs spread, bent down at elbows and knees, with two concentric circles overlaying body	Mother of Animals
female, with spread legs, bent at knees, often showing vulva	Hocker
female, with arms and legs spread, arms bent up and legs bent down, often showing vulva; has filled-in circle on each side of body	Mother of Animals
with small **figure between legs or adjacent to main figure**	Birthing
goggle-eyed, often with designs on body	Rain God or Tlaloc
with both **hands upraised**	Praying Person
with one **hand upraised**	Waving Person or Woman
head of, circular, with toothed mouth at 45-degree angle	Katcina–Hehea
head of, in profile with large forehead	God of Death
head of, with knobs on the head	Katcina–Mudhead Clown
head of, occasionally with loop at top	Head Hunting
head of, with tall hat; may have snake body	Quetzalcoatl

SYMBOL DESCRIPTION	ASCRIBED MEANING
head of, with two deer antlers above	Katcina–Deer
headdress of, often includes horns, feathers, and other materials	Headdress
headless	Death
horizontal	Death
with **horns** or special headdress	Shaman or Headdress
with **line from mouth and arms holding this line**, often with hump on back and ithyphallic	Flute Player
wearing **mask with large snout, horns, ruff and feathers** on top plus circular body extension	Katcina–Shalako
with **phallus**	Phallic Figure
with **"pumpkin" head,** round eyes and mouth	God of Death
running	Runner
with **shield, weapons and/or helmet**	Warrior
with **spirals attached or within body**	Whirlwind
swallowing arrow , stick or bough	Swallower
upside down	Death
holding **U-shaped object** near another anthropomorph	Curing
with downturned **"U" or vulva shape between legs**	Female Figure
with **weapons near game animals,** which are often impaled	Hunting
wearing animal head, usually carrying weapons near game animals	Hunter's Disguise
Anthropomorphs, two, male and female, together, occasionally with smaller figure	Family
Anthropomorphs, two, small, without facial features, but with "pony tails"	Twin War Gods
Anthropomorphs, row of, often holding hands	Dancers in Row
Anthropomorph or Zoomorph with **bones and organs showing**	X-Ray Style
with **small figure within body**	Pregnancy
two, connected at genital area	Coitus

SYMBOL DESCRIPTION	ASCRIBED MEANING
Anthropomorph, zoomorph, or abstract design, with **shape, often comma-like, associated with it or exiting from mouth**	Speech
Arc of parallel lines, with ends pointing down	Rainbow
Arrow	Arrow
Banana-shape, horizontal, with multiple vertical lines extending from top side	Boat
Bird(s)	
flying, wings outstretched, feathers often prominent	Eagle
flying, wings outstretched, feathers often prominent	Thunderbird
in profile, with curved beak and triangular body, often with long tail	Parrot
in profile, two, facing each other	Facing Birds
in profile, with drooping nose	Turkey
large, unreal	Kwataka or Qaletaqa or Kwa'toko
with **long legs**	Crane or Heron
standing, in profile	Eagle
track with three prongs	Crane or Heron
track with three prongs	Turkey
Bow	Bow
Bow and hourglass	Twin War Gods
Bullroarer	Bullroarer
Butterfly	Butterfly
Circle(s)	
complete	Sun
complete, filled in	Moon
concentric	Concentric Circles
concentric	Solstice-Equinox
concentric, often with dot in center	Sun
with **face or designs**	Sun
four, small, in cross design; may be connected with lines or separated by stick cross	Four Circles
half or full, with dot	Moon
nested, sometimes with dot	Sun

SYMBOL DESCRIPTION	ASCRIBED MEANING
or oval, with interior design, often with head, legs and spear shown around edge	Shield
two, connected with line(s); may be embellished with designs	Dumbbell
with rays and long tail	Comet
with rays	Sun
with **cross and rays**	Sun
Crescent	Moon
Crescent, with circle or star	Supernova
Cross(es)	
Fat or "red"	Cross
four-pointed, like connected isoceles triangles	Stars
"Maltese"	Cross
"Maltese"	Quetzalcoatl
stick, equilateral, often outlined; may be double or multiple	Cross
stick, equilateral, often outlined; may be double or multiple	Quetzalcoatl
stick, equilateral, within circle, often with dots surrounding circle	Cross
stick, equilateral, within circle, often with dots surrounding circle	Quetzalcoatl
of **varying sizes on ceiling of cave or shelter**	Planetarium
Design(s)	
abstract, of horizontal and vertical lines, usually enclosed	Grid
circular, mandela-like	Datura or Jimson Weed
in **circle, oval, square or rectangle**	Shield
complex, usually seen on pottery or textiles	Pottery or Textile Designs
complex, with water and plant symbols; may be in form of map	Irrigation
foot-shaped, often with left and right shown; some have interior patterns	Sandals
with **radial spokes, connected around circumference**	Spider or Spider Web
rectangular, on a wooden board, used by shaman	Tablet, Tableta, or Tabla
rectangular, with interior design	Shrine
ship's wheel	Spider and Spider Web

36

SYMBOL DESCRIPTION	ASCRIBED MEANING
ship's wheel	Squash Blossom
stepped pyramid, worn on top of head or mask	Tableta, Tablet, or Tabla
T-shaped	T–Shaped
that look similar viewed normally or upside down	Mirror Images
trapezoidal, suspended from bar	Medicine Bag
vertical, of connected rectangles, often with "eyes"	Rain God or Tlaloc
Diamond chain	Diamond Chain
Dot, in center of circle	Dots
Dot, in center of circle	Beans (also Corn, Squash)
Dots, alone	Dots
Dots, patterns of	Stars
Dots, surrounding or adjacent to figure(s)	Datura or Jimson Weed
Fish	Fish
Forms, unusual life	Spirits
Hand, red	Twin War Gods
Horns	Horns
Hourglass	Hourglass
Hourglass	Twin War Gods
Line(s)	
bisected with "V"s (spruce bough)	Katcina Clan
through **circle(s)**	Atlatl
from mouth to chest, ending in heart-shaped object	Heart Line
with **hook at end**	Atlatl
with **hook at end**	Beans
with **hook at end**	Crook
long, with object or curve at one end, often carried by anthropomorph	Staff
meandering, in complex design	River
nested, in circular or rectangular design	Maze
slant, descending from eyes	Weeping Eye
two parallel, on cheeks of anthropomorph	Twin War Gods
U-shaped line (or dots) with game animals entering or within	Enclosure
wavy, connecting zoomorphs and other figures	Kinship Lines

SYMBOL DESCRIPTION	ASCRIBED MEANING
wavy, emanating from anthro-pomorphs, often connecting with other figures	Power Lines
wiggly, with or without head at one end	Lightning
wiggly, with or without head at one end	Snakes

Line(s), horizontal

with stacked inverted half-circles or step pyramid above; may have vertical lines below (rain)	Cloud
with vertical lines extending down from it	Rain
wavy	Water

Line(s), vertical

bisected by line(s) or oval(s), usu-ally carried by anthropomorph	Rattle
bisected by many short lines; may have head, horns at top, and legs at bottom	Centipede or One-Pole Ladder
bisected by many lines which may slant downward	Corn
with dot head, bisected by two (at times one) horizontal parallel lines	Dragonfly
with dot head and dot body	Red Ant
enclosed in oval frame	Shell
like picket fence, game animals nearby	Enclosures
usually with design at end, often carried by anthropomorph	Staff
with "V" at top and circles overlaying line below	Red Ant

Mask(s) — Masks

Mask

with big ears and top feathers; often has snout	Katcina–Cha'veyo
with deer horns on top and snout with teeth	Katcina–Deer
with large snout, horns, and feathers	Katcina–Shalako
with large snout, horns, and feathers on top of extended body	Katcina–Shalako
with snout and feathers on top	Katcina–Ahole
with star in middle of face	Katcina–Planet or Star
often with horns	Katcina Clan

SYMBOL DESCRIPTION	ASCRIBED MEANING
with **stepped pyramid on top**	Katcina–Hemis
with **toothed mouth at 45-degree angle**	Katcina–Hehea
with **triangle in center and wing-like "ears"**	Katcina–Dumas/Tumash
with **two large horns, round eyes, and toothed mouth**	Katcina–Sayathlia
Meander, curvilinear	Maps
Meander, curvilinear	Migrations
Object, round, enclosed in carrying net, usually carried by anthropomorph	Water Gourd
Objects, two, round, connected to each other	Water Gourd (double)
Object(s), oval, or rectangular	
extended, often on head of anthropomorph	Feather
extended, with step design at one end	Feather
Oval, bisected by vertical and horizontal lines; may have dots within these lines	Corn
Oval, with dots or rays, suspended from anthropomorph	Medicine Bag
Oval or triangle, vertically bisected by line	Vulva
Oval(s), single or double, on vertical line, often carried by anthropomorph	Rattle
Patterns of dots, checkerboards, grids, circles, crosses, spirals, parallel lines, etc., seen with eyes closed	Phosphenes
Pits, multiple, on rock surface; may also include grooves among pits	Pit and Groove
Print(s)	
of **bare human foot**	Footprints
of **hoof, with two parallel V-shaped or one U-shaped mark, often with two dots at open end**	Deer or Elk
of **human hand**	Handprint
of **paw, with claws**	Badger
of **paw with claws**	Bear
of **paw, with dots for toes and claw points**	Bear

SYMBOL DESCRIPTION	ASCRIBED MEANING
three-toed footprint of bird	Turkey
Quadruped(s)	
with **anthropomorph on its back**	Horseman
with **antlers**	Deer or Elk
large, with claws	Bear
with **long ears**	Rabbit
heavy body, with raised trunk	Mastodon or Mammoth
with **ball-like feet, short ears, long tail, often doubled-back over body, or extended up or down**	Mountain Lion
with **small ears and tail**, often near game animals	Coyotes, Dogs and Wolves
small, with claws	Badger
with **one or two horns, curving back over body**	Mountain Sheep
with **two horns, spreading left and right**	Mountain Sheep
Rectangle, vertical, with design	Bullroarer
Rectangle, horizontal, enclosing short vertical lines	Rainbow
Rectangle, with interior design	Sipapu
Rectangle, with interior design	Shrine
Snake with head plume	Plumed Serpent
Snake with head plume	Quetzalcoatl
Snake-like figure, possibly with head	River
Spiral, single	Emergence
Spiral, single	Shell
Spiral, single	Solstice or Equinox
Spiral, single	Water
Spiral, single	Whirlwind
Spiral, double-linked	Emergence
Spiral, double-linked	Sipapu
Spiral, double-linked	Migration
Swastika, with arms pointing either clockwise or counterclockwise	Swastika
Swastika, with arms pointing either clockwise or counterclockwise	Migrations
Triangles, four, isoceles, joined at bases to form star	Star
Triangles, multiple, nested or connected	Butterfly
Triangles, three, pointing down	Phallic Figure

SYMBOL DESCRIPTION	ASCRIBED MEANING
"U"s and "C"s, interlocking	Water
"X" with tips curved in	X-Incurved
Zoomorph(s)	
with **circular body, and multiple legs**	Spider and Spider Web
with **dot head and horns, arms and legs bent down at elbows and knees; also has tail**	Water Skate
with **head at both ends**	Two-Headed
head of, with ears and long snout	Coyote, Dog or Wolf
small, near anthropomorph, often at head or shoulders	Spirit Helpers
with **tail, arms raised and bent at elbows, legs spread and bent down at knees, often with circular body**	Frog, Lizard, or Toad

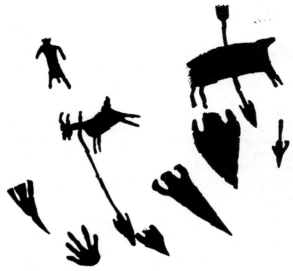

Petroglyphs, Diablo Dam, Texas

These spears have been likened to the Archaic Shumla point (Sutherland and Steed 1974:3). In some cases the point itself takes on anthropomorphic aspects and appears to be a very stylized man with raised arms. The man becomes the point or vice versa and again shamanic power is implicit. Along with these elements are numerous figures of square-bodied deer and mountain sheep, commonly pierced by a spear. One cannot escape the feeling that this is a site with magical power, that it was an important hunting shrine. [Schaafsma 1980:56]

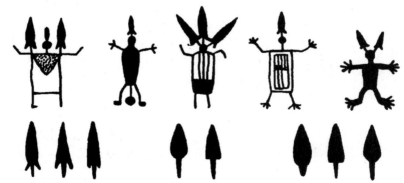

Petroglyphs, Coso Range, California

(Top row) Anthropomorphs with Projectile Points . . . The shape of the points suggest bottom-notched arrow points.
(Bottom row) Projectile points with foreshafts. Group on left are probably arrow points. Remaining groups may be atlatl points.

[Grant, Baird and Pringle 1968:37]

Pictographs, Baja California, Mexico

The belief that shamans could cause illness by sorcery and that by killing the suspected evil shaman, individuals could "purchase their own health and life" (Aschmann 1966:66), was a universal theme in the central and southern regions of the peninsula. I would suggest, however, that arrows . . . are used, in most cases, to symbolize the negation of the power of a shaman or animal in conjunction with a mythological metaphor.

(Above) A black deer has the arrow shaft placed over the body, holding the animal in place. (Above right) the mythological being or evil shaman is being held in place by the arrows across his body, negating his power.
[Smith 1985:46]

Hopi Mesas, northern Arizona

Figure (above) gives sketches (of petroglyphs) of the . . . different forms of arrows. [Mallery 1893:746]

Petroglyphs, Three Rivers, New Mexico

Petroglyphs of desert bighorn sheep with arrows.
[Grant 1978:192]

Petroglyph, Galisteo, New Mexico

There are . . . arrow swallowers (Sims 1963:218).
[Schaafsma 1980:265]

Atlatl or Spear Thrower

• Line through circle • Line with hook at one end • Line through circle(s), often with hook at one end, loop(s) at other

In Rock Art Actual

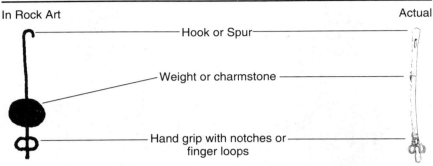

The atlatl or spear thrower was man's first efficient hunting weapon. It was a straight stick about two feet in length with a hook or spur at the tip end and a hand grip with notches or finger loops at the other end. One or several weights or charm stones were tied to the shaft. The spear, over four feet in length, had a conical depression at its butt end which fitted into the hook or spur of the atlatl.

In rock art the weights or charm stones are much exaggerated in size, due probably to the magic they supposedly contained—magic to guide the spear to its target.

The use of the atlatl began before 1,000 B.C., continuing to about 500 A.D. in the southwest, when it was supplanted by the bow and arrow.

[After Grant 1979]

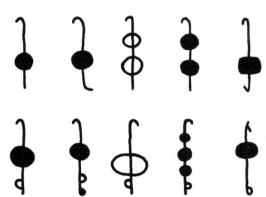

Petroglyphs, Coso Range, California

The stylized atlatls are almost invariably shown with one, two, or three stone weights attached to the weapon. . . . These stones added little to the efficiency of the atlatl and it is likely their chief function was as charm stones or fetishes to bring luck to the hunter. . . . The Coso atlatl stones are greatly exaggerated in proportion to the size of the weapon. A plausible explanation for this exaggeration is that it might increase the effectiveness of the charm stones if they were depicted as very large.

[Grant, Baird and Pringle 1968:49]

Atlatl or Spear Thrower (continued)

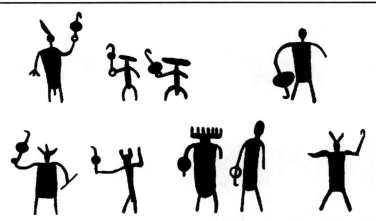

Petroglyphs, Coso Range, California

Petroglyph figures with atlatls, Petroglyph and Renegade Canyons, Coso Range. [Grant et al. 1968:54]

Petroglyphs, Picacho Mountains, Arizona

Figure 6.13. Western Archaic tradition petroglyph on panel F-13, *atlatl.* Shelter Gap, Cluster F.
[Wallace and Holmlund 1986:97]

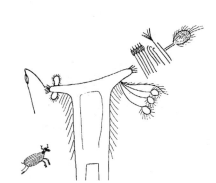

Pictographs, Seminole Canyon, Texas

The shaman figures assume a distinctive form. . . . They are usually a single shade of red, elongated and large; 40% are over 6 ft. tall, and six of them are over 10 ft. in height. . . . They often lack heads. . . . More than half of the . . . shaman hold an atlatl in the right hand with the butt of a feathered dart in place against it. [Newcomb 1976:183]

Petroglyphs, State of Utah

Location of Atlatl petroglyphs in State of Utah.
[Castleton and Madsen 1981:172]

45

Badger

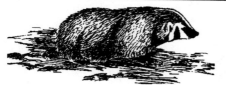

Badger [Murie 1954:82]

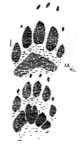

Badger Tracks

(Top) Badger's left front foot. (Bottom) Badger's left hind foot. Badger tracks, shown herewith, are extremely toed-in, and the long claws of the front feet . . . leave marks. [Murie 1954:82-84]

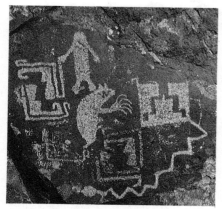

Petroglyphs, Gallisteo, New Mexico

Rio Grande Style petroglyph (of) badger. [Schaafsma1980:270]

Petroglyphs, Willow Springs, Arizona

Badger clan symbols (Hopi) recognized by Edmund Nequatewa, a Hopi Indian. [Colton 1946:4]

Drawing of badger from petroglyph

The badger is another animal god, and highly esteemed for his curing powers, especially among the Hopi. Because he lives and digs in the ground he . . . knows roots and herbs which "he is always scratching out." According to legend the badger taught the Hopi how to use these for curing, knowledge that led to the founding of the still important Badger Clan.
[Packard 1974:28-9]

(Above and below) Signatures of Hopi at archaeological site, northern Arizona, 1897

Yoyowaiya (from Sitcomovi) Honani gens (badger clan); totems: (above) badger with bundle of medicine on back and purification feather in forepaw and (below) badger's paw.
[Fewkes 1897:1-11]

46

Beans

Petroglyph on boulder of irrigated farm-ing area, Sonora River, Sonora, Mexico

Especially evident are the accurate locations of the main river channel, the *acequia madre* or principal irriga-tion ditch, fields, and the adjacent permanent habitation sites. The actual locations of fields are indi-cated on the glyph by dots within circles. This particular iconographic motif has been interpreted as maize, beans, or squash plants in another part of Mexico (Mountjoy 1982:119, below). [Doolittle 1988:46-47]

Pictographs, Tomatlán River, Jalisco, Mexico

Lumholtz (1900) recorded the fre-quent use of dots to indicate maize kernels, ears of maize, squash or beans, as well as raindrops and stars on occasion. Perhaps the clump of tiny circles or dots within circles can be interpreted as maize, beans or squash. [Mountjoy 1982:119]

Symbols commonly used on (Hopi) kachina masks

Bean sprout. [Colton 1949:18]

Painting of Hopi kachina figurine

Tala'vai (Morning kachina) figurine. The eye, *hazru'bushi*, newly sprouted bean plant; the mouth, *pa'tsro kukuadta*, snipe footprint.
 [Stephen 1936:211, Plate III]

Painting of Hopi kachina

The picture of Muzribi, the Bean kachina, has on each side of the mouth, the sprouting seed of a bean.
 [Fewkes 1903:101, PL. XXXIX]

Comment on bean planting ceremony

At the full of the December–January moon (1887-8) . . . Powa'mu chief, who is the Kachina clan chief, plants beans secretly in Chief kiva . . . (p.155). Jan. 26–Maintain hot fires in the kivas . . . (p.162). Jan. 31—This morning beans were plucked and gathered from the boxes and prepared in a stew and served to the men in the kivas . . . (p.253). Powa'nu is a ceremony of prognostication, for omens for the year's crop come from the growth of the ritual beans (p.156).
 [Stephen 1936]

Bear

- Large quadruped with claws
- Paw print with claws
- Paw print with dots for toes and claws

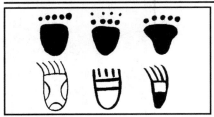

Bear Tracks

Petroglyphs (except lower right which is painted) from left to right in order: California, New Mexico, North Carolina, Nebraska, Idaho, and British Columbia.

[Grant 1967:57]

Comment on bear in Indian life
The bear was a most important animal to the North American Indian, the living symbol of strength and courage. To kill a bear, especially the formidable grizzly, was a great feat. . . . The grizzly and the more timid black bear are the most widespread of the North American carnivores and played a major part in tribal ritual and mythology.

[Grant 1967:55]

(Above and below) Signatures of Hopi at archaeological site, northern Arizona, 1897

All are members of the Bear Clan. Symbols are bear paw, except lower right above which represents bearskin robe. [Fewkes 1897:1-11]

Bear tracks

(Left) Grizzly bear, left front and rear foot; (right) black bear, left front and rear foot.

[Murie 1954:25-28]

Petroglyphs, Bandelier National Park, New Mexico

. . . magnificent bear.

[Rohn et al. 1989:108]

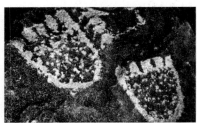

Petroglyphs, Cook's Peak, New Mexico

In the Pueblo world, the bear track stands for the curing power of the bear, and the paw is equal in power to the mask of other deities. When Keresan shamans put on their bear paws, they "became bears" (Parsons 1939:170). Bear paw effigies from Tularosa Cave dated A.D. 799-900 (Martin and Plog 1973:186, Plate 35) affirm the ancient significance of this element in the ceremonial life of the Indians of the Southwest.

[Schaafsma 1980:195, 207]

Bird-Headed Humans

• Anthropomorph with bird in place of head or on top of head

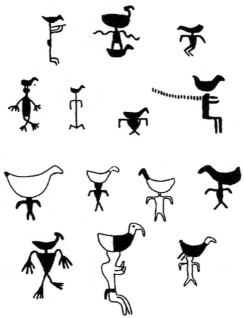

Petroglyphs (top row) and pictographs (remaining rows) of bird-headed humans, Canyon de Chelly and Canyon del Muerto, northern Arizona

Often birds appear perched on the heads of humans or even in place of the human head. Not all of these perching creatures appear to be turkeys, but in a significant number of instances the big bird is unmistakable . . . the bird-headed man variation would seem to have originated in Canyon de Chelly. Despite great numbers of paintings and some petroglyphs depicting this being in the canyon, the motif is rare elsewhere. Several of the figures (elsewhere) were recorded with men holding atlatls. . . . (Thus) . . . we can postulate a beginning for the motif in late Basketmaker or Early Modified Basketmaker times (circa 500-600 A.D.).

[Grant 1978:210]

Petroglyph, Marsh Pass, Arizona

Bird symbolism is prevalent in shamanic symbolism throughout the world. . . . Shamans often claim to be able to engage in flights in which the soul, when it leaves the body, takes the form of a bird.

[Schaafsma 1986a:194]

49

Birthing

(*See also* Two-Headed)

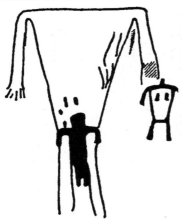

A-55

Pictographs, Green Mask site, Grand Gulch, Utah

(Above) Rock painting of a possible birth scene and "females."
[Cole 1984b:3]

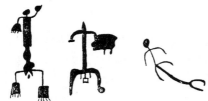

A-56

Petroglyphs, Petrified Forest, Arizona

Characteristics include . . . possible birth scenes. [Martynec 1985:77]

Petroglyph, Owl Springs, Monument Valley, Arizona

. . . this delivery scene is recorded. If the . . . headdress conforms to modern Hopi custom, she was unmarried.
[Ritter and Ritter 1973:80]

Petroglyphs, Picacho Mountain, Arizona

Two panels from the North Pass Site display striking depictions of what may be birthing scenes (Figures A-55 and A-56). In both cases the "mother" is drawn as a hollow-bodied anthropomorph. In Figure A-55 something is apparently depicted within the "mother's" body. In both cases, the "infant" is drawn smaller than the "mother," and in Figure A-56 the possible umbilical cord and placenta are illustrated as a single wavy line and an area of amorphous dinting. In Figure A-56 the "infant" is still attached to the "mother" by a possible umbilical cord.
[Wallace and Holmlund 1986:144]

50

Blanket Designs

(See also Pottery and Textile Designs*)*

• Rectangle or square with interior design, often with "tassels" at corners

(Above) Petroglyphs, Waterflow, New Mexico

Waterflow is perhaps most well known for its many decorated block designs. . . . Some of the forms . . . have what appear to be a strong suggestion of the four-corner tassels of blankets.

[J. Warner 1983:31-32]

(Above) Petroglyph, Lacienaguilla, New Mexico

At the Cochita Reservoir and at Lacienaguilla, New Mexico, Schaafsma (1975:149) describes these occurrences as masks or heads over box or blanket designs. . . . All of these could be taken as specific instances of consummation or modest scenes of copulation. . . . According to the deductive reasoning of Georgia Lee and A.J. Bock (1982) the simple blanket design at Waterflow (see top illustration) . . . could possibly be a shorthand form of the blanket scenes at . . . Lacienaguilla.

[J. Warner 1983:32-33]

(Below) Petroglyph, Cook's Peak, New Mexico

The goggle-eyed figure, so prevalent in the rock art of the Jornada region, is depicted in abbreviated form at the Mimbres sites. His presence is signified by the eyes alone or eyes attached to striking blanket motifs. . . . This figure is believed to be a northern version of the Meso-american Rain God, Tlaloc.

[Schaafsma 1980:201-203]

(Below) Prehistoric Mexican Codices

(Left) The first human pair, the procreation of men, from the Codex Borgia. [Seler 1963:9]
(Right) The first human couple, from Codex Vaticanus 3773 (B).

[Seler 1903:67]

Boot

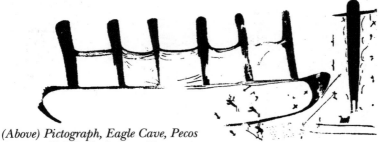

(Above) Pictograph, Eagle Cave, Pecos Canyon, Val Verde County, Texas

For example, in VV65 a black canoe filled with solid black post-like shapes, presumably human figures, is overlapped by a design containing a black figure with a geometric red body panel (termed elsewhere "a later red and black Fisherman; his Catfish is out of the picture to the right"). . . . The pictographs, most especially in VV 65, offer the only evidence of the knowledge of the dugout canoe in this region. They are not necessarily evidence of its use, for it might have been known to coastal people, though it is more plausible to imagine that canoes were actually used on the rivers (Rio Grande and Pecos Rivers). Trees of sufficient size are still found in some of the canyons. . . . The painting, in monochrome black, is about 12 ft. long and 6 ft. high. It seems to represent six men riding in a dugout canoe.

[Grieder 1966:712, 717, & 718]

(Below) Pictograph, Eagle Cave, Pecos Canyon, Val Verde county, Texas

VV 65. Red-outlined Canoe, about fifteen feet long. Painted solid black with red outline.

[Grieder 1966:713]

(Below left) Pictographs, Painted Cave, near Santa Barbara, California

This pictograph . . . show(s) the centipede, a sign of death, according to local Chumash legend (upper left).
Pictographs . . . of figures adjacent (upper and lower right) to the centipede, allegedly show the dead ready for burial and the funerary boat transporting the dead to the nearby Channel Islands for burial (lower left).

[Ritter and Ritter 1973:82]

52

Petroglyphs, Little Petroglyph Canyon, Coso Range, California

This pair of archers might represent . . . conflicting supernaturals or be a record of some battle or duel.
[Ritter and Ritter 1973:77]

B B

Petroglyphs, Willow Springs, Arizona

Hopi clan symbols for Bow Clan.
[Colton 1931:4]

Signature of Hopi workman at archaeological site in 1897

Nücitima (from Oraibi) Awata gens (clan); totem, bow.
[Fewkes 1897:9, PL. IV]

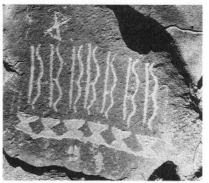

Petroglyphs, Largo Canyon drainage, New Mexico

The War Twins . . . are major deities in Navajo mythology. They have many names but the elder twin is most often called Monster Slayer and the younger Born-for-Water. . . . Dance impersonators of Monster Slayer are painted with a symbol of the bow. . . . Supernaturals carrying the bow may in some cases represent this deity. . . . Both the hourglass (symbol for Born-for-Water, the younger twin war god) and the bow (the elder twin) also occur apart from anthropomorphic contexts in rock art.
[Schaafsma 1980:315-31]

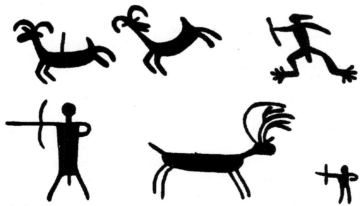

Petroglyphs, Coso Range, California

Figures hunting with bow and arrows. [Grant, Baird, and Pringle 1968:54]

Breath
(*See also* Heart Line)

- Line(s) from mouth to chest, ending in heart-shaped object
- "S" sign in center of figure

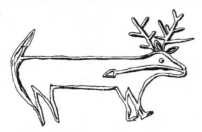

Petroglyph, Zuni Reservation, New Mexico

In many cases the deer has a "heart line" from its mouth to its interior; in pictographs the heart line is generally red. Similar depictions of deer with heart lines are also found on Zuni pottery water jars. . . . The heart line is a symbolic representation of the source or "breath" of the animal's life (Cushing 1886:515). In the rock art, arrows sometimes project from the bodies of the deer as if they had penetrated the heart portrayed at the end of this line. Sometimes pictographs and petroglyphs of bears and horned or plumed serpents also have heart lines. [Young 1988:82]

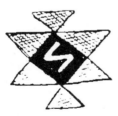

Petroglyph (?), Hopi area, northern Arizona

Describing the . . . (above) figure he (Mr. Keam, trader in Hopi area of Arizona in 1880s) says: "The figure represents a woman. The breath sign is displayed in the interior." [Mallery 1893:705]

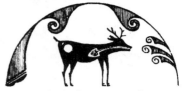

Design on Zuni Pottery, northwestern New Mexico

It will be observed that in paintings of animals there is not only a line drawn from the mouth of the plainly depicted heart, but a little space is left down the center or either side of this line (see above) which is called *o-ne-yäthl-kwa'to-na*, or the "entrance-trail" (of the source or breath of life).
[Cushing in Green 1979:245]

Comments on breath
To the primitive Shaman, all force . . . seems to be derived from some kind of life. . . . Now the supreme characteristic . . . of any . . . form of life, is breath, which like force or stress, is invisible. . . . Thus he reasons . . . breath is the force of life. . . . Therefore, he thinks . . . of the wind as necessarily the breath of some living form or being. . . . He also imagines that this great being of the wind resides in the direction whence comes prevailingly its wind or its breath.
[Cushing in Green 1979:207-8]

Cushing on meeting his first Zuni Indian: "I shook the proffered hand warmly and said: 'Zuni?' 'E!' exclaimed the Indian, as he reverentially breathed on my hand. . . . (Later) one of them approached . . . I grasped his hand and breathed on it. . . . The old man was pleased; smiled and breathed in turn on my hand."
[Cushing in Green 1979:48, 50]

Bullroarer, Rhombus, or Whizzer

• Vertical rectangle with design

Petroglyphs, Alamo Mountain, New Mexico

Similar to figure seen on Apache Bullroarer, recorded by Bourke in 1880s. (See below) May depict the Apache Wind God.
[Bilbo and Sutherland 1986:19]

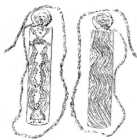

Drawing of rhombus as used at San Carlos Agency, Apache area, Arizona

The rhombus was first seen by Capt. John G. Bourke at a snake dance of the Hopi in the village of Walpi, Arizona, in 1881. The medicine men twirled it rapidly about the head and from front to rear, with a uniform motion, and succeeded in faithfully imitating the sound of a gust of rain-laden wind. As explained by one of the medicine men, by making this sound they compelled the wind and rain to come to the aid of the crops. At a later date Bourke found it in use among the Apache, and for the same purpose. *(Continued at right)*

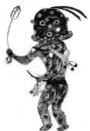

(Above and below) Drawing of Hopi Kachinas: Tcolawitze (above) and Pakwabi (below), both with whizzers with lightning symbols.
[Fewkes 1903:61, 108]

The form of rhombus in use among the Apache at this time was a rectangular piece of wood, seven or eight inches in length, one and a quarter inches in width, and a quarter of an inch thick. The extremity through which the twisted cord passed was simply carved to represent a human head. The Apache explained that the lines etched on the front side of the board were the entrails of their wind god and those painted on the rear side were his hair. The hair was of several colors, and the strands were crooked to represent lightning. The medicine rhombus of the Apache was made by the medicine men, generally of pine or fir that had been struck by lightning on the mountain tops. Such wood was held in the highest estimation among them and was used for the manufacture of amulets with special power.
[Mails 1974:151]

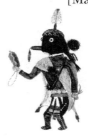

Butterfly

Petroglyph, Pictograph Point, Mesa Verde National Park, Colorado

(The design above) . . . is a stylized butterfly, a signature of the Póvol-nyam or Butterfly Clan.
[Waters 1963:51]

Pottery bowl, Sikyatki, Arizona

The most beautiful of all the butterfly designs are the six figures on the vase (above). [Fewkes 1898:678]

Petroglyphs, (left) Moki (Hopi) area, northern Arizona (right) Picacho Mountain, Arizona

(Left) Butterfly. [Mallory 1893:555]
(Right) Butterfly. [Wallace 1986:225]

Pottery design, Sikyatki, Arizona

Hopi depict the butterfly as a triangle or as connected triangles symbolizing fertility and life. . . . The stacked triangular form is also referred to as the "cloud ladder."
[Bentley 1988:42]

Petroglyphs, Willow Springs, Arizona

(Left) Butterfly Clan Symbols, Hopi. [Colton 1946:4]
(Right) Butterfly Clan symbols, Hopi. [Michaelis 1981:18]

Pottery designs, Sikyatki, Arizona

A butterfly with a . . . geometric form (upper right) is represented with outstretched wings, rounded abdomen, and rectangular body . . . (the other butterfly designs) have more complicated forms.
[Fewkes 1919:255]

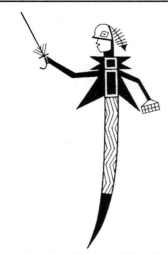

From Mimbres Black on White Bowl, Galaz Ruin, New Mexico

Along the neck region is the butterfly motif forming the hilt of the dagger (Anyon and LeBlanc 1984:93c). [Bentley 1988:59]

Felsite head, Casas Grandes, Mexico

At Casas Grandes . . . the butterfly motif was also identified by DiPeso as the dead warrior motif and is also referred to as a "cloud ladder" motif. This motif . . . at times is placed directly above the head region of human figures recovered at Paquime (Casas Grandes) (DiPeso 1974(2):557, (7):259-260, 293-97). [Bentley 1988:68-9]

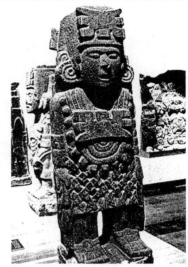

Toltec warrior statue, Tula, Mexico

Appearing in the familiar guise of a butterfly, Quetzalcoatl both shields the heart of a warrior and alights on his forehead to inspire his thoughts. [Vasquez 1968:90]

Comment on butterflies in Mexico
They (butterflies) were treated with affection and were thought of as the returning spirits of the dead.
[Burland and Forman 1975:30]

Pictograph Point, Mesa Verde, Colorado
Sikyatki ruin (Hopi), northern Arizona

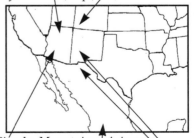

Picacho Mountains, Arizona
Tula, Hidalgo, Mexico
Casas Grandes, Mexico
Mimbres area, Galaz ruin, New Mexico

Centipede or One-Pole Ladder

• Vertical line bisected by many short lines; may have head, horns at top, legs at bottom

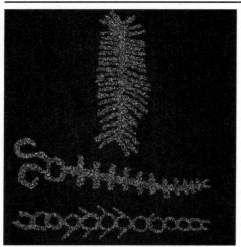

Petroglyphs, Zuni area, northwestern New Mexico

(Top to bottom): Pecked centipedes 30 cm x 10 cm, 15 cm x 50 cm, and 17 cm x 110 cm respectively.
[Young 1988:76]

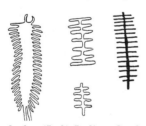

Petroglyphs: (Left) Indian Creek; (center) Parowan Gap and Clear Creek; (right) Short Canyon, all Utah

Elements (above) are referred to by different names on different element lists. Above left show a very naturalistic centipede. Many element lists refer to more abstract forms as one-pole ladders. Whether or not these abstract forms are actually centipedes is uncertain. It is questionable that any of them represent one-pole ladders.
[Warner 1982b:5]

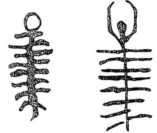

Petroglyphs, Arizona and Utah

"Centipede" (left) Santan Mountains, Arizona (after Schaafsma 1980:87) and near Moab, Utah (after Schaafsma 1971:55).
[Steinbring and Granzberg 1986:213]

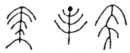

Petroglyphs, Picacho Mountain, Arizona

Centipede/Cornstalk.
[Wallace and Holmlund 1986:224]

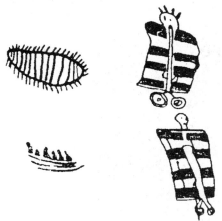

Pictographs, Painted Cave, near Santa Barbara, California

(Above, upper left) Painted Cave, near Santa Barbara, California, contains beautiful polychromes which show the centipede, a sign of death, according to local Chumash legend.

(Above right) Pictographs—again in Painted Cave—adjacent to the centipede, allegedly show the dead ready for burial and (above lower left) the funerary boat transporting the dead to the nearby Channel Islands for burial.

[Ritter and Ritter 1973:83, 84]

Petroglyphs, northern Arizona

Drawings from . . . different areas compared. The forms have been classified as . . . centipedes, insects and spider (which are not specified). The left three symbols are from Kayenta and the right symbol is from Cohonina. [Colton 1946:7]

Pictograph, Painted Cave (?), California

The centipede motif is presented (above). Symbols associated with these sites probably represent beings and themes connected with the mythic past. . . . Pictographic representations of Coyote, Lizard, Bear, *Centipede*, Hummingbird, and so on are examples of the personalized beings the Chumash believed were capable of acquiring and acting upon (magical) power (Blackburn 1975:66-68).

[Hudson and Lee 1984:35]

Comment on centipede motif in pictographs at Burro Flats, California

In Chumash myth, the centipede is the archetypal shaman's apprentice (see Blackburn 1975:202-204). The centipede has also been associated with death (Ritter and Ritter 1970:409).

[Benson and Sehgal 1987:10]

Cloud

• Horizontal line with inverted half-circles or step pyramid above; may have vertical lines descending below (rain)

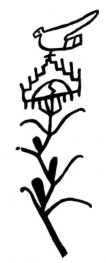

(Above and next page, top) Signatures of Hopi workmen in archaeological dig in 1897, northern Arizona

6, 19. Omowuh (Rain-cloud) gens (clan); totem, rain-cloud.
9, 10, 11. Patki (Water-house) gens (clan); totem, rain-cloud.
13. Nuva (Snow) gens (clan); totem, rain-cloud and corn plant.
14. Kaü (Corn) gens (clan); totem, rain-cloud and corn plant.
116. Kwalakwa; totem, rain-cloud (and next page).
[Fewkes 1897:1-10]

Petroglyphs, Oakley (Willow) Springs, northern Arizona

Moki (Hopi) cloud etchings, the three left-hand characters (above) from the Gilbert Manuscript, and variants from Oakley (Willow) Springs, Arizona.
[Mallery 1893:700]

Petroglyphs, Three Rivers, New Mexico

The corn-cloud terrace-bird complex. The example is unusual in that the terrace appears on top of the corn instead of at the base.
[Schaafsma 1980:230]

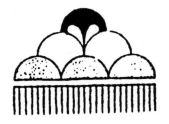

(Left) Symbol on various media, Hopi area, northern Arizona

The symbol for clouds and falling rain. . . . In the traditional design a Kachina face . . . looks out over the billowing clouds.
[O'Kane 1950:248]

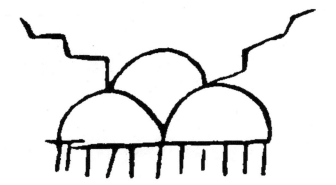

(Below) Petroglyphs, near Winona, Arizona

Among numerous petroglyphs found on the cliffs just across the valley, those shown are particularly interesting. The drawing on the left represents a cloud reflected in the water below. In the drawing to the right, the cloud terrace symbol formed by the figure's upraised arms is repeated upside down by his legs in the same manner as in the cloud to the left. The figure represents Panaiyoikyasi, deity of the Water Clan. The drawing under them shows four large waves of water, indicating the four migration routes to be completed by the Water Clan. [Waters 1963:64]

(Above) Petroglyphs, Willow Springs, Arizona

Clan symbols of Cloud Clan recognized by Edmund Nequatewa, a Hopi Indian. [Colton 1946:4]

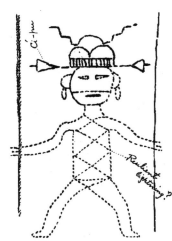

Petroglyph, Oraibi (Hopi), northern Arizona

On the west side of Oraibi pecked in sandstone is the figure of a cloud kachina (O'mau kachina).
 [Stephen 1936:1032-33]

Coitus

• Two anthropomorphs or zoomorphs connected at genital areas

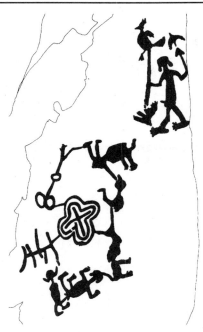

Petroglyphs, Petrified Forest National Park, Arizona (Illustration from Schaafsma 1980: Fig. 118)

In the so-called "Cave of Life" in the Petrified Forest National Park, Arizona a remarkable petroglyph panel can be found (above). Major elements of this panel are (1) a couple engaged in the act of sexual intercourse (bottom), (2) a kokopelli (upper middle), (3) a shaman figure with ceremonial staffs adorned with birds and feather tufts (top), and (4) a large star in the form of a cross with a double outline. Altogether they seem to represent a portrayal of a fertility rite or ceremony including the presiding priest or shaman, a star of some apparent symbolic significance, the male and female ritual actors or participants and the sacred presence represented by Kokopelli in his aspect of the locust or other insect. . . . It has been sug-gested that the couple engaged in sexual intercourse represents an example of ritual coition, a phenomenon that has been identified in the ceremonial inventory of other primitive peoples including other North American Indian Tribes (Hunger 1983). [Faris 1986:4-6]

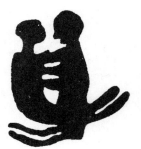

Petroglyph, Owl Springs, Monument Valley, Arizona

Coital scene.
[Ritter and Ritter 1973:51]

62

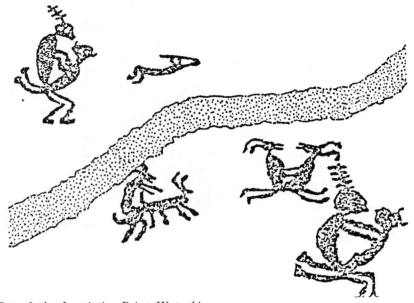

Petroglyphs, Inscription Point, Wupatki National Monument, Arizona

At the upper left and lower right are seated pairs of anthropomorphs copulating. [Hunger 1983:116]

Petroglyphs, Peterborough, Ontario, Canada

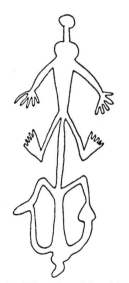

Petroglyphs, Waterflow, New Mexico

Instances of symbolic copulation. . . . Another pair of petroglyphs is similar in conception; the composition is without a phallic figure, but a serpentine form connects with what appears to be the clitoris of yet another symbolic vagina.

[Vastokas and Vastokas 1973:86]

Since there are several copulating figures . . . then this could definitely add credence to the sacred nature of this location—a possible fertility site.

[Judith Warner 1983:35]

Combat

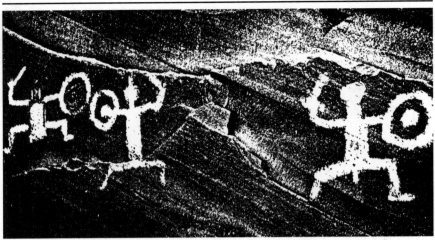

Pictographs, Defiance House, Forgotten Canyon, Utah

The name (of the ruin) derives from the club-wielding pictographs that appear to guard the village, located on a talus slope high (550 feet) above Forgotten Canyon floor. (Note: figure at right is about 1.2 meters tall.)

[Jennings 1978:137, Fig. 139]

Map showing locations (dots) of combat motifs in Utah

Tightly restricted elements associated with the Anasazi include . . . combat motifs found between the Green and San Juan Rivers . . . (in southeast Utah).

[Castleton and Madsen 1981:173]

(Below) Pictographs, Cara Pintada, Sonora, Mexico

Paintings in black, middle cliff area. All these figures are quite small. (Some are) about two inches tall. [Grant 1976:52]

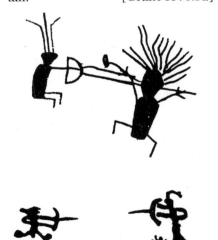

Petroglyphs, Little Petroglyph Canyon, Coso Range, California

This pair of archers might represent . . . conflicting supernaturals or be a record of some battle or duel. [Ritter and Ritter 1973:7]

64

(Above) Pictograph, Burro Flats, California

Symbols representing dynamic elements in opposition would be expected in the choice of subject matter and its arrangement within the total composition (of rock art among the Chumash). Two examples are Painted Cave with its possible depiction of a solar eclipse and Burro Flats (above), with its depiction of the same comet over an interval of days as it approached and departed from the sun (Hudson and Underhay 1978:88, fig. 14).
[Hudson and Lee 1984:38]

(Below) Pictograph, Shelter Rock site, Mojave Desert, California (in Chemehuevis Indian territory)

A dramatic discovery was a red radiating symbol with a "tail," which may represent a comet. . . . The Kawaiisu, who in culture and language are closely related to the Chemehuevis, also believed in a Sky Coyote, sometimes referred to as "White Coyote." It was said that he may be seen going across the sky, and that the sight of him portends death and destruction (Zigmond 1977:76). [Rafter 1987:29]

Concentric Circles

Pictographs, Hidden Cave, Durango, Colorado

"Concentrics" on back and roof of cave, in either black or white as indicated.　　[Daniels 1964:n.p.]

Comment on Pictographs, Arrow Grotto, Feather Cave, Capitan, New Mexico— see Sun

Those (pictographs) associated with the crevice filled with arrows in the upper grotto are related to Sun. . . . The primary source for identification of the Sun . . . is the symbol of three concentric circles. . . . In Pueblo explanations of this old symbol, so standardized as possibly to warrant designation as a glyph, the outer circle represents the ring of light around the Sun, the second represents Sun himself, and the inner circle or dot his umbilicus, which opens to provide mankind with game and other food.　[Ellis and Hammack 1968:35]

(Below) Footprint of Masau, god of death and the metamorphosis of nature, as seen by Hopi Indians during mythical migration

They found a place where (there were) many footprints like this. . . . Four days our uncles searched for the maker of the footprints, when our oldest uncle saw, coming over the west mesa, a who-was-it. Our uncle went to meet the stranger who was hideous and terrible, covered with blood and loathsomeness and there was no flesh on his head. They kept walking toward each other and when they came together our uncle took hold of him and it was *Masau.* . . . (He said), "Look in the valleys, the rocks and the woods and you will find my footsteps there."　　[Stephen 1940:7-8]

66

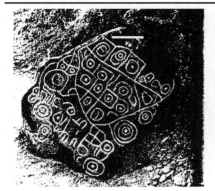

Petroglyphs, Sonora River, Sonora, Mexico

. . . the "map," found (on a boulder) on the edge of the flood plain in the extreme northern end of the Valley of Sonora, a few kilometers north of Bananuchi . . . bear(s) a strikingly similar likeness to the portion of the valley immediately surrounding the location of the glyph as seen from above. Settlements are depicted by the concentric circles, a motif used by many cultures to represent areas of habitation (for example Munn 1973:119). [Doolittle 1988:46-47]

Drawing of a basic phosphene design (from Kellogg, Knoll and Kugler 1965:1129)

. . . "phosphene" refers to the images perceived by the human brain as visual images in the absence of visual stimuli. . . . (They) are associated with altered states of consciousness.

[Hedges 1981:1]

Petroglyphs, Pit River, California

According to Floyd Buckskin, a Pit River Indian (personal communication 1981) the concentric circles shown above mark the place where spirit beings or very powerful shamans can pass through the rock from one world to the next.

[Benson and Sehgal 1987:6-7]

Comment on Burro Flats, California pictographs

Design elements with three or five concentric circles may be depictions of the Chumash or Fernandeño conception of the universe . . . it appears that the main panel . . . integrates the symbolism . . . to convey a . . . theme. This theme is virtually universal and has to do with the ability of the shaman and shaman-initiate to travel between the upper and middle worlds . . . for the purpose of obtaining power or knowledge. [Edberg 1985:91]

Further comment on concentric circles

The authors of this paper agree with his interpretation (Edberg above) and will expand upon this theme by suggesting that the symbol can also function as a metaphor for a tunnel, path or passageway from one of these worlds to another.

[Benson and Sehgal 1987:10]

Corn

Petroglyphs, San Cristobal, New Mexico

Carvings of corn are among the most realistic to be found at San Cristobal. . . . They all appear to have been done with special care, most of them with full ears. They were done no doubt with the idea of increase through magic, to thus secure good crops and plentiful food supply. [Sims 1949:7]

(Below) Petroglyph, near San Francisco Mountains, Arizona

The object resembling a centipede at left is a common form (of corn symbol) in various localities of Santa Barbara county, California. . . . In other parts of Arizona and New Mexico petroglyphs of similar outlines are sometimes engraved to signify the maize stalk.
 [Mallery 1893:48]

(Below) Petroglyphs, Hopi Mesas, Arizona

There are several pictographs below which are similar to those referred by others as figures of men (left), but which might be regarded as symbols of growing corn. In others there is a central stalk (middle), with curving lines in pairs at intervals. . . . The ear of corn is represented (right) in pictographs as on *ka-tci-na* masks and on the slabs carried by women in the *Mamz-rau* dance, by an oval figure crossed by parallel lines at right angles to each other forming rectangles, each with a dot in the middle, which represent the kernel. [Fewkes 1892:21]

Petroglyphs, Willow Springs, Arizona

Clan symbols recognized by Edmund Nequatewa, Hopi indian. Corn, melon (clan). Symbol is usually a corn plant, but may also be the "germ god" (top of page).
[Colton 1946:4]

Kachina Mask Designs, Hopi Mesas, northern Arizona

Corn symbols commonly used on kachina masks. [Colton 1949:18]

Pictographs, La Pena Pintada site, Tomatlan River, Jalisco, Mexico (near area of Cora and Huichol Indans)

The cross-hatched design (above right) . . . may indicate maize stalks with ears, or heaps of maize at harvest time. . . . Another design symbolically associated with maize is the spotted black fish (above left). Green corn is called "black fish" and "ears of corn are depicted . . . by the painting of a fish, which is called by the Mexicans *bagre*" (Lumholtz 1900:214).
[Mountjoy 1982:119]

Petroglyphs, Largo drainage, Gobernador Basin, New Mexico

Comma shapes are said to represent germinating corn seeds.
[Schaafsma 1966:20]

Coyote, Dog, or Wolf

- Quarduped with small ears and tail, often near game animals
- Head with ears and long snout

Petroglyphs, Chalfont Canyon site, California

The unusual pecked elements . . . are very intriguing (above). They are all figures with long pointed snouts or beaks and appendages which appear to be either ears or head feathers. Possibly they are stylized representations of Wolf or Coyote, both popular figures in the Owens Valley Paiute mythology (Steward 1933). . . . In the local mythology Coyote is portrayed as the father of the Owens Valley Paiute, but for the most part is looked upon as a trickster and evil being who motivates people to evil behavior. Wolf is portrayed as a wise, benevolent being and is presented as the creator in one creation myth. Steward's ethnography also records prayers to both Coyote and Wolf (1933:308).
[Mundy in Meighan 1981:133]

(Right) Pictographs, Chumash (no exact site given, except in southern California)

Possible Coyote (larger figure) and Lizard, often mentioned together in Chumash mythology.
[Hudson and Lee 1984:35]

Comment on mythical Coyote and Mountain Sheep, California area
Specifically the origin myth of the Shoshone speakers in the vicinity of the Coso Range indicates that the world could not be populated until after Coyote had killed a bighorn sheep and used its neckbone as a penis or penis sheath to overcome the toothed vagina of the first woman, even though Coyote had already proved his prowess in hunting and shown himself to be an adequate provider . . . the evidence points to the bighorn sheep as symbolic of male success in hunting and in sexual activities in a general sense. [Whitely 1982:269]

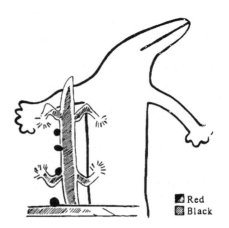

◢ Red
▨ Black

70

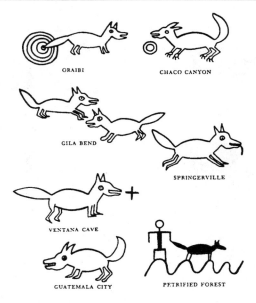

Petroglyphs, located as indicated

The coyote figure at Oraibi (Arizona) illustrates that the Coyote Clan had completed all four rounds of its migration, the tail pointing to the center point meaning that the clan finally had reached its permanent settlement. The Chaco Canyon (New Mexico) figure shows that the clan had reached only two *pasos* at that time. The two figures at Gila Bend (Arizona) indicate that the clan had gone in one direction and had then returned. The tongue hanging out of the coyote at Springerville (Arizona) shows that he had been running ahead of the clan to find a place to settle and had turned back. It was a function of the Coyote Clan to perform this duty. In front of the coyote found in Ventana Cave Arizona, is a four-pointed star—the "hurry star," whose appearance warned the people they must hurry to cover the four directional legs of their migra-

tion. At Petrified Forest (Arizona) a man is shown holding the tail of the coyote—in this case called a *poko,* "an animal who does things for you." To some Hopis the coyote figure found at Guatemala City indicates the starting place of the migrations. [Waters 1963:106]

Signature of Hopi, northern Arizona

Isauuh (Coyote) gens (clan); totem, coyote's head.
[Fewkes 1897:5, Pl. III]

Comment on coyote in Hopi area
(Coyote) is foolish rather than evil. He scattered the stars and marred the chiefs' plans of setting them symmetrically in the sky; he cast the stone down the si'papu and prevented the return of the dead. He is the pet of Witch; he is a thief and steals corn and melons.
[Stephens 1936:1224-5]

Coyote, Dog, or Wolf (continued)

Petroglyphs, Coso Range, California

. . . dogs continue to be drawn naturalistically, though the dog is sometimes pictured with a fantastically long tail, curved over the back and touching the head.
[Grant, Baird and Pringle 1968:18]

Dogs are depicted attacking sheep, bearing out statements by living Paiutes and Shoshoni that in the early days dogs were used to help drive the game animals past ambush points.
[Grant, Baird and Pringle 1968:29-30]

Pictographs, Horseshoe (Barrier) Canyon, Utah

These figures are comparatively simple. The large dog at the left, approximately 18 inches long, is a commonly occurring motif.
[Schaafsma 1980:65]

(Below) Cueva Pintada, Baja California, Mexico

An important reference regarding coyotes or wolves and the importance with which they were viewed by the Indians is provided by Father Sigismundo Taraval, who worked among the Guaicura. "They belong to the sun, the stars, the sea, the globe. They believe that a dog was their maker. Whatever they hear from their wizards and old men about the customs, acts, and life of the dog, this they attempt to emulate" (Taraval 1931:29). Figure below illustrates black wolves at Cueva Pintada. This is one of the best examples of the coyote/wolf motif to be found in the Great mural region. The symbolism of the coyote/wolf motif is found throughout the Sierra de San Francisco cave paintings.
[Smith 1985:43]

Crane or Heron

- Bird with long legs
- Three-pronged bird track

Petroglyph, Canyon de Chelly, Arizona

Identifiable birds in Canyon de Chelly rock art (include): crane petroglyph at site TWT-1.
[Grant 1978:171]

Petroglyph, Peterborough, Ontario, Canada

These glyphs may represent herons, local to the marshy areas of the Kawarthas, but they are more likely depictions of the crane, a common totem-bird among the Algonkians. . . . The crane was also an important *manitou* supplicated by the prophesying *Jessakkid* shamans in particular "as an object of a peculiar and benign influence."
[Vastokas and Vastokas 1973:110]

Drawings of wading birds

(Left) Great blue heron
(Right) Sandhill crane
[Murie 1954:327]

(Left) Petroglyphs, Zuni, New Mexico and (right) drawing of bird track

(Left) Crane tracks, 7 cm x 9 cm.
[Young 1988:75]
(Right) Sandhill crane track in mud.
[Murie 1954:327]

Creator or Sky God

- Circle with cross design
- Head with one horn

Petroglyph, Hopi Mesas, Arizona

It is very common to find shields depicted on the rocks by the Tusayan pueblo people. . . . Of the circular form, the most elaborate (above) has the whole interior occupied by a cross with bars of equal length, in each of the four angles of which are seen a circle, the friendship signs, and two smaller crosses. A face with a single *a-la* or horn is appended to the rim. The cross is the symbol of the sky god *Co-tok-i-mung-wuh* and has been observed by me on shields introduced in the *Ma-lo-ka-tci-na* dance at Cipaulovi. [Fewkes 1892:23]

Drawings of ceremonial masks

(Left) Sotuqnang-u, a deity, not a kachina; horn on top of head, cloud symbols under eyes (p.134); (right) also high conical mask painted white (p.126).
 [Colton 1949]

Painting of kiva mural, Hopi area, northern Arizona

Design on north side wall, Oak mound kiva. Sho'tokununwa, 85 cm high. . . . In left hand, a netted gourd (*pavwi'pulu*).
 [Stephen 1936:Plate V]

Comment on Sotuqnang-u, God of the Sky

Sotuqnang-u, god of the sky, the clouds, and the rain, is good, dignified and powerful. He is occasionally impersonated in one of two forms, masked and unmasked. When masked the impersonator wears a white case mask with one horn. There are cloud designs on the cheeks and at the bottom of the back of the mask. When unmasked the impersonator wears a hat shaped like a star with feathers hanging over the face, and his hair hanging down this back.
 [Colton 1949:78]

Figurine of Sho'tokunuuwa, Hopi area, northern Arizona
 [Stephen 1936:Plate XII]

Crook

• Line with hook at one end, often held by anthropomorph

Petroglyph, San Cristobal, New Mexico

The carving at the top of this plate is interesting since it shows, in quite a realistic manner, some of the ceremonial paraphernalia used by the San Cristobal people. In his left hand the man holds two prayersticks, one with a feather and one made of bent reed; a gourd waterjar is suspended from his wrist.

[Sims 1949:6 Plate VI]

(Below) Petroglyph, Mancos Canyon, Mesa Verde, Colorado
(Below right) Petroglyph, Cedar Mesa, Utah

Crooks are commonly depicted in rock art of the Anasazi. Figure

(below left) shows a Basketmaker petroglyph from Mancos Canyon, Mesa Verde, Colorado, of a possible shaman with a bird "headdress" and holding a crook. A number of crooks are exhibited in rock art on Cedar Mesa, Utah (Cole 1984a), and a petroglyph panel from Cedar Mesa is shown in Figure 9 (below right) . . . (which) shows a "copulating" couple and a crook, graphically emphasizing a symbolic association between crooks and fertility. . . . Parsons (1985:69) observes that crooks are used at Hopi villages for runners to touch "for long life" and are placed at the Soyala shrine with prayer sticks and at Hopi altars as prayer sticks. Fewkes (1903:Pls. 12, 30) illustrates the Hopi katsinas Natachka Wuqti or Soyok Wuqti and Tcanau both holding crooks.

[Cole 1989:62 & 79-81]

Cross
(*See also* Stars)

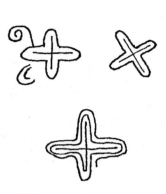

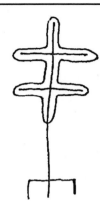

Petroglyphs, El Tecomate, State of Sinaloa, Mexico

The most interesting type (of cross) is found in El Tecomate and at the foot of the Majada de Arriba (in the State of Sinaloa, Mexico), for without doubt they seem to be the same type of crosses that in Tula, Hidalgo and other places (in Mexico) represent Quetzalcoatl, under the aspect of the "Morning Star" or "Venus." To add further weight to what has been shown about the aforementioned god, in one of the petroglyphs from El Tecomate (upper left, top row), the god would seem for certain to be speaking, because of the commas which are exiting from the image (an indication of speech in the Codices of ancient Mexico).

[Ortiz de Zarate 1976:61-62, 117]

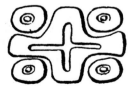

Mayan glyph for the planet Venus
[Seler 1963:191]

Comment on Quetzalcoatl and cross
A beneficent deity at Teotihuacan, Quetzalcoatl later became an astral figure, demanding human sacrifice (Soustelle 1967:94). He occurs in the Mexican iconographic system in both anthropomorphic and serpent form, and he is also symbolized by the morning star, often in the form of an outlined cross (Villagra 1954:80). [Schaafsma 1980:238]

Petroglyph, Hopi Mesas, Arizona

Of the circular form (of shield), the most elaborate has the whole interior occupied by a cross with bars of equal length, in each of the four angles of which are seen a circle, the friendship signs, and two smaller crosses. A face with a single a-la or horn is appended to the rim. The cross is the symbol of the sky god Co-tok-i-nung-wuh (star god).
[Fewkes 1892:23]

Cross (continued)

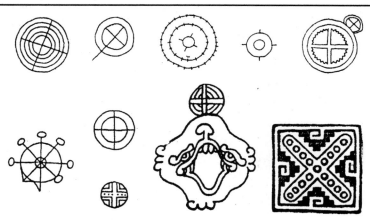

Petroglyphs and pictographs from California and Nevada sites; two lower right symbols are Mexican cave design and imprint from roller stamp

Consisting generally of a double circular pattern centered on a set of orthonogonal lines, the so-called pecked cross or quartered circle figure is shown to exhibit a remarkable consistency in appearance throughout its 29 reported locations (in the southwest and Mexico), thus suggesting that it was not perfunctory. . . . These symbols may have been intended as astronomical orientational devices, surveyor's bench marks, calendars, or ritual games.

[Aveni, Hartung and Buckingham 1978:267-270]

Drawings from Hopi pottery and rock art, northern Arizona

A conventional design frequently displayed in their pottery decorations . . . represents a Maltese cross, which is the conventional emblem of a virgin. The origin of this emblem may be plainly traced: when they depict the figure of a virgin, the hair discs on each side of the head are always drawn thus (above left). These two figures representing the discs, laid across each other, produce the Maltese cross (above right). [Stephen 1940:27-28]

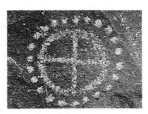

Petroglyphs, Three Rivers, New Mexico

Circle-dot motif. . . . Possibly it refers to Quetzalcoatl.
[Schaafsma 1980:235]

"Maltese Cross," Snaketown, Arizona

So-called cross of Quetzalcoatl (Kurath and Marti 1964: Figs. 133, 206). [Haury 1976:319]

77

Curing

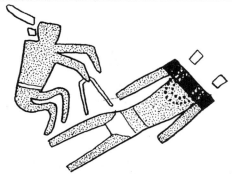

Pictographs, Canyon de Chelly, Arizona

A woman is painted in a horizontal position. Bending over her is a feathered figure pointing a wicket-shaped object at her pelvic region. This is a very simple but graphic illustration of what is possibly a shaman exorcising bad spirits that are preventing the woman from having a baby. Nearby is another figure holding a similar wicket-shaped object. [Grant 1978:185]

(Below) Petroglyphs, Picacho Peak, Arizona

. . . what we interpret to be a shaman stands over a horizontal figure, holding some unidentified item up to his mouth with his right arm, and another figure, perhaps a dancer, is actively involved above him. We believe this scene may be a representation of a curing ceremony.
 [Wallace and Holmlund 1986:144]

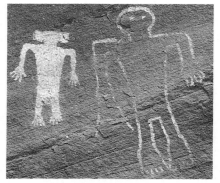

Pictographs, Canyon de Chelly, Arizona

Basketmaker woman in white and probably a shaman carrying a wicket-shaped object. This scene seems to be related to another in the same shelter in which a reclining female is administered to by someone holding over her a similar device.
 [Schaafsma in Noble 1986a:25]

78

Dancers in Row

• Row of anthropomorphs, often shown holding hands

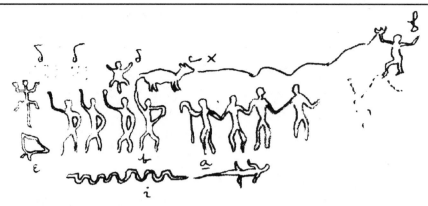

Petroglyphs, South Mountain, Arizona

I found . . . another extremely important group . . . a representation of a sort of Pasture (?) dance . . . four or more figures are depicted, their right hands raised aloft, their lefts resting upon the hips. Over the head of each of these figures, now but faintly traceable, were originally represented the forms of animals, probably expressive of the names or sacerdotal characters of the actors . . . one above them . . . bearing the unhandled trident in one hand from which this line seems to issue . . . while the other arm and hand is held aloft. The first (of the second group) carries in his right hand a shepherd's crook, while his left hand grasps the right of the following figure. . . . This staff is perfect and distinct in outline; it is identical . . . to the elaborate staffs of the *Kawowillikwe*, or "Herders" of the Sacred Drama Dance in Zuni. [Cushing 1888:2-3]

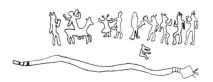

(Below) Petroglyphs, Navajo Reservoir area, New Mexico

The smaller figures . . . , although still conventional and reduced to essentials, have flexible bodies arranged in a variety of life-like positions. Pictured in hand-holding strings, they possess a gaiety of form and a movement due to the repetition of shapes that give them a dancing effect.

[Schaafsma 1963:30]

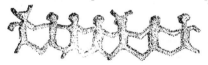

(Below left) Pictographs, Hueco Tanks, Texas

The Apaches usually painted a large panel with dancing figures, men with large penises confronting women, and a large snake (10-15 feet long). . . . Most probably these were realistic depictions of actual fertility dances, as there is strong artistic evidence that the snake, male phallus and spear point were closely associated. Sites 1, 6 ("Comanche Cave"), 15, 17g, and 26 A-B are probably historic Apache pictographs. [Sutherland 1976:64]

79

Datura or Jimson Weed
(*See also* Dots and Phosphenes)

• Dots surrounding or adjacent to figure(s) • Mandala-like circular designs

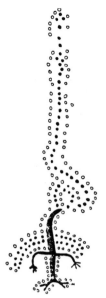

Pictograph, Chumash Indian area (Site SBA 1318), southern California

Possible example of symbol associated with the use of Datura. It is quite reasonable to assume that a certain number of these symbols were the result of drug-induced vision questing, which emphasized inversions and reversals of normative standards and the distortion of reality (Blackburn 1975:80-84). Datura was one such substance well known among the Chumash and used in the acquisition of power.
[Hudson and Lee 1984:41]

Comment on use of Datura—Chumash
A student who ingested Datura described the physiological effects to Dr. Thomas Blackburn (personal communication). Following a state of vivid hallucinations, the student perceived large, brightly colored mandala forms on a dark background which spontaneously appeared over his normal vision.

For weeks afterward, everything he looked at appeared to be surrounded by tiny white dots. Any one familiar with Chumash rock art designs will immediately recognize the implications of these phenomena. The mandala (usually in red) on a dark background is a common motif in the Chumash area. Outlining with small white dots is one of the distinctive features of their rock art. [Hudson and Lee 1984:42]

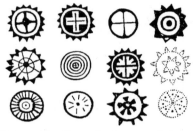

Pictographs, Sun-wheel or mandala elements [Hudson and Lee 1984:27]

Comment on Chumash rock art
"Abstract" or non-naturalistic art of this type may represent visions triggered by the ingestion of Datura inoxia, whose veneration as the supernatural Old Woman Momoy and use by the Chumash is well documented in myth and folklore.
[Furst 1986:223]

Comment on use of Datura—Zuni
In 1879 the writer discovered that the Zunis employed a narcotic . . . found to be *Datura stramonium* or jimson weed . . . when the rain priests go out at night to commune with the feathered kingdom, they put a bit of powdered root into their eyes, ears and mouth so that the birds may not be afraid and will listen to them when they pray to the birds to sing for the rains to come. [Stevenson 1904:385]

Death

(*See also* Headless and Curing)

- Upside-down anthropomorph
- Horizontal anthropomorph
- Headless anthropomorph

Petroglyphs, Picacho Mountain, Arizona

Additional anthropomorphic petroglyphs of interest include several which are clearly drawn upside-down and few which are horizontally depicted. Occasionally these are included as part of apparent scenes. While there is no specific reason to assume a similar meaning in Hohokam culture, in many other societies, this sort of depiction indicates death or illness, and an example illustrated (above) from the North Pass Site offers some substantiation to this claim. In it what we interpret to be a shaman stands over a horizontal figure, holding some unidentified item up to his mouth with his right arm...We believe this scene may be a representation of a curing ceremony.
[Wallace and Holmlund 1986:144]

Pictograph, Chumash Indians (SLO 104), southern California

A few, however, are quite typically malevolent in nature, such as the Nunashish, spirits, ghosts, were-beings, and so on. We suspect that the occurrence of any of these, along with headless forms or forms of people upside-down or bleeding from the mouth (above), symbolize sickness or death (Blackburn 1975:69; Hudson 1979).
[Hudson and Lee 1984:43]

Painting by Plains Indians

. . . it shows the fashion of painting the dead among the Iroquois; the first two are men and the third is a woman. [Mallery 1893:660]

(Left) Petroglyphs, Pictograph Point, Mesa Verde National Park, Colorado

The old chief Salavi is pictured horizontally to show that he has passed away. The jagged line above him denotes water, which ends in a spring in the right, and out of this grows the spruce tree into which he transformed himself at death.
[Waters 1963:51]

Deer or Elk

• Quadruped with antlers • Hoof print with two parallel V-shaped or one U-shaped mark, often with two dots at open end

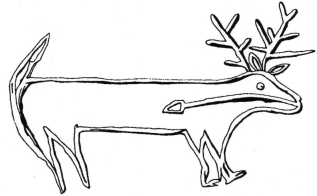

Petroglyph, Zuni, New Mexico

Incised deer with heart line, 15 cm x 20 cm, ZRAS site 10.
[Young 1988:83]

(Below) Signature of Hopi workman at archaeological site, northern Arizona

Hahawi (Sitcomovi, obiit 1892). This man functioned for his nephew as asperger in the secret ceremonials of the Antelopes. . . . He belonged to the Sowunwu (Deer) clan. Totem, figure of an antelope or deer. [Fewkes 1897:2]

Petroglyph, Hopi Mesa, Arizona

 Deer Track.
[Mallery 1893:748]

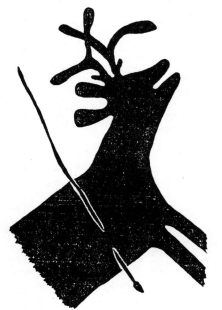

Petroglyphs, Zuni, New Mexico
Deer tracks, 5 cm x 5 cm x 8 cm.
[Young 1988:75]

Pictograph, Baja California, Mexico

A black deer has the arrow shaft placed over the body, holding the animal in place. [Smith 1985:46]

82

Diamond Chain

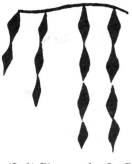

(Above) Pictographs, Smugglers Canyon, Anza-Borrego State Park, California and (above right) Baker Dam area, Joshua Tree National Monument, California

The puberty rites of the Luiseno girls . . . lasted three months. . . . The final event of the Luiseno celebration consisted of a race, called a "hayie," to a certain rock, where a relative of each girl awaited her with a little pot of red ochre paint. On arrival each initiate painted a design on this rock. Informants indicated that these designs were always diamond-shaped and represented the rattlesnake.

[Vuncannon 1977:96-100]

Pictographs, Baker Dam area, Joshua Tree National Monument, California

The second grouping seems to be unique. . . . The diamonds do not appear to be joined together, and are not painted in proper vertical lines. [Vuncannon 1977:99]

(Left) Pictographs, La Pena Pintada site, Tomatlan River, Jalisco, Mexico (near area of Cora and Huichol Indians)

The intertwined lines in the pictograph designs were found by Lumholtz (1900:41, 126: 1904: plate xx, 291) to signify the root of the squash vine, the criss-crossing water gourd vine, the bean plant, or the double gourd. [Mountjoy 1982:119]

Pictographs, Alamo Hueco Mountains, New Mexico

An element that looks as if it might represent a long ripe seedpod occurs in the last . . . room.
[Schaafsma 1980:51]

. . . the Painted Grotto, a shelter in the Guadalupe Mountains of southeastern New Mexico, is the most exciting. . . . The possibility that certain motifs . . . are . . . stylized representations is reinforced by comparison with Australian Aboriginal art, in which diamond chains and parallel zigzag designs denote seedpods and tree grubs, respectively (McCarthy 1938:28).
[Schaafsma 1980:52]

Dots (*See also* Datura, Enclosures, and Phosphenes)

• Dots surrounding or adjacent to figure
• Dots alone • Dot in center of circle

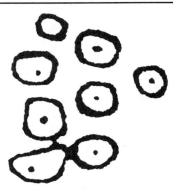

Pictographs, La Pena Pintada site, Tomatlan River, Jalisco, Mexico (near area of Cora and Huichol Indians).

Lumholtz (1900) recorded the frequent use of dots to indicate maize kernels, ears of maize, squash or beans, as well as raindrops and stars on occasion. Perhaps the clump of tiny circles or dots within circles . . . can be interpreted as maize, beans or squash. [Mountjoy 1982:119]

(Below) A and B—Drawings of Entoptic Phenomenon (Phosphenes) by Siegel 1977:138b and k; C and D— Pictographs, San Rock Art, South Africa; and E—Petroglyphs, Coso Range, California

Entoptic phenomena (phosphenes) . . . mean . . . visual sensations derived from the structure of the optic system anywhere from the eyeball to the cortex. . . . Although there are numerous entoptic forms, certain types recur. We have selected six (including): (C) dots.
 [Lewis-Williams and Dowson 1988: 202, 203, 206]

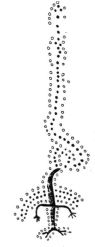

Pictograph, Chumash Indian area (Site SBA 1318), southern California

Possible example of symbol associated with the use of Datura. . . . A student who ingested Datura described the physiological effects. . . . Following a state of vivid hallucinations, the student perceived large, brightly colored mandala forms on a dark background which spontaneously appeared over his normal vision. For weeks afterward, everything he looked at appeared to be surrounded by tiny white dots.
 [Hudson and Lee 1984:42]

Comments on dot symbols
A single animal is sometimes shown enclosed in a circle of dots that appears to represent a corral or trap, an interesting adjunct to the hunt scene. [Schaafsma 1980:131]

A	B	C	D	E

84

Dragonfly

• Vertical line with dot head at top, bisected by two (at times one) horizontal parallel lines

Petroglyph, Hopi Mesas, Arizona

The dragonflies have always been held in great veneration by the Moki (Hopi) and their ancestors, as they have been often sent by Oman to reopen springs which Muingwa had destroyed and to confer other benefits upon the people.

[Mallery 1893:704-5]

16F 17E

Dragonflies from kiva murals, Awatovi and Kawaika-a ruins, Arizona

Top: Fig. 16E. Awatovi, Room 528 and Fig. 16F. Kawaika-a, Room 6. Bottom: Fig. 17E. Awatovi.

[Smith 1952: 218-220]

Petroglyphs, Hopi Mesas, Arizona

Dragonflies are most often portrayed on altars, pottery, and petroglyphs, possibly because they are shamanistic creatures (Parsons 1926:250) and have supernatural powers (Benedict 1935, v.II, 9).

[Wright 1988:151-2]

Symbols used by Dakota tribe, Plains Indians

The same disposition of straight lines, which is called the Latin cross, was and is used by the Dakota (tribe) to picture or signify both in pictograph and gesture sign, the mosquito-hawk, more generally called dragonfly. The Susbeca is a supernatural being. He is gifted with speech. He warns men of danger. He approaches the ear of the man moving carelessly . . . at right angles, as shown in figure at above left, and says to him, now alarmed, "Tci-tci-tci!"—which is an interjection equivalent to "Look out—you are surely going to destruction!" "Look out—tci-tci-tci!"

[Mallery 1893:725-726]

Petroglyphs, Zion National Park, Utah

Dragonflies are aquatic life, and their song resembles the word for water in pueblo languages: "Tsee, tsee, tsee" (Packard 1974:22). They are a positive sign of water, fertility and abundance. [Harris 1986:45]

85

Dumbbell

(*See also* Pit and Groove)

• Two circles, two dots or two circles with center dot, connected with line(s); may be embellished with designs

(Left) Petroglyph, Alamo Canyon/Diablo Dam, Texas

Topside again, a "dumbbell" or "spectacle" symbol. One Navajo informant told us this symbol means a conference took place at whatever location it's found (Carl Gorman, personal communication). This symbol may appear with either a straight or curved connecting line, and the circles at each end may be pecked in solidly or not. "If one or both circles have rays coming from them, it means a lot of talk took place," said Carl. The symbol is found throughout the southwest and deep into Mexico, to the writer's certain knowledge.

[Apostolides 1984:22 & Fig. 3]

(Right) Petroglyphs, Tomatlan Valley, State of Jalisco, Mexico

On the rocks with petroglyphs in the Tomatlán zone, we found 125 elements composed of two symbols for eyes (simple or elaborated), joined by one or more lines. . . . At times the line was embellished with some elements, generally arcs. . . . Based on the calendric aspect of the rock paintings at La Peña Pintada 1, and including the possible importance of the transit of the sun across the sky . . . , it is suggested that the design of the eyes (of the sun) united by one or more lines represents the road or the passage of the sun in the sky, from the eastern horizon to the western horizon (translated by the author). [Mountjoy 1987:46]

Eagle
(*See also* Thunderbird)

• Standing bird in profile • Bird facing front, wings spread, feathers prominent

Petroglyphs, San Cristobal, New Mexico

The handsomely carved personage . . . wears a large headdress made from the feathers of the golden eagle, the tips of which are marked by a step-pattern.

[Sims 1949:6, Pl. VI]

Petroglyphs, Pictograph Point, Mesa Verde National Park, Colorado

Eagle clan symbol, indicating a separation of that clan from the other people and settlement near their point of origin—*sipapu* (spirals).

[Mesa Verde Mus. Assn. n.d.:10]

Painting of god, Zuni area, New Mexico

. . . the Knife-feathered Monster . . . is represented as possessing a human form, furnished with flint knife-feathered pinions, and tail. His dress consists of the conventional terraced cap (representative of his dwelling place among the clouds). . . . His weapons are the Great Flint-Knife of War, the Bow of the Skies (the Rainbow), and the Arrow of Lightning and his guardians or warriors are the Great Mountain Lion of the North and of the Upper Regions.

[Cushing 1883:40 & Pl. X]

Petroglyphs, Zuni, New Mexico

The six Beast Gods, however, rarely appear together in rock art. Only those identified as the mountain lion . . . Knife-Wing or eagle (above) . . . and bear track . . . commonly occur and even these three seldom appear together on the same rock face. [Young 1988:130]

(Left) Petroglyph, Frijoles Canyon, Bandelier National Monument, New Mexico

In Bandelier rock art, eagles appear in highly stylized form as seen from below in flight (here on shield).

[Rohr et al. 1988:137]

Ear Extensions

• Front facing anthropomorph with extension from left (usually) ear, ending in arc or balloon

Pictograph, Canyon del Muerto, Arizona

The most provocative of the canyon Anasazi paintings are the large human figures with top-of-head ornaments and left ear appendages. Identical figures are found in petroglyph form in the Butler Wash area of southeastern Utah. The Butler Wash figures include bighorn sheep that appear contemporaneous. There are many Basketmaker and Modified Basketmaker sites in this region, and the petroglyphs of the large human figures with ear ornaments seem of the same period. John Cawley (personal communication 1974) reports the ear appendage petroglyph figures from both sides of Butler Wash and on the south bank of the San Juan River. . . . There is considerable evidence indicating a flow of ideas between Butler Wash and Canyon de Chelly. [Grant 1978:211-212]

(Below) Pictograph, Canyon del Muerto, Arizona

One of the curious "ear" figures from Ear Cave, site CDM-123 with elaborate top-of-head and left-ear appendages. These Basketmaker or Modified Basketmaker devices may have been connected with shamanistic attributes, indicating "power" of some sort. [Grant 1978:261]

(Left) Petroglyphs, Butler Wash, San Juan River, Utah

In one instance these objects are clearly feathers, as indicated by the detail in the painting, but in others the series of arcs or similar shapes at the end of the "feathers" is enigmatic. This type of headgear occurs also in Basketmaker petroglyphs at Butler Wash on the San Juan River (left). [Schaafsma 1980:111-112]

Emergence
(*See also* Sipapu)

• Spiral • Double-linked spiral

Design on Mimbres bowl, New Mexico

The . . . bowl . . . illustrates the climbing from the other worlds and the moment of emergence (into this world). The figures are painted black, "the customary color in representing nude figures." Since the figures . . . are also without decoration of any sort, the black of nudity also could suggest here the abject condition of the men in the first three worlds. For as Cushing reports . . . (on the Zuni): ". . . black were our fathers, the late born of creatures, like the caves from which they came forth." [Carr 1979:10]

Petroglyphs, Rock Ruin, Natural Bridges National Monument, Utah

The round base of the Kiva is the womb of the earth from which man emerged into this, the fourth world. Birth in this world is normally associated with and through water. So also the emergence of mankind into this world through the womb of the earth was through the waters of a flood and represented by the spiral lines moving upward and outward.
[Harris 1981:170-171]

Petroglyph, Pictograph Point, Mesa Verde National Park, Colorado

A. "Sipapu," the place at which the Pueblo people emerged from the earth (Grand Canyon)—interpreted by four Hopi men in 1942.
[Mesa Verde Museum Assn. n.d.:8]

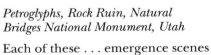

Petroglyphs, Rock Ruin, Natural Bridges National Monument, Utah

Each of these . . . emergence scenes exhibits one or two emergence ladders or plants. Trees, vines and animals contribute to the success of each emergence (White 1932:87-9; Tyler 1964:107; Parsons 1923:137).
[Harris 1981:170]

Enclosures

(*See also* Dots and Hunting)

• U-shaped line (or dots) with game animals entering or within
• Vertical lines like picket fence with game animals nearby

Petroglyphs, Near Venice and other sites in Utah

(Below) Petroglyphs, Northumberland and Hickison Summit sites, Nevada

The Fremont Petroglyph design element referred to as an "enclosure" occurs at 13 sites near Venice, Utah. . . . Outside the Venice area it is often represented with and partially duplicates the distribution of the one-horned two-legged sheep. . . . This type of sheep is generally shown either going into the enclosure or already enclosed. . . . Immediate observation suggests that this form which sometimes include sheep, may be a corralling device used in a hunting process. . . . The basis for another interpretation comes from the Ashley and Dry Fork (Utah) sites where a copulation scene occurs within an enclosure. Since there are also several anthropomorphs with "vulva forms" represented with the same shape, the second point should be fertility.
[Warner 1981:104-5]

Herds (of game animals) very likely traveled . . . through passes to winter pastures. . . . As a migrating herd approached a preordained kill site, hidden drivers would have shown themselves in an attempt to force the herd toward the first in a series of attack stations where hunters were waiting. . . . As the hunters showed themselves to launch their projectiles, they too would be acting as drivers, frightening the animals . . . toward the next attack station. . . . The petroglyph clusters (below) are these hypothesized attack stations.
[Thomas 1981:68]

(Left) Petroglyphs, Pahranagat Lake vicinity, Nevada

Ticked lines in combination with animal and other figures . . . may represent diversion fences used in game drives (Heizer and Hester 1978).
[Schaafsma in D'Azevedo 1986b:219]

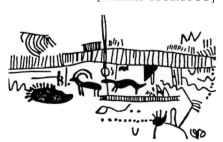

90

Facing Birds

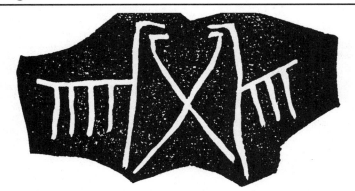

(Above) Petroglyph, San Cristobal, New Mexico

The wing feathers of the pair of birds at the top of this page are stylized into the symbol for falling rain. [Sims 1949:Plate I]

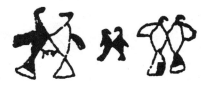

(Above) Petroglyphs, West Mesa, New Mexico

The strongest correlations between Hopi clan symbols and West Mesa escarpment petroglyphs are found in a . . . group of bear . . . and badger . . . paws; and in a highly diverse group of bird form petroglyphs.
 [Eastvold 1987:135]

(Below) Petroglyph, Three Rivers, New Mexico

Figure 189. Further bird motifs from Three Rivers: (b) a symmetrical composition with birds and terrace. [Schaafsma 1980:230]

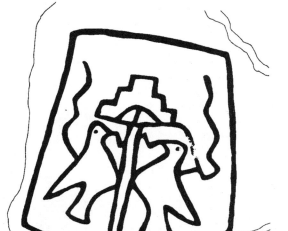

Family

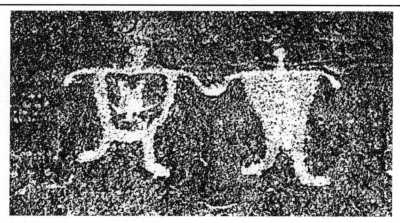

(Above) Petroglyphs, a Gobernador Canyon site, New Mexico

A notable group of anthropomorphs occurs in a Gobernador Canyon site. Dominating the panel are a pair of large human figures holding hands. A male and female seem to be represented. That the female figure is pregnant is indicated by the small upside-down form of a child within the torso . . . it seems possible that petroglyph making in these instances was connected with fertility ritual. [Schaafsma 1972:6]

(Below) Petroglyphs, Waterflow, New Mexico

Since there are . . . several elements which may suggest a "family concept," then this could definitely add credence to the sacred nature of this location—a possible fertility site. [Judith Warner 1983:35]

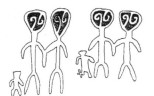

(Below) Petroglyphs, Navajo Reservoir, New Mexico (redrawn from Schaafsma 1963)

Rock pictures played a part in fertility ceremonies, and the design element of the bisected circle, considered a fertility symbol in many parts of the world, is abundant in the West. Phallic drawings are frequently seen at southwestern sites and a fine example is shown here. The amusing rock pecking seems to show, in the clearest posterlike manner, the wish of the male figure for a man-child. [Grant 1967:31]

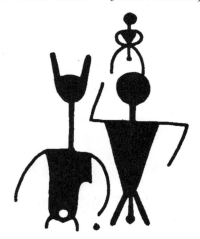

92

Feathers

- Extended oval or rectangular object(s) above head of anthropomorph
- Same shape with step design at end

Drawings of various feather designs on pottery at Sikyatki Ruins, Arizona

Above figures represent an unusual type of feather symbol, readily distinguished from others by the notch at the end, the edge of which is commonly rounded. Note: Mallery 1886:47, Fig. 12 . . . illustrated two clusters of . . . Hopi feathers copied by G.K. Gilbert from petroglyphs at Oakley (Willow) Springs, Arizona. The first cluster belongs to the type shown (above right) as eagle tails.
[Fewkes 1898:135]

Comment on feathers and their function
Feathers are among the most important objects employed in Pueblo ceremonies, and among the modern Hopi feathers of different birds are regarded as efficacious for different specific purposes. Thus the turkey feather symbol is efficacious to bring rain, and the hawk and eagle feathers are potent in war. . . . Belief in a difference in the magic power of certain feathers was deeply rooted in the primitive mind, and was regarded as of great importance by the ancient as well as the modern Hopi.
[Fewkes 1898:135]

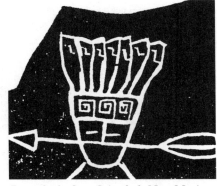

Petroglyph, San Cristobal, New Mexico

The handsomely carved personage . . . wears a large headdress made from the feathers of the golden eagle, the tips of which are marked by a step-pattern. . . . This symbol apparently had its origin and development in a rather brief period of Pueblo culture; a period known to be comparatively late in pre-Spanish times, and this may be a clue to help in dating the carving.
[Sims 1949:6]

(Below) A selection of Feather Conventions as used in the Jeddito mural paintings. Three at left = eagle; three at right = turkey.
[Redrawn from Watson Smith 1952:174]

Female Figure

(*See also* Vulva)

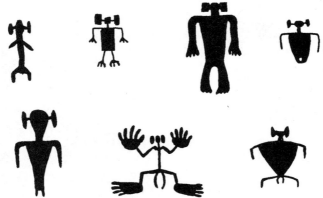

Petroglyphs and Pictographs, Canyon del Muerto and Canyon de Chelly, Arizona

Anasazi depictions of women.
[Grant 1978:179]

Drawing of female hair arrangement from Development Pueblo burial in Tsegi Canyon, Arizona (redrawn from Guernsey 1931)

The evidence of rock paintings and artwork on pottery shows that Modified Basketmaker women were adopting a hair style that would remain unchanged in the Anasazi country until modern times. The hair was parted in the middle and gathered in whorls or tied in bundles over the ears. [Grant 1978:40]

(Below) Pictographs, Canyon del Muerto, Arizona

There are few representations of women, who are always rare in rock art. Female figures are usually identifiable by square blocks alongside the head, indicating hair coiling over the ears, and sometimes by genitalia. This traditional stylization of women continued into Great Pueblo times. At one site (CDM-88) that includes many kinds of figures not found elsewhere in the region, women are indicated with hips or breasts. [Grant 1978:178-179]

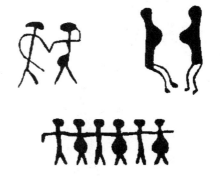

94

Petroglyph, Hopi Mesas, Arizona

Petroglyph of a maid 2 feet high. . . .
The maid is pecked with rubbed
outlines; hair and gown rubbed
over with dark iron ochre, face,
mantle and leggings whitened. It
is called *paihi'shata,* very old, but
someone occasionally rubs the fig-
ure with ochre and white clay.

[Stephen 1936:1012]

Drawings, Hopi Mesas, Arizona

The Maltese cross is the emblem of
a virgin; still so recognized by the
Moki (Hopi). It (comes from) . . .
the form in which the maidens
wear their hair, arranged as a disk
of 3 or 4 inches in diameter upon
each side of the head.

[Mallery 1893:729]

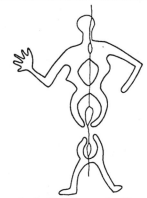

*Petroglyph, Peterborough, Ontario,
Canada*

. . . the figure may therefore be that
of a woman. . . . The largest, visually
most impressive, and iconographi-
cally most significant of the female
figures measures some five feet in
length (above). . . . The most inter-
esting feature of this petroglyph,
however, is a red mineral seam that
runs along the length of the figure.
The rendering of this image was no
doubt directly inspired by the
crevices and the red seam and per-
haps the female itself was seen as
pre-existent at this site.

[Vastokas and Vastokas 1973:80]

*(Below) Petroglyphs, Hawley Lake,
Sierra County, California (after Payen)*

. . . there occur vulvaforms and also
a figure with a vulvaform definitely
placed in its natural position.

[McGowen 1978:29]

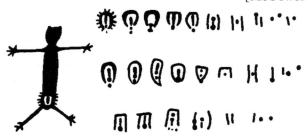

Petroglyph, Cook's Peak, New Mexico

. . . fish depictions are highly realistic. Both tadpoles and fish were found pecked on bedrock surfaces near potholes in which water collects during rainstorms.
[Schaafsma 1980:203]

(Below) Pictograph, Tomatlan River, Jalisco, Mexico

Another design symbolically associated with maize is the spotted black fish(below). Green corn is called "black fish" and ears of corn are depicted . . . by the painting of a fish, which is called by the Mexicans "bagre." [Lumholtz 1900:214 in Mountjoy 1982:119]

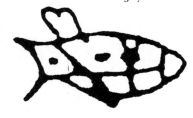

Petroglyphs, Three Rivers, New Mexico

Abstract fish design (fish over a foot long). I suggest that the interpretation of Jornada Style life-forms goes beyond the mere identity of species. What we see here is not the work of prehistoric naturalists, but rather a group of figures carefully selected on the basis of their roles in the ideological structure.
[Schaafsma 1980:232]

(Below) Petroglyph, Hopi Mesas, Arizona

Fish (*pa'kiwa*) graving.
[Stephen 1936:1029]

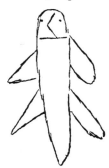

96

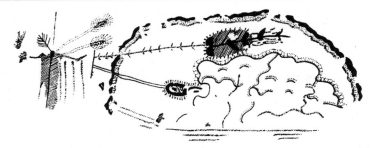

Pictograph, Satan Canyon, Val Verde County, Texas

In the center of VV40 there is a large composition in red, black and yellow. On the left we see what is called a human figure. On the right is a large wavy arch design. Within the concentric borders of the arch are two fish, represented even to their skeletons. That the people of this region should represent fish is not surprising, for fish bones are common in the shelter middens (Johnson 1964:79; Sayles 1935:118), and gar and catfish especially, are still caught in the rivers. Both of the painted fish are attached to lines which lead toward the human figure, ending at a black perpendicular line near his arm. One must conclude that the fish are caught by the man, whom we may identify as a Fisherman, capitalized to indicate that he is a type. Since fish are caught in rivers, it seems plausible to identify the wavy arch design as a River (again a type), presented symbolically as viewed from above. From the shelters high in the cliffs, the rivers and canyons actually give the impression of a series of great curves. . . . The first three of these subject identifications, then, are the Fisherman, the fish, which I will arbitrarily designate a Catfish, and the River. . . . The fourth subject is the Canoe. [Grieder 1966:716-717]

(Below) Pictographs, Eagle Cave, Val Verde County, Texas

Large Fisherman in black and red with yellow interior panel, about five feet tall. Sun-like Catfish is at far right. [Grieder 1966:714]

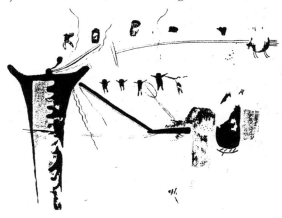

Flute Player (Kokopelli)

• Anthropomorph in profile with line from mouth and arms holding this line, often with hump on back and ithyphallic

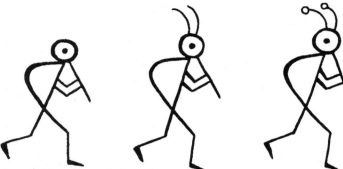

Drawings to illustrate symbols of clans and kachinas

The locust *mahu* is known as the Humpbacked Flute Player, the *kachina* named Kokopilau, because he looked like wood (*koko*—wood; *pilau*—hump). In the hump on his back he carried seeds of plants and flowers (the Kokopilau or Kokopelli is often made with a long penis to symbolize the seeds of human reproduction also) and with the music of his flute he created warmth. When the people moved off on their migrations over the continent they carved pictographs of him on rocks all the way from the tip of South America up to Canada, and it was for these two *mahus* (left and middle above) that the Blue Flute and Gray Flute clans and societies were named.

[Waters 1963:38]

Drawing of Hopi Kokopelli

After Fewkes. [in Sims 1949:5]

(Below) Kiva Mural, Awatovi, Arizona

The erotic aspect of the male figure almost certainly suggests Kokopolo Kachina, who appears occasionally at kachina dances. His mask is usually black, with a vertical white stripe; he is represented as hump-backed, with an erect penis. . . . This latter, in dances today, is of carved wood or a gourd tied around the waist. He dashes about . . . simulating intercourse with various feminine spectators, as the mural suggests. . . . I am of the opinion that Kokopolo . . . is carrying out his traditional role.

[Dockstader 1954:50]

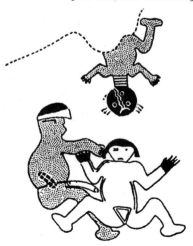

Petroglyphs and Pictograph (center), Canyon de Chelly, Arizona

There is a notable break in the strictly front-view figure of Basket-maker times, and in the climax period of canyon rock art (probably mid-Developmental Pueblo), figures are shown in profile, especially as seated humans, often playing the flute. [Grant 1978:177-178]

Petroglyph, Cienagillos, New Mexico

A flute is being played by *Kokopelli* who appears in typical fashion, as if dancing and ithyphallic.
[Ritter and Ritter 1973:70]

Petroglyph (left) and pictographs, Canyon de Chelly, Arizona

During this period there were many examples of flute-players. . . . Some are twinned with "rainbow" effects over their heads, as at site CDC-78, Pictograph Cave.
[Grant 1978:177-178]

Pictographs, Hidden Valley Cave, near Durango, Colorado

Human figure—the Flute Player.
[Daniels in Morris and Burgh 1964:87-8]

Footprints
(*See also* Sandals)

• Prints of bare human foot

Petroglyphs, Mimbres site near Cook's Peak, New Mexico

Human footprints carved in sequence across bedrock at a Mimbres petroglyph site.
[Schaafsma 1980:207]

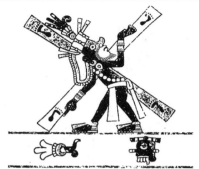

Illustration in ancient Mexican book— Codex Ferjervary-Mayer

Panel from the *Codex Ferjervary-Mayer* showing Yacatecuhtli, Lord Nose, the patron god of the merchants. His large red nose makes him easily identifiable, and he is carrying the symbol of the crossroads with merchants footprints on them.
[Burland and Forman 1975:95]

Petroglyphs, Smith Fork Bar, Glen Canyon, Utah

The carefully delineated patterns of sandal tracks, both the plain solid types (above) and those in outline with decorative interior patterning, indicate an interest in aesthetic effect. [Schaafsma 1980:136]

(Left) Petroglyphs, Desha Canyon mouth, Glen Canyon area, Utah

This scene approximates a successful kill or hunt depiction as complex as any known for the Glen Canyon region. [Turner 1963:68]

Four Circles
(*See also* Warriors)

- Four small circles, in a cross design
- May be connected with lines or separated by stick cross

Petroglyph, NA2681, San Juan River, Glen Canyon area, Utah

Informant recognition: "Connected four circles . . . is similar to *keptevipi*, a religious device used in the Niman (Hopi) ceremony for purifying the earth."

[Redrawn from Turner 1963:62]

Drawing of the eyes of guardian of Gila Monster's water in Chemehuevi myth

The fourth water, Gila Monster's own personal water, was guarded by an insect person, Eyes on Top of Each Other (called in *The Chemehuevis* the Four-Eyed Insect). In this myth he is manlike, for it is said that he paced up and down, and that Sidewinder (a snake) "bit him on the testicles." In his insect form, he "has four eyes" arranged as above. [Laird 1984:105]

(Right) Petroglyphs with four circles sign, Petroglyph Canyon, Coso Range, California

[from Grant 1967:102]

Drawing of glyphlike carvings at Cenote Cave, Tancah, Yucatan, Mexico

Conspicuous among the Mexican-ized glyphlike forms which make up the carvings of the Tancah Cenote Cave is a Lamat sign, a hieroglyph for the planet Venus as well as for a Maya day (above right and below). Also shown is 1 Ahau, the date on which the heliacal rising of Venus occurs (above left). The calendrical signs Lamat and 1 Ahau together must be read as Venus as the Morning Star, during the first five days of the helical rising, emerging from the land of the dead. [Miller 1977:113-114]

Mayan glyph for a day and for the planet Venus

[Redrawn from Schele and Miller 1986:318]

101

Friendship

(*See also* Swastika)

Petroglyph, Hopi Mesas, Arizona

It is very common to find shields depicted on the rocks by the Tusayan pueblo people. . . . Of the circular form the most elaborate (above) has the whole interior occupied by a cross with bars of equal length, in each of the four angles of which are to be seen a circle, the friendship sign (lower right) and two smaller crosses. A face with a single *a-la* or horn is appended to the rim. The cross is the symbol of the sky god, *Co-tok-i-nung-wuh*. . . . The so-called friendship signs are drawn with the finger on the corn smut with which the breast of *Hu-mis-ka-tci-na* is daubed.

[Fewkes 1892:23]

Drawings of Hopi symbol

Figure above is another form of the *nakwách*, symbol of brotherhood also formed when the priests clasp hands in the same manner during the public dance of Wuwuchim today. [Waters 1963:52]

Petroglyph, Hopi Mesas, Arizona

Ute shield. Moon and Friendship mark (upper left and lower right). "When the moon was half gone i.e. full moon, with our friends we slew the enemy." [Stephen 1936:131]

Design from manuscript

The left hand design above, taken from the manuscript catalogue of T.V. Keam, is water wrought into a meandering device, which is the conventional generic sign of the Hopitus (Hopis). The two forefingers are joined as in the right hand design in the same figure. In relation to the latter Mr. Keam says: "At the close of the religious festivals the participants join in a parting dance called the 'dance of the linked finger.' They form a double line, and crossing their arms in front of them they lock the forefingers of either hand with those of their neighbors . . . singing their parting song." [Mallery 1893:643]

Frog, Lizard, or Toad

• Zoomorph with tail, arms upraised and bent at elbows, legs spread and bent at knees, often with circular body

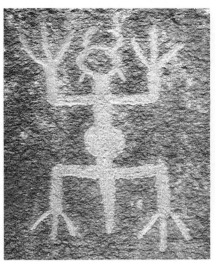

Petroglyph, Chaco Canyon, New Mexico

Lizards became important in Anasazi rock art iconography after about A.D. 1,000.

[Schaafsma in Noble 1984:61]

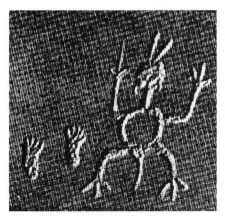

Petroglyphs, Hanlipinkia, Zuni area, New Mexico–Arizona

Primitive Zuni before the amputation of tail; on left, feet after removal of the web.

[Stevenson 1904:PL VIId, e]

Petroglyph, Zuni area, New Mexico

Rock carvings and paintings that evoke parts of tales and myths and the emotions associated with these vitally important "texts," operate . . . as "metonyms of narrative." The visual image stands for and calls forth verbal recitation. One such group of images consisted of varieties of "lizard men," which are lizardlike anthropomorphic figures prevalent in the rock art of the Zuni-Cibola region. Several Zunis identified these figures as "the way the Zunis looked at the time of the beginning" or "in the fourth underworld," often adding "when we still had tails.". . . When the people reached this surface after having traveled through the four underworlds they were dazzled by the light of the Sun and were made human by the Twins (Twin War Gods). They were washed, their tails were cut off, their webbed digits were separated and the genitals were removed from the tops of their heads. They were also hardened or finished in the same fire with which the Twins hardened the soft surface of the earth. [Young 1988:123-124]

God of Death or Metamorphosis (Maasaw)

- Anthropomorph with "pumpkin" head, round eyes and round mouth
- Human head in profile with large forehead ("pac-man")

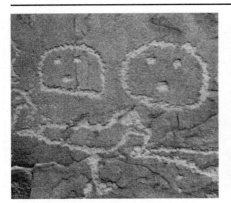

Petroglyphs, Willow Springs, Arizona

Massaw petroglyphs at Tutuventiwngwu (Willow Springs, Arizona). Two basic configurations portray the (Hopi) god: the frontal view with eyes and mouth (left above) and the "pac-man" type profile emphasizing the god's bulging forehead (above right).

[Malotki and Lomatuway'ma 1987a:25, 99]

Pictographs, Betatakin, Tsegi Canyon drainage, Arizona

. . . Hopi elders . . . feel that the large circular painting at Betatakin (above) is a Fire Clan symbol, the figure within representing the god Masauwu. [Schaafsma 1980:148]

(Below) Boundary stone, Hopi Mesas, Arizona

Stephen made no study of land holding. In 1888 he notes the use of certain field marks, and of a boundary stone between Shunopovi and Oraibi (Hopi) lands, (which is) a figure of Ma'sauuh (below). . . . This was erected many years ago. The eyes and nose marks are merely round shallow holes with a black rim painted around them. Honani (a Hopi informant) thinks the head was carved and the face holes painted to keep the young people from destroying it. The name of Ma'sauuh is attached to it for the same reason also.

[Footnote in Stephen 1936:390]

Cover illustration of Maasaw, from Stories of Maasaw, A Hopi God *by Ekkehart Malotki and Michael Lomatuway'ma 1987b*

Track of Maasaw in myth

They found a place where (there were) many footprints (going around) like this. . . . Four days our uncles searched for the maker of the footprints, then our oldest uncle saw, coming over the west mesa, a who-was-it. Our uncle went to meet the stranger who was hideous and terrible, covered with blood and loathsomeness and there was no flesh on his head. They kept walking toward each other and when they came together our uncle took hold of him and it was Masau. . . . (He, Masau, said) "Look in the valleys, the rocks and the woods and you will find my footsteps there." [Stephen 1940:7-8]

Petroglyph, Willow Springs, Arizona

According to a member of the Maasaw clan at Hopi, the glyph specifically portrays the *nukpanmaasaw* or "evil Maasaw." This interpretation is based on the bow associated with it on the right, linking the figure with fighting and war.
[Malotki and Lomatuway'ma 1987a:201]

Signatures of Hopi workmen at archaeological site, northern Arizona, in 1897

(Left) Full figure of Maasaw.
(Right) Head of Maasaw.
[Fewkes 1897:1-11]

Grid

(*See also* Enclosures and Phosphenes)

• Abstract design of horizontal and vertical lines, usually enclosed

Petroglyphs, Cluster A, Shelter Gap site, Picacho Mountains, Arizona

Possibly related to hunting and hunt scenes for the Picacho glyphs are several specific design elements we have treated as abstract, but which may actually be representational. These include rakes, double rakes, ladders, and possibly grids. . . . Several Great Basin researchers have noted the strong indications in some of their sites that these elements appear to represent nets or fences used to divert and capture game animals (Hiezer and Hester 1974:11-14; Nissen 1982:630-631). Given graphic petroglyph depictions and the environmental contexts for some of the sites theirs is a reasonable hypothesis . . . the abnormal frequency of Archaic grids at Cluster A in Shelter Gap suggests a hunting motivation for the site during the time when this style was in vogue. The fact that these particular elements are some of the most common and distinctive for the Western Archaic tradition may thus be indicative of a general preoccupation with hunting as a motivation for the production of the art.
[Wallace and Holmlund 1986:146]

Drawings of visual phenomena with petroglyph in bottom row

(Top row) "Lattices" (are) considered a basic phosphene design. Basic phosphene patterns tend to recur (Kellog, Knoll, and Kugler 1965:1129; Kluver 1942), and charts of the common design elements have been compiled. When pressure is applied to the closed eye, for example, most people will see a moire-like pattern of checkerboard designs shortly after onset of pressure (Walker 1981).
[Hedges 1981:18]

(Middle row) Drawings of Entoptic Phenomena seen during altered states of consciousness and hallucinations. Entoptic phenomena mean . . . visual sensations derived from the structure of the optic system anywhere from the eyeball to the cortex. . . . Although there are numerous entoptic forms, certain types recur. We have selected six (including): (1) basic grid and its development in a lattice and expanding hexagonal pattern.

(Bottom row) Grid Petroglyph, Coso Range, CA. (Grant et al. 1968:82).
[Lewis-Williams and Dowson 1988:202, 203, 206]

106

Handprint

(*See also* Twin War Gods)

• Prints of human hand

Pictographs, Canyon de Chelly, Arizona

The hand is perhaps the most useful and valuable part of man's anatomy, particularly to primitive man. In addition, it is an identifying symbol. If I put my handprint down on paint and then impress it on a rock surface in a sheltered spot, I have made my mark and it will endure long after I am gone. . . . Modern Pueblo Indians consider the handprint a kind of signature. . . . Sacred spots were sometimes marked by a handprint so that the supernatural beings would know who had made the supplications and offerings (Ellis and Hammack 1968:36). According to Dutton (1963:179) handprints are often an expression of sympathetic magic indicating the wish of the maker to bring forth whatever is depicted, such as clouds or deities. [Grant 1978:168-9]

(Below) Petroglyph, Cienagillos, New Mexico; Pictograph, Abo Gap, New Mexico

(Left) . . . the two distal phalanges of the middle finger were missing. (Right) . . . a hand with the distal two phalanges, perhaps part of the proximal phalanx missing from the middle finger.
[Ritter and Ritter 1973:90, 89]

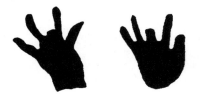

(Below left) Pictographs, Canyon de Chelly, Arizona (from Grant 1978:163)

. . . . Basketmaker figures are not ordinary men. They are abstract, remote, static forms, lacking human qualities. Their elaborate headgear is another clue to their supernatural affiliations. . . . The handprints are usually stamped near the figures, or they may be placed on their torsos or around their heads. . . . They may have been left as signatures of prayer requests or made in the act of obtaining power—either from the rock art figure itself or from the place it occupied. In both cases some kind of supernatural power associated with the human forms is implicit. [Schaafsma 1986a:26]

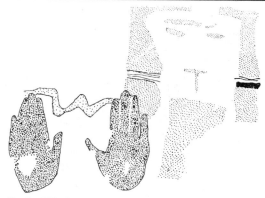

Pictographs, Butler Wash, Utah

That the representations themselves also had supernatural importance or power associations is suggested in the Basketmaker examples by the handprints placed near the masks just as they were placed in and around complete figures in a manner to suggest that they served as a type of signature, perhaps identifying an individual who had offered prayers to or through the figure portrayed (Schaafsma 1980 117-119).
[Schaafsma and Young 1983:28]

Comments on functions of hands at Zuni

With infinite patience he (Cushing in 1880s) revived the primitive functions of his own hands, living over again with them (the Zunis) their experiences of prehistoric days . . . *when the hands were so at one with the mind that they really formed a part of it.* . . . To reconstitute the primitives' mentality, he had to rediscover the movements of their hands, movements in which their language and their thought were inseparably united. . . . The primitive who did not speak without his hands did not think without them either. [Levy-Bruhl 1985:161]

Pictograph, Canyon de Chelly, Arizona

The red handprint is also a symbol of the Elder War God.
[Grant 1978:169]

Comment on hands among the Hopi

The left hand is regarded as sacred (*hya'kyauna*) and used in placing or removing the mask; and in the left hand are placed prayer sticks and feathers and meal offering. . . . The right hand is called *tunush'ma'htu,* food hand . . . and . . . regarded as ceremonially defiled.
[Stephen 1936:371]

(Below) Petroglyph, Canyon de Chelly, Arizona

Anasazi woman. [Grant 1978:178]

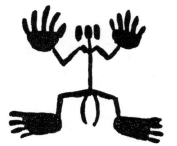

Headddress (*See also* Tableta, Tablet, and Tabla)

• Headdress of anthropomorph, often includes horns, feathers and other materials

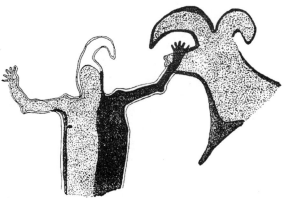

Pictograph, Cueva la Palma, Baja California, Mexico

Figure (above) illustrates what Crosby (1975) has come to call the "sackhat man" headdress. This headdress I believe is associated with a clan symbol for bighorn sheep. At Cueva la Palma (above), the bighorn mountain sheep shaman, whom we might call "Lord of the Bighorn Mountain Sheep," is being represented. The human form has a bighorn sheep head-dress in yellow ochre that curls toward the bighorn sheep painted to his left. [Smith 1985:36]

(Below) Petroglyphs, Sheep Canyon, Coso Range, California

Figures with sheep horn head-dresses from Sheep Canyon (Late Period).
 [Grant Baird and Pringle 1968:40]

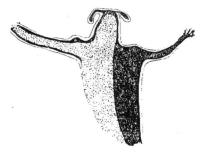

Pictograph, Cueva Pintada, Baja California, Mexico

Father Napoli's description (of a shaman's headdress) "On his head he wore some tails, taken from deerskins . . ." provides us with a plausible identification of a charac-teristic headdress pictured in the great Mural paintings (above).
 [Smith 1985:34]

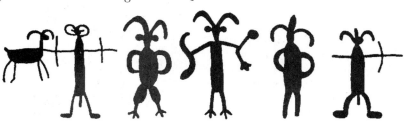

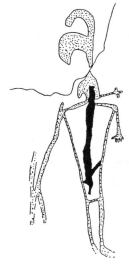

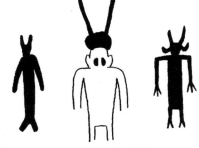

Pictographs, Canyon de Chelly, Arizona

Pictograph, Green Mask Site, Grand Gulch, Utah

San Juan-style anthropomorph with a mark over the neck and torso Panel 7, the "Green Mask" site, Grand Gulch, Utah. [Cole 1984b:3]

A great deal of the rock art of the Great Pueblo period . . . appears secular. However, there are exceptions and the horned figure is the most prominent. This type of figure is found over a very wide area. . . . Waters (1963:108) illustrates several Hopi petroglyphs of horned people that he says are members of the Two Horn Society of the powerful Bow Clan. The Hopi almost certainly immigrated to their present area from Canyon de Chelly and other population centers in the Kayenta area. . . . Many of the horned figures so common in rock art in many parts of the world certainly represent shamans. The idea is very ancient.
[Grant 1978:205-6]

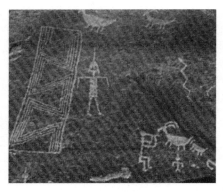

Petroglyphs, Site NA 7179, Lower Cha Canyon, Glen Canyon area, Utah

Style 4 (A.D. 1050-1250). Informant recognition: . . . Anthropomorphs are "Warrior Gods" since they are wearing helmets with the single feather sticking up.
[Turner 1963:50]

Petroglyph, Hopi area, Arizona

. . . A headdress (tableta) used in ceremonial dances.
[Mallery 1893:746]

Head Hunting

• Anthropomorphs carrying human heads, often suspended from stick
• Human head alone, occasionally with loop at top

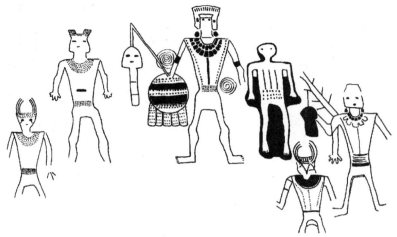

(Above and below) Petroglyphs, Ashley and Dry Fork Canyons, near Vernal, Utah

The Classic Vernal anthropomorphs . . . may also be portrayed carrying small shields . . . or what may be either masks or human heads. . . . The heads carried by these figures vary from being highly detailed to being simplified almost beyond recognition.
 [Schaafsma 1971:15, Figs. 5 and 6]

(Below) Utah sites with "Head Hunters"
 [from Castleton and Madsen 1981:171]

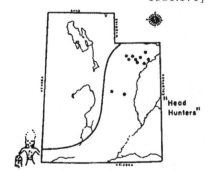

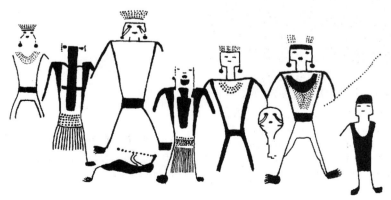

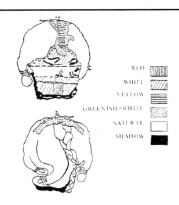

(Above left) Pictograph, Green Mask site, Grand Gulch, Utah
(Above right) Front (top) and rear (bottom) drawing of painted human head skin, Marsh Pass, Arizona after Kidder and Guernsey (1919: Plate 87a, b)

(Above left) The "Green Mask" glyph is approximately 15 cm wide and 20 cm high and is executed in pigments of green, yellow, red, and white. Long reddish hair hangs down on both sides of the face, and the lower portions appear as if braided and/or bound.

(Above right) Kidder and Guernsey (1919) reported finding a "scalp" or "trophy head" . . . in Cist 16, Cave I, in Kinboko Canyon at Marsh Pass, Arizona . . . the "trophy" was found in association with a Basketmaker burial of the "mummified" upper half . . . of a girl of about 18 years of age . . . the "trophy" made from the skin of a human head was found below it under the left shoulder . . . fastened to it were remnants of two strings, the ends of which extended in the direction of the "mummy's" neck . . . it is the entire head skin of an adult, with the hair carefully dressed. . . . The face has been colored rather elaborately.

[Cole 1984:1-6]

(Below) Petroglyphs, Sand Island, Utah

Mask or face petroglyphs. . . . Note the loops or handles on the tops of (some) of the elements and a stem-like addition on the head of another. [Cole 1985:14]

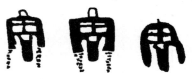

Comment on Hopi head hunting
The Hopi took heads as well as scalps, a trait which they had in common with the Aztecs.
[Parsons in Stephen 1936:XXIV]

(Below) Petroglyph, Dry Fork Canyon, Utah

Classic Vernal Style Anthropomorph, drawn from the photograph by Dale Ritter in Grant (1967). [Faris 1987:28]

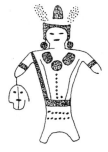

Headless

(*See also* Death)

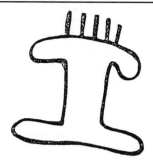

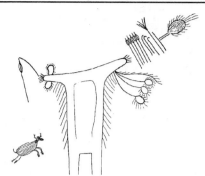

Pictographs, Seminole Canyon area, Texas

The shaman figures assume a distinctive form in Period 2 (above). They are usually a single shade of red, elongated and large; 40% are over 6 feet tall, and six of them are over 10 feet in height. They usually are drawn in full-front view, although some figures are shown in profile, a feature seldom found in later paintings. They often lack heads, although not necessarily headdresses, and facial features are never portrayed.
[Newcomb 1976:183]

Pictographs, southern California

We suspect that the occurrence of any of these (Nunashish, spirits, ghosts, were-beings, and so on), along with headless forms (above) or forms of people upside down or bleeding from the mouth, symbolize sickness or death (Blackburn 1975:69; Hudson 1979).
[Hudson and Lee 1984:43]

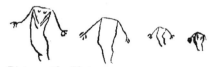

Pictograph, Plains area

(Figure above) taken from Mrs. Eastman's Dakota . . . shows the Dakota pictograph for "killed"; left to right is a woman, man, and boy and girl killed. [Mallery 1893:660]

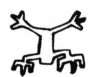 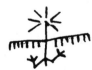

Pictographs, Burro Flats, California. Left figure in white is superimposed on right in red.

Immediately to the right of this motif (concentric circles) is a composite design that consists of a red figure with wings (or feathered cape) and lines radiating from its head (right above), overlaid by an upside-down white figure (left above) that appears to be headless. . . . This composite design can function as a metaphor for the two aspects of the shaman, the red figure portraying the shaman in flight and the headless white figure representing the other aspect of the shaman, in his death-like trance. The close proximity of this composite design to the concentric-circle design suggests that the shaman has been placed at the entrance of a tunnel, poised for his journey to the land of the dead.

[Benson and Sehgal 1987:13]

Heart Line
(*See also* Breath and X-Ray Style)

• Line(s) from mouth to chest, ending in heart-shaped object

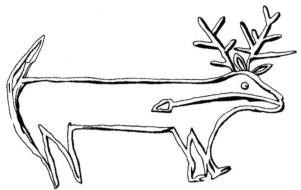

Petroglyph, Zuni Reservation, New Mexico

In many cases the deer has a "heart line" from its mouth to its interior; in pictographs the heart line is generally red. Similar depictions of deer with heart lines are also found on Zuni pottery water jars. . . . The heart line is a symbolic representation of the source or "breath" of the animal's life (Cushing 1886:551). In the rock art, arrows sometimes project from the bodies of the deer as if they had penetrated the heart portrayed at the end of this line. Sometimes . . . bears and horned or plumed serpents also have heart lines. [Young 1988:82]

(Below) Petroglyph, West Virginia, redrawn from Garrick Mallery 1893

Many Indian tribes drew representations of game animals with a "heart line" running from the mouth of the animal to the vital organ. The Ojibwa called such drawings *muzzin-ne-neen,* and they were used in hunting-magic ceremonies. When an arrow was drawn piercing the heart of the animal it was hoped that equal success would attend the hunter in the field. This motif is found in West Virginia, Minnesota (where the heart line also occurs in human figures), Montana, Wyoming, Utah and New Mexico. [Grant 1967:67]

Petroglyph, LA 3017, Navajo Reservoir area, New Mexico

. . . bison, with heart lines, the deer, owl and eagle are among the figures represented.
 [Schaafsma 1963:Fig. 37]

Comment

Animals shown with the heart line are considered supernatural by the Ojibway and the Zuni.
 [Ritter and Ritter 1976:65]

114

Hocker or Receptive Female

• Female anthropomorph with legs spread, bent at knees, often showing vulva

Petroglyph, El Morro, New Mexico

The spread-eagle, "hocker," or receptive female motif is found at a number of rock art sites.
[Ritter and Ritter 1976:66]

Petroglyph, Peterborough, Ontario, Canada

A squatting figure with what appears to be an opening into its lower abdomen may also portray a female figure of religious and sexual significance (above). . . . Wherever such squatting female images appear, however, they tend to signify a complex meaning of symbolic death and rebirth and are particularly prevalent in works of art that function in ceremonies of initiation or transition.
[Vastokas and Vastokas 1973:90-1]

Petroglyphs, First Mesa, Arizona

Corn and female figure with sky symbolism. [Schaafsma 1980:290]

(Right) Drawing from Codex Borbonicus 13, an ancient Mexican book
[Caso 1958:55]

115

Horns

Petroglyphs and Pictographs at Oraibi, Arizona (upper left), Utah (upper right), Mesa Verde, Colorado (lower left), and El Paso County, Texas (lower right)

(Among the Hopi) . . . the ceremonies conducted by the Two-Horn and One-Horn Societies and owned by the Bow Clan are still today among the most important in the annual cycle. . . . These Two Horns are the larger figures found at Oraibi and Mesa Verde and carved on a cliff bank of the Colorado River in Utah. The smaller figure to the right is their godfather. The middle figure in the Utah drawing carried an oval-shaped object identified as the *mong-wikoro* (chief's water jar), which is emptied into the small hole known as the Tipkyavi (womb) during the ceremony. The two figures colored with *suta* (red paint) and found in a cave in El Paso County, Texas, are members of the One-Horn Society as shown by their single horns. The figure on the right is a member of the Two-Horn Society. [Waters 1963:108]

(Below) Petroglyphs, Willow Springs, Arizona

Hopi Clan Symbol—Horn Clan.
[Colton 1946:4]

(Below) Petroglyphs and Pictographs, Utah (left to right first three) and Mexico

Available sources on Ojibwa pictography . . . clearly indicate that a very special significance is attached to horns. Whenever they appear, they denote "superior power," or more than ordinary endowments and talent. . . . The majority of them, however, indicate either shamans' spirits or figures of the shaman himself.
[Vastokas and Vastokas 1973:74-75]

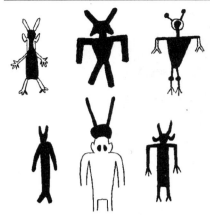

Pictographs, Canyon de Chelly area, Arizona

Many of the horned figures so common in rock art in many parts of the world certainly represent shamans. The idea is very ancient, first appearing in the Paleolithic caves of southern France, where a famous example is the horned "sorcerer" of the Trois Frères site. Eliade (1964:154-155) notes that the shamans of certain Siberian tribes wore caps bearing iron staghorns and that much of their power was attributed to such headgear. Similar horns were worn by Korean shamans, and possible shamans wearing bighorn sheep horns appear in the petroglyphs of some Great Basin Shoshoneans (Grant, Baird and Pringle 1968:40).
[Grant 1978:206]

Petroglyphs, Coso Range, California

At . . . sites in Sheep Canyon there are drawings of men wearing sheep horns. One carries ceremonial objects (sheep horn, snakes?).
[Grant, Baird and Pringle 1968:40]

Petroglyphs, Largo Canyon drainage, New Mexico

One of the most frequently depicted supernaturals in the Largo drainage is the *ghaan'ask'idii*, Humpbacked God (above). These *ye'i* wear mountain sheep horns, and their humps, from which eagle feathers radiate, are said to contain seeds and mist. The figure invariably carries a staff. This personage is regarded as either a deified mountain sheep or a guardian of the sheep, and is defined as the "god of the harvest, god of plenty, god of the mist" (Reichard 1950:443-44); he is frequently present in modern drypaintings. Here again is a horned deity, horns being insignia of supernatural power.
[Schaafsma 1980:317]

Comment

Further, ethnographic data show that the horned sheep has supernatural significance and that horns in themselves indicate shamanic and godly power.
[Schaafsma 1980:153]

Comment

The horn almost universally has been "the insignia of supernatural power—especially shamanic power or even power of the gods" (Furst 1974a:135). [Schaafsma 1980:239]

Horsemen

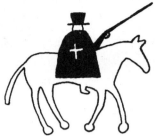

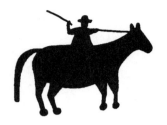

(Above left) Pictograph, Canyon del Muerto, Arizona; (Above right) Petroglyph, Largo Canyon, New Mexico

There are Navajo paintings of Spanish horsemen—the most outstanding example being the panel of a Spanish cavalcade high on the cliff above the Standing Cow Ruin in Canyon del Muerto (CDM-4). (This represents) Spanish cavalry of the Narbona expedition (1804-1805). . . . The three-foot central figure with the black cape and cross may represent the Spanish leader. . . . According to Ann Morris (1930) this painting was made by a Navajo named Dibe Yazhi (Little Sheep, or Lamb). Little Sheep's Pueblo mother came to the canyon from Jemez Pueblo sometime before 1804 and married a Navajo. In 1976 her descendants were still living in hogans directly beneath the famous painting.
[Grant 1978:221-223]

(Below) Pictograph, Cara Pintada, State of Sonora, Mexico

The horseman is about two inches high. [Grant 1976:52]

(Below) Petroglyph, Alamo Mountain, New Mexico

. . . Horses and riders are frequently represented in Apache rock art . . . (below) seems to represent Apaches. [Schaafsma 1980:335]

118

Hourglass

Petroglyph, Chaco Canyon, New Mexico

Navajo petroglyph of Born-for-Water, the younger of the Navajo Twins. This is found next to the sun rock carving. The hourglass shapes that ring the face identify this incised figure as Born-for-Water. It symbolizes the scalp knot that he tied after his brother monster slayer killed the monsters that plagued the Navajo after their emergence from the underworld.
[Williamson 1984:172]

(Below right) Petroglyphs, Three Rivers, New Mexico

There is also what might be referred to as the "long mask," extended in length and divided horizontally. Three masks of this type have a cross or star on the cheek. . . . The paw print on two Three Rivers examples is notable. . . . The paw print and star, judging from parallel iconography among the Pueblos, could signify warrior associations. There are stars on the rock above the mask . . . which has a paw print on the chin and a nose in the shape of an hourglass. The hourglass has warrior associations for present-day Indians in the Southwest. [Schaafsma 1980:219-220]

Petroglyphs, Largo Canyon drainage, New Mexico

The War Twins . . . are major deities in Navajo mythology. They have many names but the elder twin is most often called Monster Slayer and the younger Born-for-Water. . . . Dance impersonators of Monster Slayer are painted with a symbol of the bow. . . . Supernaturals carrying the bow may in some cases represent this deity. . . . Both the hourglass (symbol for Born-for-Water, the younger twin war god) and the bow (the elder twin) also occur apart from anthropomorphic contexts in rock art.
[Schaafsma 1980:315-31]

119

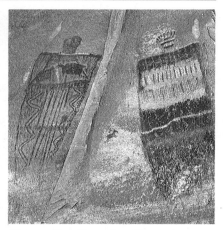

(Above) Pictographs, Candelaria Peaks, northern Chihuahua, Mexico
(Below) Petroglyphs, Diablo Dam, near Fort Hancock, Texas

The most significant representational Archaic rock drawings in this general region (in the general vicinity of the Rio Grande from El Paso south to the big Bend) are the paintings from the Candelaria Peaks (above). . . and the petroglyphs of men, spears, and animals north of Fort Hancock at Diablo Dam (below).
[Schaafsma 1980:56, 57, 59]

Pictographs, Horseshoe (Barrier) Canyon, Utah

. . . it is felt that evidence supported the probability that the Barrier Canyon Style artists were hunter-gatherers immediately preceding the Fremonters of the region. . . . The long wall of the shelter is covered with dozens of richly decorated anthropomorphs.
[Schaafsma 1980:61, 67]

(Below) Petroglyphs, South Mountain, Arizona

The human figure on the right with the cane is a typical Hohokam ceramic motif. [Schaafsma 1980:92]

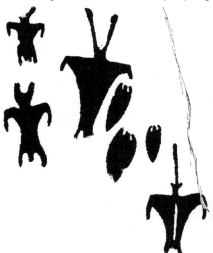

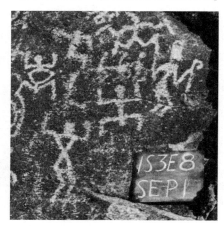

120

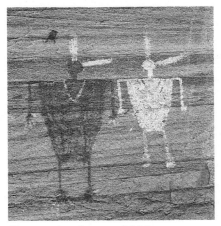

Pictographs, Canyon del Muerto, Arizona

Paired Basketmaker anthropo-morphs with distinctive headgear. Figures are about 3 feet tall.
[Schaafsma 1980:113]

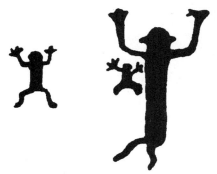

Petroglyphs, Pictograph Point, Mesa Verde National Park, Colorado

Representations of the Pueblo People, according to Hopi informants.
[Mesa Verde Mus. Assn. n.d.:11]

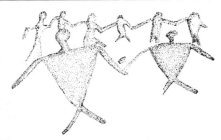

Petroglyphs, Site LA 3015, Navajo Reservoir area, New Mexico

. . . these figures, dominated by broad-shouldered men, are . . . on (a) heavily patinated part of the cliff. [Schaafsma 1963:10, Fig. 9]

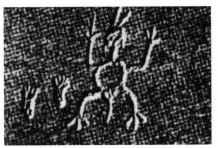

Petroglyph, Zuni area, New Mexico

Primitive Zuni before removal of tail. [Stevenson 1904:Pl. VIId,e]

(Left) Petroglyphs (?), Hopi area, Arizona

Moki (Hopi) . . . describing the . . . character of the figure (at left), he says: "The figure represents a woman. The breath sign is dis-played in the interior. The simpler design in the right-hand character consists of two triangles, one upon another, and is called the 'woman's head and body.'"

[Mallery 1893:705]

Hunter's Disguise

• Anthropomorph wearing animal head, usually carrying weapons near game animals

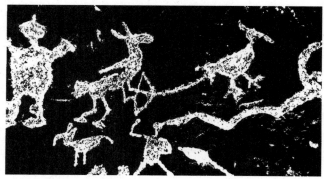

(Above) Petroglyphs, Sandia Canyon, Bandelier National Monument, New Mexico

The remarkable group in the Sandia Canyon retreat shows a hunter disguised in a deer head and skin, possibly also with a turkey tail(?), shooting an arrow at a turkey moving away from him. The figure at the extreme left probably represents a mudhead kachina.

[Rohn et al. 1989:108]

(Below) Drawing of Indians disguised as wolves stalking buffalo, Great Plains, United States

While the herd of buffalo is together, they seem to have little dread of the wolf. . . . The Indian . . . has taken advantage of this fact, and often places himself under the skin of this animal . . . and easily shoots down the fattest of the throng.

[Catlin 1844:254]

(Below) Drawing of a deer's head disguise used by Yavapai Indians, central Arizona

In hunting deer they use as a decoy a head covering or mask, *mu-hu*, made of the skin and antlers from a buck's head. . . . A hoop which fits the hunter's head keeps the neck in shape. The mask is put upon the head like a hat and held by strings tied under the chin.

[Corbusier 1886:14-15]

Hunting

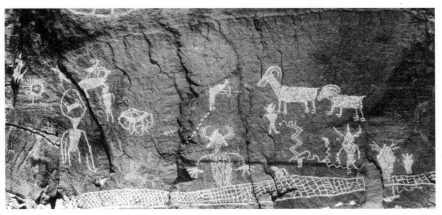

Petroglyphs, Nine Mile Canyon, Utah

Hunt scene and antlered anthropomorphs, Northern Rafael Style.
[Schaafsma 1980:176]

Petroglyph, Zuni Reservation, New Mexico

. . . the depiction of game animals not only recorded a successful hunt but propitiated the spirits of the animals that had been slain, ensuring more such success in the future. . . . (Above) is a pecked figure of a mountain sheep that has been carved with a hole in the center of its body, perhaps indicating the heart that the successful hunter's arrow will strike . . . whatever the original motive for their production, such images, once made, might very well have been used in ritual activities aimed at ensuring the success of the hunt.
[Young 1988:164]

Comment

A majority (87 percent) of 900 field studied petroglyph and pictograph sites with hunting content from throughout western North America occur in or near present historic or prehistoric hunting areas (also game trails, hunting blinds, box canyons, water holes and buffalo jumps) which suggest most were probably used as hunting medicine or magic (cf Heizer and Baumhoff 1962:281; Schaafsma 1965:7,9; Ritter and Ritter 1970:397).
[Ritter and Ritter 1976:67]

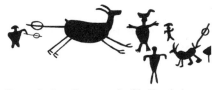

Petroglyphs, Canyon de Chelly, Arizona

Another animal important in this area was the bighorn sheep . . . these representations were presumably made by a hunting people familiar with hunting magic, as a few of the sheep are impaled with spears or arrows. [Grant 1978:191]

123

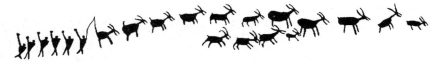

Petroglyphs, Canyon de Chelly, Arizona

. . . possibly represents a communal sheep drive. The open-mouthed bighorn is typical of the Early Developmental Pueblo style.

[Grant 1978:183]

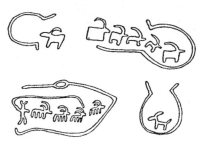

Petroglyphs, primarily Venice area, Utah

The Fremont Petroglyph design element referred to as an "enclosure" (above) occurs at 13 sites near Venice, Utah. . . . The term "enclosure" is non-generic but descriptive. . . . Other terms which have been used for this design include "corralling device," "vulva and womb forms" and "grave indicator.". . . Immediate observation suggests that this form—which sometimes includes sheep, may be a corralling device used in a hunting process. The basis for another interpretation comes from the Ashley and Dry Fork sites where a copulation scene occurs with an enclosure. . . . In addition several local individuals near Venice refer to this symbol as a "grave marker" since it has occurred near some Fremont graves. [Warner 1981:104-6]

(Below) Petroglyphs, Hickson Summit and Northumberland sites, Nevada

It is this author's contention that these two Great Basin rock art sites were settings for a method of hunting herd animals which involved *consecutive attacks* by hunters stationed at preordained hiding places . . . as the animals moved past the first attack station they would be attacked by hunters hidden there (etc.). . . . *The petroglyph clusters are these hypothesized attack stations.* . . . "Horseshoe" motifs (below) are found in great profusion (at these stations). . . . Is it possible that the horseshoe is strictly a hunt-related motif? . . . The terms "vulva-form" and "fertility symbol" have been used in the literature to denote the "horseshoe" motif . . . ; it has been interpreted as a representation of female genitalia (Davis 1961:236-239; Giedion 1962:173-192; Payen 1968:37). If the horseshoe's intimate association with hunting as well as its genital symbolism can be established, then it is entirely plausible that the horseshoe motif actually carried with it a broader concept of "plenty" relating not only to fertility and increase, but also to the . . . hunting system.

[Thomas 1976:71]

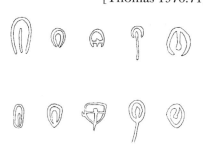

Irrigation

(*See also* Maps)

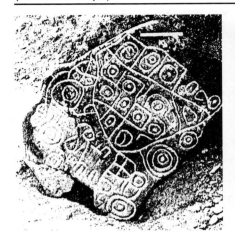

Petroglyphs, Valley of Sonora, Mexico

Petroglyph, San Cristobal, New Mexico

The new archaeological evidence for irrigation consists of what might well be one of only a few maps known to have been made prehistorically in the New World. . . . The "map," (was) found on the edge of the floodplain in the extreme northern end of the Valley of Sonora, a few kilometers north of Banamichi. . . . It does bear a strikingly similar likeness to the portion of the valley immediately surrounding the location of the glyph as seen from above (see below). Especially evident are the accurate locations of the main river channel, the *acequia madre* or principal irrigation ditch, fields, and the adjacent permanent habitation sites.

[Doolittle 1988:46-47]

Above: Entire face of boulder is covered with stalks of irrigated corn in various stages of growth. Semicircular lines at top right depict reservoirs and other lines signify irrigation ditches.

[Montgomery 1964:27]

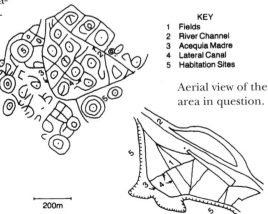

KEY
1 Fields
2 River Channel
3 Acequia Madre
4 Lateral Canal
5 Habitation Sites

Aerial view of the area in question.

200m

125

Katcina (Ahola)

• Mask with feathers on top and a snout

Petroglyph, San Cristobal, New Mexico

This may be a portrait of *Ahola*, but is questionable.

[Ritter and Ritter 1973:57]

Signature of Hopi workmen at archeological site, 1897, northern Arizona, member of the Katcina Clan

Simoitiva. Katcina gens (clan); totem, mask of Ahole (a katcina).

[Fewkes 1897:7 & Pl. III]

Drawing of Hopi Kachina mask

Ahola, the Germ God Kachina, Mong Kachina or Chief Kachina. Circular mask made from a yucca sifter basket covered with cloth and painted, one-third green, one-third yellow, and the lower third painted black. Black stars are painted on the yellow and green portions. The mask has a wooden beak usually turned up. Fox skin ruff. . . . Ahola appears at the Solstice and Bean Dance Ceremonies and is said to represent the spirit of the Germ God, Alosoka, who controls the growth and reproduction of all things. [Colton 1949:20]

Painting by native Hopi artist

Ahül . . . this god . . . (is) personified as leader of the katcinas. . . . The network leg-covering represents the garment worn by the sun god, and the row of globular bodies down each leg are shell tinklers. . . . In the left hand there are a small meal pouch . . . , a bundle of bean sprouts painted green, and a slat of wood . . . representing a chief's badge. [Fewkes 1903:67]

Katcina (Cha'veyo)

• Mask, with big ears, top feathers: often snout with teeth

Petroglyph, Near Sikya'tki, Hopi Mesas, northern Arizona

(Below) Drawing of Hopi Kachina Masks, northern Arizona

There is a graving of Cha'veyo . . . on a detached boulder on its northeast face at the foot of the cliffs about one-half mile south from Sikya'tki, very much weather stained and difficult to make out. . . . It is said to have been graved by the Sikya'tki men, which from its locality is very likely.
Note: In illustration of the tradition about Cha'veyo . . . which is more like the graving than the mask (below) worn by the kachina impersonator of the bugaboo.—*Ed.*
 [Stephen 1936:1027-28]

Chaveyo, an Ogre Kachina. Case mask painted black with green mark on forehead representing a snipe track and white moon symbols on cheeks, snout with teeth, wildcat skin ruff. . . . Chaveyo may come at any time during the spring months if Hopi children are particularly bad. [Colton 1949:29-30]

127

Katcina (Cholawitze and Kokosori)

- Mask, black with spots and big ears
- Anthropomorph with big ears & feather; may carry spruce bough and weapon

Drawing of Kachina Mask, Zuni Area, New Mexico

Cholawitze, Zuni Fire God. Case mask painted with black corn smut and spots of all colors, and tube mouth. Black ruff with colored spots. Breech clout, barefooted. Body painted black with corn smut and spots of all colors. Carries bow and arrows. A Zuni kachina that appears in the Pamuya at First Mesa (similar to Hopi Kokosori [right] at Second Mesa).

[Colton 1949:55 & 22]

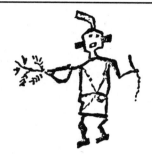

Petroglyph, Comanche Gap, New Mexico

Shulawitsi or Fire God at Comanche Gap, south of Galisteo, New Mexico.

[Sims in Dutton 1963:214]

Katcina (Cloud)

- Anthropomorph with cloud symbol on head

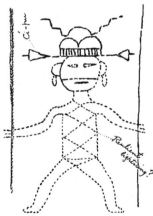

Petroglyph, Hopi Mesas, Arizona

On the west side of Oraibi pecked in sandstone is the figure of cloud kachina (O'mau kachina, Navajo, Kus'ye). [Stephen 1936:1033]

Drawing of Kachina Mask, Hopi Mesas, Arizona

Tukwünag, Cumulus Cloud Kachina. At First and Second Mesas, white case mask with cloud symbols on top. Third Mesa, no mask; feathers suspended from the headdress cover the face. . . . Carries gourd filled with water. . . . Said to bring summer rain.

[Colton 1949:42]

Katcina
(Deer or Sowiñwû)

- Mask with deer horns on top
- May have snout with teeth

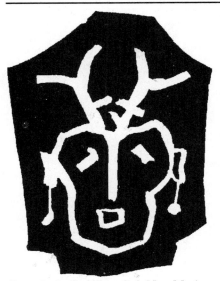

Petroglyph, San Cristobal, New Mexico

The unmasked figure . . . wears two deer antlers. Deer dancers with similar headdress may still be seen in the Rio Grande pueblo dances.
[Sims 1949:6]

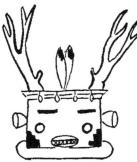

Drawing of Kachina Mask, Hopi Mesas, Arizona

Green case mask with deer horns on top of head, blossoms for ears, and snout with teeth, Douglas fir or juniper ruff. Kilt, sash, fox skin, and red moccasins. . . . Leans on a cane. . . . Has power over rain and also spasms. [Colton 1949:41]

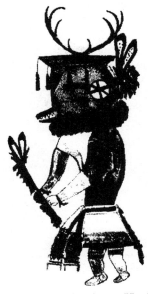

Painting of Deer Kachina, Hopi Mesas, Arizona

The Deer katcinas (Sowiñwû) have green helmets with projecting visors, from which hang rows of turkey feathers. Deer horns are attached to the top of the head and two eagle tail feathers project from the back. There is an hourglass design in black on the middle of the face and a black dot on each cheek. [Fewkes 1903:107-8]

Petroglyphs, Petrified Forest National Park, Arizona

An unusual tradition which consists of kachina-like petroglyphs. . . . Images identified as "deer dancer"(?)
[Martynec 1985:75 and Fig. 3]

129

Katcina (Dumas or Tumash)

• Mask with triangle in the center and wing-like "ears"

Petroglyph, Hopi Mesas, northern Arizona

Other petroglyphs are Tû'mash kachina. [Stephen 1936:1012]

Du'-mas-ka-tci'na. [Fewkes 1892:22]

Drawing of Kachina Mask, Hopi Mesas, Arizona

Angwusnasomtaqa or Tumas Crow Mother. Green case mask with crow's wings on the side. She wears a woman's dress. . . . By some Hopis she is considered to be the mother of all the kachinas. [Colton 1949:23]

Katcina (Hehea)

• Mask or Face design, with toothed mouth at 45-degree angle

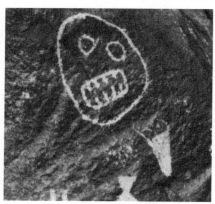

Petroglyphs, Los Lunas, New Mexico

The crooked mouth . . . is a diagnostic feature of Hehea, a widely distributed kachina. Fewkes (1903:74) expressed the opinion that "Hehea is evidently an ancient katchina, and from his appearance in many primitive ceremonies, public and secret, we may regard him as connected with very old ritual."
 [Schaafsma 1980:276, 295]

Drawing of Kachina Mask, Hopi Mesas, Arizona

Heheya. Case mask painted green or yellow, mouth round, oval or diagonal, vertical zigzag lines on face, nose represented by a painted "T," Douglas fir ruff. Wears kilt and sash, green moccasins, body painted red with yellow shoulders. He carries a rattle. Heheya appears in pairs with Soyoko.
 [Colton 1949:2]

130

Petroglyph, Hopi Mesas, Arizona

In strict language, the *na'-tci* or tablet worn on the helmet of the *Humis'-ka-tci'-na* is an *O'-mow-uh* (Cloud) figure. There is a beautiful *Hu-mis-ka-tci-na* tablet . . . cut in the rocks on the right of the carriage road to Hano, near Wal-la. The face, *na-tci* (headdress) and feathers in this are well shown.

[Fewkes 1892:19]

Drawing of Kachina Mask, Hopi Mesas, Arizona

Hemis Kachina. Case mask, of which half of the face is painted green and the other half pink, or it may be all white. Surmounted by an elaborate tableta painted with phallic and cloud symbols. . . . Carries rattle and sprig of Douglas fir. [Colton 1949:50]

Katcina
(Mudhead Clowns)

• Anthropomorph with knobs on the head

Petroglyph, San Christobal, New Mexico

Petroglyph, Zuni Reservation, New Mexico

. . . a personage struggling with a serpent. . . . They recall the Hopi drama given in the kivas each year in March, for the festival called *Ankwanti*. The festival has mainly to do with the *Palululkon* and in the theatrical performances, which usually consist of six or seven acts before large painted screens, there are realistic struggles between large horned serpent effigies and naked Mudhead Clowns.

[Sims 1949:7 Plate VIII]

Petroglyphs, Petrified Forest National Park, northern Arizona

An unusual tradition which consists of kachina-like petroglyphs commences during this time period. . . . Late Basketmaker III to Late Pueblo II (A.D. 650–1000). Images identified as "Mudhead"(?)

[Martynec 1985:75 and Fig. 3]

A final group of frequently identified kachina images in the rock art was the category of "clowns". . . ; Zunis suggested that Figures (above) were Mudheads because the apparent bellybutton; the Mudheads or *Koyemshi* often go barechested . . . and sometimes the dance kilt is worn low enough to reveal the bellybutton. Also all of the figures so identified had projections from their heads, a characteristic of both groups of clowns at Zuni, the Koyemshi and the *Newekwe* . Zunis say that the knobs of mud on the heads of the Koyemshi contain butterfly wings and "bits of soil from the people's tracks about town," while the projections from the heads of the Newekwe are squash blossoms.

[Young 1988:143-144]

Signature of Hopi workman at archaeological site, 1897, northern Arizona

Cinainiwa from Cuñopavi. Katcina gens (clan); totem, mask of Tatcúti (Mudhead).

[Fewkes 1897:7, Pl. III]

Katcina (Planet or Star) • Mask with star(s) in the face

(Above) Drawing of Hopi kachina mask, northern Arizona
(Above right) Pictograph, Hueco Tanks, Texas

Planet Kachina (Colton 1949:55; Fewkes 1903:117d) or Coto is similar to an unusual mask at Hueco Tanks. It is the only mask with star eyes and painted in green. [Sutherland 1976:137]

(Below) Photograph from exhibit at Field Columbian Museum, Chicago, showing Soyal ceremonies at Hopi Mesas, Arizona

The Star priest in the act of twirling the sun symbol, which is probably the climax of the whole (Soyal) ceremony.

[Dorsey and Voth 1901:Pl. XXIX]

Katcina (Sayathlia, Tungwup, Hu, Hututu, or Whipper)

• Mask with two large horns, round eyes, and toothed mouth
• Anthropomorph with arm raised, holding stick or whip

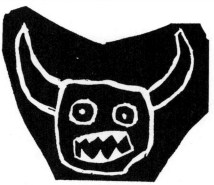

Petroglyph, San Cristobal, New Mexico

The mask with two great horns, globular eyes and serrated teeth . . . is the warrior Katcina *Sayathlia*. He appears in Zuni initiation ceremonies and also at other times as a punitive or exorcising Katcina, when he carries a yucca whip in each hand with which to flog his victims. A similar masked supernatural *Tunwup* takes part in Hopi ritual.

[Sims 1949:6]

(Below) Petroglyphs, Pictograph Point, Mesa Verde National Park, Colorado

(F) The "whipping kachinas" who "straightened out" the (Hopi) people and gave directions to their later travels.

[Hopi elders quoted in brochure published by Mesa Verde Museum Assn. n.d.:10]

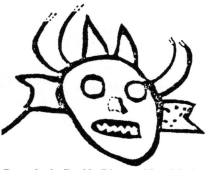

Petroglyph, Pueblo Blanco, New Mexico

This figure with two horns and dentate teeth has been identified as Sayathlia (also called Hututu) who is associated with war and medicine.

[Ritter and Ritter 1973:22]

Drawing of Hopi Kachina

Hu Kachina or Tungwup Whipper Kachina. Black case mask with white spots on the cheeks, white turkey track on forehead, long beard, horns on the side of the head. Fox skin ruff, breech clout and red moccasins. Body painted black with white spots. Carries yucca leaf whips and pieces of cholla cactus.

[Colton 1949:23]

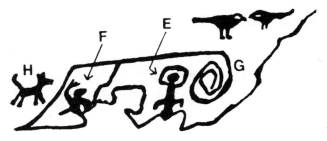

Katcina (Shalako)

• Mask with large snout, horns, feathers • Mask as above on top of extended body

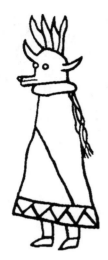

Petroglyphs, Zuni Reservation, New Mexico

Zunis identified certain kachina images in the rock art by name (i.e. *Shalako).* [Young 1988:139]

Comment on Shalako petroglyphs

The long-beaked birdlike Shalako is found in petroglyphs from the Rio Grande to the Little Colorado, suggesting that the Shalako fraternity once prevailed throughout the entire Pueblo area, although today it is best know in the west. Sims (1949:Plate I) identifies Hakto and Culawitsi (Shulawitsi), other members of the Shalako group, in the Galisteo Basin.

[Schaafsma 1980:296]

Katcina Clan

- Masks, varous, often with horns
- Line bisected by "V"s (spruce bough)

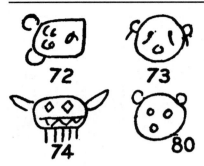

Signatures of Hopi workmen at archaeological site, 1897, northern Arizona, members of the Katcina Clan

(Below) Petroglyphs, Willow Springs, Arizona

72. Sikyamüiniwa from Oraibi. Katcina gens (clan); totem, head of Tatcükti (Mud-head).

73. Intiwa from Walpi. Katcina gens; (clan); totem, mask of Hehea (a katcina).

74. Sikyahoüava from Miconinovi. Katcina gens (clan); totem, mask of katcina.

75. Macahoüava from Oraibi. Katcina gens (clan); totem, mask of Tacab (Navaho) katcina.

76. Simoitiva. Katcina gens (clan); totem, mask of Ahole (a katcina).

80. Cinainiwa from Cuñopavi. Katcina gens; (clan); totem, mask of Tatcüti (Mud-head).

[Fewkes 1897:6-7, Plate III]

Clan symbols for the Kachina Clan . . . recognized by Edmund Nequatewa, a Hopi Indian. . . . This use of apparently unrelated symbols for the same group (clan) is explained in the clan legends which all Hopis know. As an example . . . the Kachina clan may be represented by a Kachina mask, but just as well by a branch of Douglas fir. Let us see now how this would work in our own culture. Suppose a member of the Smith family paid a visit to the top of the Empire State building and wished to leave a record that he had been there. Mr. Smith . . . draws the picture of an anvil on the wall. Sometime later his brother John arrives and draws a hammer and still later sister Jane draws a bellows. . . . If you know the meaning of the clan name and the clan story you can recognize the fact that members of the same family have left a record although the symbols are different.

[Colton 1946:5]

Petroglyphs, Willow Springs, Arizona

Hopi Clan Symbols—Katchina Clan (Mask or spruce bough).

[Michaelis 1981:15-23]

Kinship Lines

• Wavy lines connecting zoomorphs and other figures

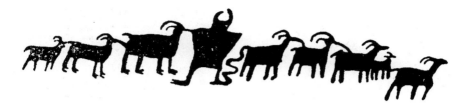

Petroglyphs, Cottonwood Canyon, near Nine-Mile Canyon, Utah

Consanguinity lines or lines joining zoomorphs and anthropomorphs, occasionaly phytomorphs, inanimate objects, and personified (anthropomorphised) objects are proposed as another motif used by the medicine man. These might be called kinship or blood lines intended to show a natural relationship such as mother and offspring or a supernatural relationship such as a person to his totem animal.

[Ritter and Ritter 1976:65]

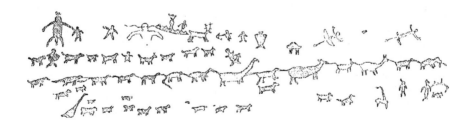

Petroglyphs, Mancos Canyon, Colorado

The most striking group observed is given in the figure above. It consists of a great procession of men, birds, beasts, and fanciful figures. . . . The whole picture as placed upon the rocks is highly spirited and the idea of a general movement toward the right is skillfully portrayed. . . . The figures forming the main body of the procession appear to be tied together in a continuous line and in form resemble one living creature. . . . Many of the smaller figures above and below are certainly intended to represent dogs while a number of men are stationed about, here and there as if to keep the procession in order.

As to the importance of the event recorded in this picture no conclusions can be drawn; it may represent the migration of a tribe or family or the trophies of a victory.

[Jackson and Holmes 1876:402-403]

Kwataka, Qaletaqa, or Kwa'toko

- Large unreal bird
- Anthropomorph impersonating bird

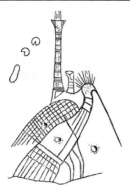

Petroglyph, Hopi Mesas, Arizona

It commonly happens that pictographs of striking character are found near shrines. None of these is more instructive than the pictograph of Kwataka, a mythic being of birdlike form. The being is regarded by the Hopi with great awe, for it is one of the most dreaded supernatural personages of the tribal Olympus and around it cluster many legends, some of which recount how it destroyed and devastated old pueblos. Some of the ruins of Arizona are directly associated with the effects of its rage. In certain respects Kwataka resembles the Zuni Achiyalatopa, "the knife-feathered being," figures of which are constant on certain Zuni altars but which I have never found on a Hopi altar. Kwataka was worshiped when success in war was desired, and offerings of medicine were placed in the depression indicating the location of the heart of this supernatural being.

[Fewkes 1906:363]

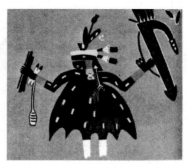

Kiva Mural, Kuaua Pueblo ruins, Bernalillo, New Mexico

Above figure depicts Qaletaqa, the traditional Hopi guardian. He carries a *hotango* (quiver of arrows), and wears a deerskin. A portion of his white knitted leggings is shown. These *namosasavu* (shin coverings) are worn only by members of the Coyote Clan. [Waters 1963:81]

(Below left and directly below) Petroglyphs, Hopi Mesas, Arizona

A Kwa'toko graving, Kwa'toko *pe'eta*, is on the edge of the cliff on the summit on a flat stone lying horizontally about fifty feet from the peach orchard house of Sikya'tala at Tuki'novi(below left). . . . Another Kwat'toko(directly below) is about seventy-five feet further northeast and is also on the horizontal rock at the edge of the cliff. . . . Three footprints are pecked inside of the rubbed lines. Kwa'toko graving (below left) is six feet long, from head to tail; four feet from claws to top of wing.

[Stephen 1936:1025]

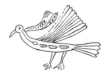

Lightning
(*See also* Snakes)

• Wiggly line with or without head at one end

Painting on Hopi kiva wall, Arizona

North wall: Sho'tokununwa (Sky God behind clouds holding lightning): face white with black lines (warrior marks); white legs, black line; hand white, black lined.

[Stephen 1936:198]

Petroglyphs, Oakley Springs (Willow Springs), Arizona

Figure above shows three ways in which lightning is represented by the Moki (Hopi). They are copied from a petroglyph at Oakley Springs, Arizona. In the middle character the sky is shown, the changing direction of the streak and clouds with rain falling. The part relating specifically to the streak is portrayed in an indian gesture sign as follows: right hand elevated before and above the head, forefinger pointing upward, brought down with great rapidity with a sinuous undulating motion, finger still extended diagonally down toward the right.

[Mallery 1893: 702]

(Below) Design on Hopi pottery

. . . represents the body of the mythic Um-tak-ina, the Thunder. This body is a rain cloud with thunder (lightning) darting through it and is probably of ancient Moki workmanship.

[Mallery 1893:703]

(Below) Drawing of altar, Hopi Mesas, Arizona

Conventionally the pictured form of the snake, without the forked tongue, represents lightning; when the tongue is expressed it represents the reptile.

[Stephen 1940:30]

139

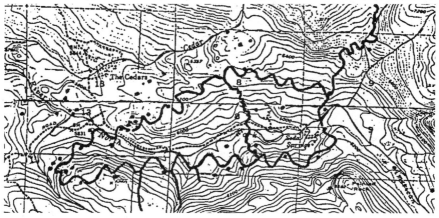

Drawing of Petroglyph at Pinehurst Site, on North Fork of American River, California, superimposed on topographic map of the area (dots = rock art sites)

The ability to superimpose the tracing of a prehistoric glyph accurately oriented onto a topographic map of the area, and to have the tracing closely follow trails identified by thirty or more rock art sites, including some seventy-seven individual bedrock outcroppings with petroglyphs, strongly supports the likelihood of map making capabilities by the early occupants of the region, the Martis Complex people.

[Gortner 1988:147-152]

(Below) Petroglyph (left) at Picacho Point, Arizona, compared to Outline Map of Point area (right)

At Picacho Point, the single most distinctive petroglyph at the site is a very large abstract form clearly pecked on the largest panel on the back or eastern side of Cluster A . . . it was clearly an outline map of the ridge upon which the site was situated, allowing for slight distortion based on the viewer's ground perception. After carefully evaluating this hypothesis we believe it to be warranted and offer figures for comparison of the mapped design with the topography of the ridge.

[Wallace and Holmlund 1986:147-148]

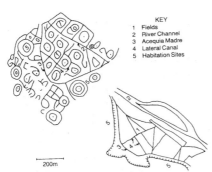

KEY
1 Fields
2 River Channel
3 Acequia Madre
4 Lateral Canal
5 Habitation Sites

200m

Petroglyph (left) compared to Map (right), Valley of Sonora, Mexico

See Irrigation for explanation.

140

Masks

(*See also* Katcinas)

GREEN

YELLOW

RED

WHITE

Pictograph, Green Mask site, Grand Gulch, Utah

The "Green Mask" glyph is approximately 15 cm wide and 20 cm high and is executed in pigments of green, yellow, red and white. Long, reddish hair hangs down on both sides of the face, and the lower portions appear as if braided and/or bound. The center "part" of the hair is yellow and red, and there appears to be green painted areas on both sides of the part. The headband on the mask is green, the forehead yellow, and the eye area is marked by a band of green. A nose band is yellow and the chin area is green with a mouth of white and yellow. [Cole 1984b:3-4]

(Below) Petroglyphs, Three Rivers, New Mexico

There is also what might be referred to as the "long mask," extended in length and divided horizontally. . . . The paw print on two . . . examples is notable. . . . The paw print and star, judging from parallel iconography among the Pueblos, could signify warrior associations.
[Schaafsma 1980:220-221]

(Left) Pictographs, Hidden Valley, Colorado

Masks are a striking feature of the paintings. . . . They occur from singly up to a group of nine. . . . Mouth and eyes are red. The nose must be imagined. Upward from the forehead reaches an area of red, often sloped like a low flat-topped cap. . . . The number of masks suggest that the(se) people indulged in a far wider range of ceremonials than is indicated by other evidence. [Daniels 1954:88]

141

Mastadon or Mammoth

• Heavy-bodied quadruped with raised trunk

Petroglyph, Moab, Utah

Near Moab, in association with mountain sheep, there is a pecked rendering of what is locally known as the "mastodon" and widely believed to be a life portrait of that extinct beast. It is a three-toed trunked animal but the brightness of the design and its lack of patina, together with the fact that the adjoining mountain sheep and accompanying initials have some patina and so are older, brand it a hoax. [Grant 1967:117]

Comment on above Petroglyph and photo of same, below right

There are two such "mammoths" near Moab, Utah. One is a short distance down river from Moab Valley in the Colorado River gorge. The other is in Indian Creek Canyon within sight of Utah 211 as that highway travels from US 163 to the Needles district of Canyonlands National Park. There are interesting arguments on both sides of the historic-or-prehistoric controversy that centers on these two petroglyphs.

On the "prehistoric" side neither petroglyph appears to be recent. Both have desert varnish built up within the chipped out parts of the glyphs. Further it is widely accepted by anthropologists and

paleontologists that early Amerinds hunted such large animals as giant bison, mammoths and giant sloths, and may even have brought about their extinction.

On the "historic" side the two "mammoth" petroglyphs do not appear to be much older, if any , than the many other glyphs nearby, glyphs that are clearly associated with the most recent stages of prehistoric creatures that did not even exist 2000 years ago. Paleontologists estimate that mammoths became extinct on this continent about 10,000 years ago. Further the oldest rock art so far discovered that is age-dated by inference as 8700 years old is simply a fist-sized rock with scratches on it.

[Barnes and Pendleton 1976:202-203]

Maze

• Circular or rectangular design of nested lines

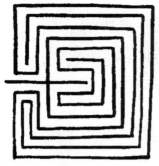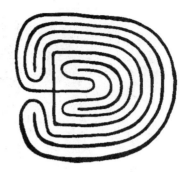

Petroglyphs, Hopi Mesas, Arizona

The whole myth and meaning of the Emergence is expressed by one symbol known to the Hopis as the Mother Earth symbol. There are two forms, the square and the circular, as shown in figures (above). There are one circular and five square symbols ranging from four to six inches in diameter carved on a rock just south of Oraibi. . . . Another is carved on the inside wall of an upper story of the ruin of Casa Grande near Florence, Arizona. The symbol is commonly known as Tapu'a (Mother and Child). The square type represents spiritual rebirth from one world to the succeeding one, as symbolized by the Emergence itself. . . . The circular type differs slightly in meaning. . . . All the lines and passages within the maze form the universal plan of the Creator which man must follow on his Road of Life; and the four points represent the cardinal or directional points embraced within the universal plan of life. . . . The symbol is said to have substantially the same meaning to other Indian tribes in North, Central and South America. The Pimas call it the House of Teuhu, Teuhu being the gopher who bored the spiral hole up to the surface of the earth for the Emergence, thus being the Spirit of the Placenta. [Waters 1963:24]

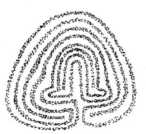

Petroglyph, Hopi Mesas, Arizona

Pecked on the more westerly of two large boulders on the trail along the west side of Shipaulovi on the terrace below the village is a curious maze called *towi'nakvi'tata*.
[Stephen 1936:1030]

(Below) Designs from Petroglyphs—Ireland (below left), from coin—Crete (middle), and from Pima (Arizona) artifact (right)

This maze symbol, exactly the same in every detail, occurs in Europe. The earliest example is on an Etruscan vase dating from the late 7th century B.C.

[Grant 1967:65-66]

143

Medicine Bag

(Above) Petroglyphs, Coso Range, California

(Below) Pictographs, Seminole Canyon, Texas

The most interesting is what we have called the "medicine bag." The first ones are quite realistic with fringed base and carrying handle. . . . Hide bags to carry the medicine bundle or collection of the shaman's sacred objects are known from many parts of aboriginal North America. Kirkland and Newcomb(1967) illustrate many examples . . . on the cave walls of the Lower Pecos River in Texas. . . . Such pouches or bags have been found scratched on pebbles from Anasazi ruins in southern Nevada.
[Grant 1968:36-37]

The shaman figures assume a distinctive form in Period 2 (figure lower left). They are usually a single shade of red, elongated and large. . . . They often lack heads, although not necessarily headdresses, and facial features are never portrayed. . . . More than half of the Period 2 shamans hold an atlatl in the right hand with the butt of a feathered dart in place against it. Suspended from the arms of about three-quarters of the figures are objects that usually resemble prickly pear pads, fringed (medicine) bags, or sticks. [Newcomb 1976:183]

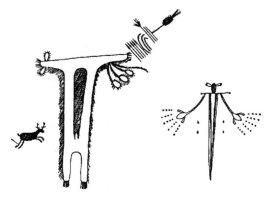

Migrations
(*See also* Spirals and Swastikas)

• Curvilinear meander, with other symbols • Double-linked spirals • Swastika

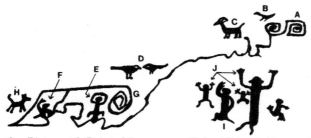

Petroglyphs, Pictograph Point, Mesa Verde National Park, Colorado

Pictograph Point is the largest and best-known group of petroglyphs at Mesa Verde. . . . The Anasazi stood on the ledge and chipped the design through the exterior desert varnish to the light sandstone beneath. In 1942 four Hopi men from northeastern Arizona visited . . . and interpreted some of the glyphs:
(A) "Sipapu," the place at which the Pueblo people emerged from the earth (near the Grand Canyon).
(B) Eagle Clan symbol indicating a separation of that clan from the other people and settlement near their point of origin.
(C) Mountain Sheep clan symbol denoting that clan's separation from other migrating people and their settlement some distance from the others' travel route.
(D) Parrot Clan symbol telling of that group taking up residence at some distance from the Mountain Sheep Clan.
[Mesa Verde Mus. Assn. n.d.:9-10]

(Below)Petroglyphs, various locations

In the migration symbols shown, the circles record the number of rounds or pasos covered, north, east, south and west. The one at Oraibi (1) shows the completed four circles, with three points covered on the return. The Chaco Canyon (2) symbol indicates two points covered and that the people are returning, as the second circle moves in the opposite direction.
[Waters 1963:103-4]

1 2

ORAIBI CHACO CANYON

(Left) Designs involved in Hopi migrations in prehistoric times

We can see now that the complete pattern formed by the migrations was a great cross whose center Tuwanasavi (Center of the Universe) lay in what is now the Hopi country in the southwestern part of the United States and whose arms extended to the four directional pasos. . . . Upon arriving at each paso all the leading clans turned right before retracing their routes. . . . The rest of the clans turned left. These minor clans did not have complete ceremonies.
[Waters 1963:113-4]

145

Mirror Images

• Anthropomorphic or abstract designs that look similar viewed normally or upside down

Pictographs (left and center) and Petroglyph (right) at Canyon de Chelly and Canyon del Muerto, Arizona

(Below) Petroglyphs near Springerville, Arizona

The double-ended or mirror figures . . . are common motifs in many parts of the world. (Left) Painted in white at site CDC-6; (Middle) Outlined in white at site CDM-2; (Right) Petroglyph at site CDC-9. . . . A curious design appears in canyon paintings and petroglyphs during this period (Great Pueblo). It is the double-headed human figure which looks the same in normal position as it does upside down.

[Grant 1978:197]

The drawing (on) the . . . left represents a cloud reflected in the water. In the drawing to the . . . right, the cloud terrace symbol formed by the figure's upraised arms is repeated upside down by his legs in the same manner as in the cloud to the left. The figure represents Panaiyoikyasi, deity of the Water Clan. The drawing under them shows four large waves of water, indicating the four migration routes to be completed by the Water Clan. [Waters 1963:64]

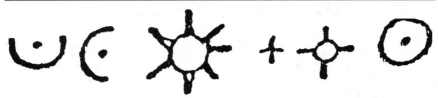

Petroglyphs at Willow Springs, Arizona

Hopi Clan Symbols for the Moon Clan (extinct) recognized by Edmund Nequatewa, a Hopi Indian.　　　　[Colton 1946:4]

(Below) Petroglyph, Hopi Mesas, Arizona

Ute shield (with) Moon and Friendship mark. "When the moon was half gone, i.e., a full moon, with our friends we slew the enemy." About 2½ feet x 2 feet, rubbed on rock.
[Stephen 1936:131]

Petroglyphs at Willow Springs, Arizona

Moon Clan; affiliated with the Star Clan; Symbols: half moon, moon cross, full moon; migrated from New Mexico; now extinct.
[Michaelis 1981:16]

(Below) Pictographs of astronomical bodies from Northern Arizona (two at left) and from Abo and Chaco (two at right), New Mexico

Possible depictions of sun, moon and star (plus one hand at right) during Supernova of 1054 A.D.
[Eddy 1981:111]

Hopi Design

Moon symbol commonly used on Hopi kachina mask.
[Colton 1949:18]

Mother of Animals

(*See also* Hocker and Water Skate)

• Hocker with a filled-in circle on each side of body • Water Skate, with two concentric circles overlaying body

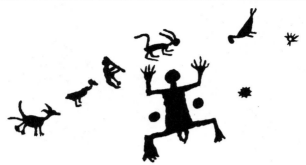

Petroglyph, Butte Site, Petrified Forest National Park, Arizona

A large female figure dominates the right side of the panel, arms raised and bent at the elbow, legs extended and bent at the knee. . . . The animals, a rabbit and an unidentified quadruped, are in sexually-receptive attitudes, with upraised tails. It is apparent that this panel is concerned with reproduction and animal increase. . . . What deity could the female figure represent? In the Pueblo pantheon, each community has a female spirit who is in charge, so to speak, of game animals: the Deer Mother of Taos; Fire-Old-Woman of Cochiti, Nambe, and Isleta, "the one asked for animals"; Chakwena Woman of Zuni; and at Hopi, Tuwabontumsi, Earth-Altar Young Woman, synonymous with Tihkuyi-wupti, Childbirth Water Woman who is mother to the antelope, deer, mountain sheep, and rabbits (Parsons 1939:178).
[McCreery and McCreery 1986:3-5]

(Below) Petroglyphs, Oak Canyon mouth (NA7136), Glen Canyon area, Utah

Informant recognition: "Mother of Animals *(Tekeowati)* on right. Usually just the head sticks up. It is sometimes seen in the night dressed all in white and peeking out and looking for you. Mother of Animals seen today as vision when thinking about game animals."
[Turner 1963:57]

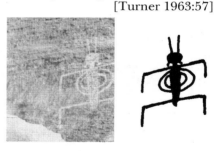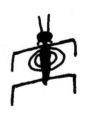

(Left) Signature of Hopi workman at archaeological site, northern Arizona, 1897

His name is Sikyahonauwuh from Walpi of the Kukute (lizard) clan; totems (include) . . . Earth-Altar Woman (Tuwapontumsi or Tihkuyiwupti, female associate of Masawuh; also called Itanu, "our mother"). [Fewkes 1897:5]

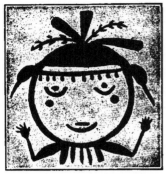

Pottery designs at Sityatki ruin, Hopi area, northern Arizona

The ancient Tewan earth goddess, Hahaiwugti, is represented above. She appears also in figure above right where her picture is painted on a ladle, the handle of which represents an ancient Tewan clown called by the Hano people Paiakyamu. [Fewkes 1919:178]

(Below) Pictograph, Betatakin Cliff Dwelling, Tsegi Canyon drainage, Arizona

Also of significance . . . are the large white circular paintings occurring with cliff dwellings. . . . Anderson (1971) suggested that these paintings may have served as integrative symbols standing for certain socioreligious institutions or affiliations. . . . Ethnographic support for this type of interpretation has been offered by Hopi elders, who feel that the large circular painting at Betatakin below is a Fire Clan symbol, the figure within representing the god Masauwu. [Schaafsma 1980:148]

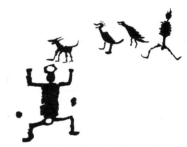

Petroglyphs, Crack-in-the-Rock Site, Wupatki National Monument, Arizona

Another possible representation of the Hopi goddess of game. [McCreery and McCreery 1986:4]

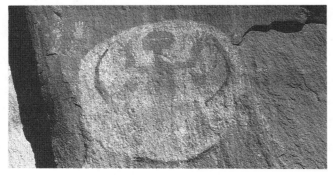

Mountain Lion

- Quadruped with ball-like feet, short ears, long tail, often doubled back over body or extended up or down

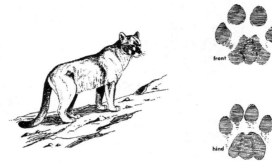

Drawings of mountain lion and front and hind paw prints

The mountain lion or puma, *Felis concolor,* at one time ranged over all of the United States . . . southward through Mexico into south America. . . . This American lion, called cougar on the Pacific Coast, is nocturnal and so secretive that the sight of one in the wild is a rarity and a choice experience.

[Murie 1954: 118]

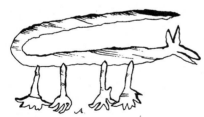

Petroglyphs on Zuni Reservation, New Mexico

Above: incised and abraded mountain lion, 25 cm x 50 cm.

[Young 1988:83]

. . . whether portrayed in rock art or a kiva mural, the mountain lion is characterized by a long tail bent over the body of the quadruped.

[Young 1988:156]

(Below) Petroglyph in Petrified Forest National Park, Arizona

Pecked animal, possibly a mountain lion on sandstone. [Grant 1967:13]

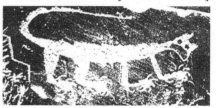

Comments

In the Mohave myth there are two totemic lion figures, helpers to Mustamho (the creator), who are known as Numeta and Hatakulya. These lion figures are present in numerous petroglyph locations. Numeta is normally depicted with his tail up in the air while Hatakulya has his tail down.

[Johnson 1986:21]

In Hopi mythology, the mountain lion is the symbolic animal of the north and is sometimes painted on the north wall of their kivas or as part of their pictographic art work. The Hopi illustration of the mountain lion is often depicted . . . with extra long bodies, necks, legs, tails and large ball-like feet.

[Johnson 1986:22]

Mountain Sheep

• Quadruped with one or two horns curving back over body • Quadruped with two horns spreading left and right

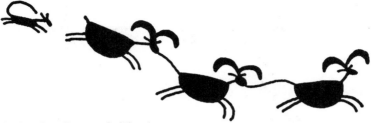

Petroglyphs, Coso Range, California

Mountain sheep (connected—see Kinship Line) with dog.
[Grant, Baird and Pringle 1968]

Comment

In northern Arizona and southern Utah, the many representations of the bighorn apparently reflect the importance this animal had for these people in their economic pursuits, and indications are that a good deal of supernatural significance was attached to the sheep, apart from their utilitarian functions. [Schaafsma 1981:26]

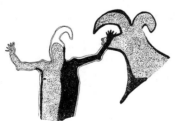

Pictographs, Cueva La Palma, Baja California, Mexico

Figure above illustrates . . . the "sackhat man" headdress. This headdress I believe is associated with a clan symbol for bighorn sheep . . . the bighorn mountain sheep shaman, whom we might call "Lord of the Bighorn Mountain Sheep," is being represented.
[Smith 1985:38-39]

Comment from the Hopi

. . . Palangwu (Red Rock Place), a great cliff near the mouth of the Canyon de Chelly (Arizona). . . . This place-name derives, of course, from the word *pangwu* for the bighorn sheep, leader of the animal kingdom. [Waters 1963:246]

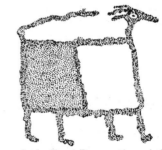

Petroglyph, Zuni Reservation, Arizona

Mountain sheep, all pecked. 45 cm x 40 cm. [Young 1988:73]

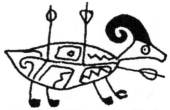

Petroglyph, Three Rivers, New Mexico

Mountain sheep pierced with arrows. [Grant 1978:192]

151

Parrot

• Bird in profile, with curved beak and triangular body, often with long tail

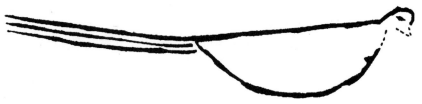

Petroglyphs, Zuni Reservation, New Mexico

Incised macaw, 15 cm x 55 cm.
[Young 1988:84]

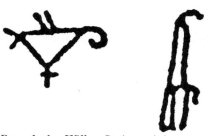

Petroglyphs, Willow Springs, Arizona

Parrot Clan symbols recognized by Edmund Nequatewa, a Hopi Indian. [Colton 1946:4]

(Below) Petroglyph, Willow Springs, Arizona

Parrot Clan; affiliated with Macaw Clan; symbol is bird with curved beak, hawk; located First Mesa; migrated possibly from Casas Grandes via Zuni.
[Michaelis 1981:15 & 18]

(Left) Petroglyphs at Pictograph Point, Mesa Verde National Park, Colorado

In 1942 four Hopi men from northeastern Arizona visited Pictograph Point . . . with this interpretion: (D) Parrot clan symbol telling of that group taking up residence at some distance from mountain sheep clan (see Migrations).
[Mesa Verde Mus. Assn. n.d.:10]

Patterned Body Anthropomorphs

• Anthropomorphs with complex designs on body

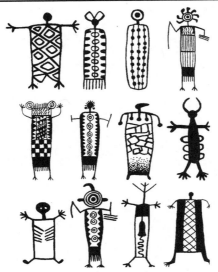

Petroglyphs, Coso Range, California

The patterned body anthropomorphs become very elaborate and a basic type occurs again and again, showing fringed skirt, painted body, feathered headdress, earrings, and carrying ceremonial objects. . . . These figures almost certainly represent the costumed principals of the sheep cult and may have been the shamans.

[Grant, Baird and Pringle 1968:39]

(Below) Pictographs, Cara Pintada, Sonora, Mexico

Fine line figures from the lower gorge. . . . Brown, red and white—largest figures about 10 inches tall.

[Grant 1976:50]

(Below) Yarn paintings done by Huichol Indians, Sinaloa, Mexico

Body patterns derived from visionary imagery are found in ethnographic examples. Deities and spirit beings in Huichol yarn paintings, such as the image of the Mother of Maize (below left) are drawn with the characteristic fill patterns of this art (Furst 1969:18).

[Hedges 1985:20]

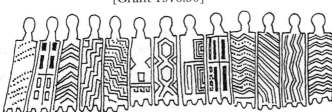

153

Phallic Figure
(*See also* Flute Player)

• Anthropomorph with phallus • Three connected down-pointing triangles

Petroglyphs, Hopi Mesas, Arizona

1. (This figure) represents *Pa-buk-e* who is said to appear in the *Wa-wac ka-tci-na* (racing *ka-tci-na*). It (the *Wa-wac*) is a foot-race in which members of the tribe are challenged to run for prizes of corn, paper-bread, and similar food, the clowns flagellating the contestants if they overtake them. They (the clowns) also have the right to tear off the clothes of those running against them. [Fewkes 1892:23]

2. The figure of a phallus . . . with a *na-tci* (cloud symbol) occurs, and is one of the most instructive which was seen. The representations of the *pou-le,* male organ, and the *la-wa,* female organ (4 above) . . . (were) found on the cliff of the first terrace below Sitcumovi.
[Fewkes 1892:20]

3. The conventional phallic symbol is sometimes three triangles side by side (with cloud symbol) . . . but may take the form of two right-angled triangles, with smaller angles adjoining. This is likewise the squash symbol. [Fewkes 1892:20, Plate II]

(Below) Petroglyphs, Newspaper Rock, Petrified Forest National Park, Arizona

. . . depiction of both male and female genitalia is found at Newspaper Rock.
[Ritter and Ritter 1972:110-111]

(Below) Kiva painting at Awatovi (room 529), Arizona

Kokopelli's associations are shown— (with) a woman, either *Kokopelli Mana* or a maiden to be seduced.
[Ritter and Ritter 1973:81 & 93]

154

Phosphenes

(*See also* Concentric Circles and Grid)

• Patterns of dots, checkerboards, grids, circles, crosses, spirals, parallel lines, etc., seen with eyes closed

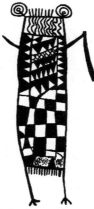
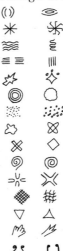

Phosphene Pattern (left) and petroglyph, Little Petroglyph Canyon, Coso Range, California

(Below) Drawings of Basic Phosphene Designs from Kellogg, Knoll and Kugler 1965:1129 in Hedges 1981:2.

The term "phosphene" refers to the images perceived by the human brain as visual images in the absence of visual stimuli. . . . Phosphenes can result from a variety of causes, including gentle pressure on closed eyes, migraine headaches, . . . fasting, physical tests of endurance, meditation, or the ingestion of hallucinogenic substances (Oster 1970; Siegel 1977; Walker 1981). . . . As an example (above figures) illustrate a phosphene pattern consisting of combined and super imposed checkerboards and arrays of triangles (Walker 1981:176) reminiscent of the patterns on the body of an anthropomorph from Little Petroglyph Canyon.

[Hedges 1981:6]

a) ⟨image⟩

b) ⟨image⟩

c) ⟨image⟩

d) ⟨image⟩

e) ⟨image⟩

(Left) Phosphene Designs and Petroglyphs

a) phosphene (Oster 1970:82); b) Tukano art (Reichel-Dolmatoff 1978: Plate IV); c) rock painting, Montevideo, Baja California; d) petroglyph, South Mountain, Arizona (original oriented vertically); e) petroglyph, Grapevine Canyon, Nevada. [Hedges 1981:4]

Pit and Groove

- Multiple pits on rock surface
- May include grooves among the pits

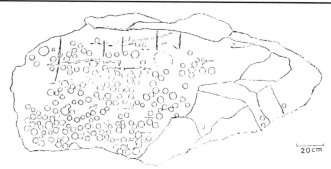

`20cm`

McCardle Flat petroglyph boulder, (Sha-511), northern California

These rock art complexes were major public sites with the cupped rock art an integral part of the societal structure and ritual. Ethnographic evidence suggests that the art was associated with the World Renewal (or related) ceremonies that restored the world to the way it was meant to be by the spirit people, caused the salmon to spawn upstream, restored acorns and pine nuts, made people happy, prevented disease and affected the weather (Palmer 1980:17).

[Nissen and Ritter 1986:73]

Comment on pit and groove petroglyphs

The pit-and-groove style is distributed widely through many parts of the western United States and is well represented at several west-central Nevada sites (Heizer and Baumhoff 1962:209, pls. 1,3). Boulders with this type of modification may be covered with random depressions or pits, usually an inch or two in diameter but sometimes as large as 12 inches across (fig. 2d). When grooves also occur, they may connect or encircle pits. Dates from 5500 B.C. to as late as 500 B.C. are suggested for this style.

[Schaafsma 1986b:216]

Comment on pit and groove petroglyphs

Associated with the migration legends of the Luiseno (and Diegueno?) were the songs of Munival, songs of the landmarks of ancestors, which relate the travels of the people and the different places where they stopped. According to Dubois when the people scattered from Ekvo Temeko, Temecula, they were very powerful. When they got to a place they would sing a song to make water come there and would call that place theirs; or they would scoop out a hollow in a rock with their hands to have that for their mark as a claim upon the land . . . (Dubois 1908:158). [Minor 1975:15]

Comment on pit petroglyphs in Tomatlan Valley, State of Jalisco, west Mexico

. . . the most frequently found design is the pit . . . 10,230 identified (out of 12,104 [petroglyphs] on 339 rocks . . .). The pit seems to be the most simple form for representing the eye or the face of the solar god, even the sun itself. In its more elaborate form the engraved pit is found in the center of one or more concentric circles, in the center of a spiral, or as the head of an anthropomorphic figure. (Translated by the author.) [Mountjoy 1987:41]

Planetarium
(*See also* Stars)

• Crosses, usually painted, of varying sizes, on the roof of cave or shelter

Pictographs, site CWC-13, Cottonwood, Canyon, Arizona

. . . the most intriguing subjects of the Navajo artists are the star panels, for they appear to be unique in North American rock art. . . . Besides appearing on the ceilings of caves, the stars and constellations are pictured on ceremonial prayer sticks, gourd rattles, and particularly in the sandpaintings. . . . The Navajo recognize thirty-seven constellations, many of which are involved in their legends and mythology. . . . Although many of them bear no resemblance to the Anglo constellations, (those) . . . that agree exactly or partially with the Anglo constellation system are *nahookos bikha'i*, the Big Dipper; *nahookos ba'aadi*, Cassiopeia; *hastiin skai*, with *dilyehe*, the Pleiades; *so'hotsii*, Aldebaran; and *atseets'osi*, a star in Orion. *Yikaisdahi*, is the Milky Way, and *atsetso*, is a star in Scorpio. . . . According to Britt (1973:11) the traditional Navajo are extremely reluctant to talk about the star panels to Anglo-Americans, for they are considered special places. Modern-day shamans still visit the planetarium sites to leave offerings.

[Grant 1978:228-231]

(Below) Pictographs, LA 3022, Panel 6, Navajo Reservoir area, New Mexico

"Planetarium" of star and flower forms . . . painted primarily in red, orange and red and, rarely, in black and blue.

[Schaafsma 1963:Plate III]

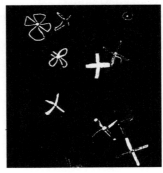

(Below) Petroglyph, Largo Canyon, New Mexico

Navajo Ye'i petroglyph with star formation on the left side of the face. Black God was often depicted with such a star arrangement, usually the Pleiades. [Grant 1978:229]

157

Plumed Serpent *(See also* Cross, Quetzalcoatl, and Star)

• Snake with plume on head or may have human-like head with tall hat

Pictograph, Hueco Tanks, Texas

The chief deity of the great Toltec civilization of Mexico (A.D. 856-1250) was Quetzalcoatl, god of learning. Legends describe him as a bearded white man who taught the Toltecs the arts, the calendar, writing, and law. Quetzalcoatl is often personified as a feathered rattlesnake and representations of him adorn many ruins of temples. . . . The Aztecs (A.D. 1324-1521) took over the Toltec culture and continued the cult of Quetzalcoatl. . . . The Hopi knew him as *Palulukon* or Water Serpent, and in Zuni mythology he was *Kolowisi*, the Great Horned Serpent, guardian of the springs and streams.

[Grant 1967:57]

Petroglyph, Segi Canyon, Arizona

. . . a rock drawing . . . shows Baho-li-kong-ya, a god, the genius of fructification, worshiped by the living Moki (Hopi) priests. It is a great crested serpent with mammae, which are the source of the blood of all the animals and of all the waters of the land.

[Mallory 1893:476]

(Below) Pictograph, near Ft. Hancock, Texas (upper) and petroglyph, near Cook's Peak, New Mexico (lower)

Diverse forms of what are believed to be northern variants of Quetzalcoatl. [Schaafsma 1980:7]

(Below) Petroglyph, San Cristobal, New Mexico

. . . each shows a personage struggling with a serpent. . . . They recall the Hopi drama given in the kivas each year in March . . . which usually consist of six or seven acts before large painted screens. . . . There are realistic struggles between large horned serpent-effigies (the great serpent *Palulukon*) and naked Mudhead Clowns. [Sims 1949:7]

Pottery or Textile Designs

(*See also* Blanket Designs)

• Complex designs, usually seen on pottery or textiles

Red and white kiva paintings, CDM-174, Canyon del Muerto, Arizona

The only paintings that show good craftsmanship during the Great Pueblo era are some elaborate rectilinear abstract patterns that reflect weaving and pottery designs.
[Grant 1978:197]

Comment on pottery designs in rock art

. . . at Zuni . . . first . . . they recognized them as textile or pottery designs; . . . second some regarded them as "done by our ancestors" to communicate "some sort of message that we no longer understand."
[Young 1982 in Schaafsma 1987:27]

(Below) Petroglyph, North Mesa, Wupatki, Arizona

Textile pattern as petroglyphs. . . . The overall "limitless" design of the . . . petroglyph is typical of Sinagua weaving. [Schaafsma 1987:20]

(Below) Petroglyphs, Four Corners area

The curious designs given (below) have a very perceptible resemblance to many of the figures used in the embellishment of pottery.
[Jackson and Holmes 1876:402]

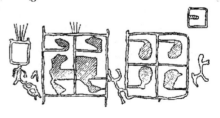

(Below) Designs from textile fragment, Camp Verde, Arizona

Textiles such as this Sinagua brocaded cotton cloth fragment from a site near Camp Verde, Arizona, may have inspired petroglyphs such as the one on North Mesa near Wupatki (left). [Schaafsma 1987:25]

159

Power Lines

(*See also* Kinship Lines)

• Wavy lines, emanating from anthropomorphs, often connecting with other figures

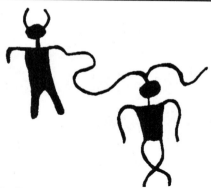

Petroglyphs, Canyon de Chelly, Arizona

These petroglyphs with connecting, or "power" lines are common in the Mesa Verde area, although there are only a few examples from the Great Pueblo period in Canyon de Chelly. [Grant 1978:212]

(Below) Pictographs, Seminole Canyon, Texas

In general . . . these figures (Period 4) . . . use . . . streams of red dots or lines (which) accompany three of them. In one case, force lines issue from an atlatl and cut through a prone figure (Kirkland and Newcomb 1967:67, Plate 28, No.1).
 [Newcomb 1976:185]

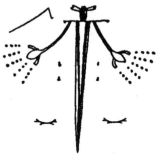

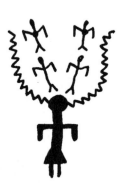

Pictograph, Canyon de Chelly, Arizona

This unusual Modified Basket-maker-Developmental Pueblo painting at site CDC-78 possibly represents power lines and spirits emanating from the head of a shaman. [Grant 1978:247]

Comment on power lines

Of the Period 3 shamans, 50 percent have wavy or sinuous lines associated with them. These commonly have been interpreted as snakes, but there are some indications that they are "force lines," extending from a shaman to his human or animal subjects.
 [Newcomb 1976:184]

160

Praying Person

• Anthropomorph with both hands upraised

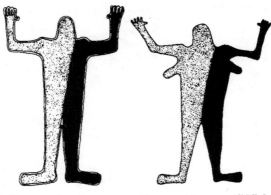

Male and Female Pictographs, Cueva Pintada, Baja California, Mexico

The arms raised upward are a symbolic form of worship.

[Dunne 1968:253 in Smith 1966b:108]

Comment in A.D. 1535-36 by de Vaca on the Indians of northern Mexico

. . . when the sun rose, they opened their hands towards the heavens with a great shouting and then drew them down over all of their bodies. They did the same again when the sun went down.

[Hodge 1907:106-8 in DiPeso 1974 (4):60]

Petroglyph at Pictograph Point, Mesa Verde National Park, Colorado

Figure above shows the old wu'ya, Salavi, leader of the Badger Clan. His arms are upraised because he is an important, holy man and has nothing to hide. He keeps good thoughts and is on guard against evil, day and night, as shown by the symbols of the sun and moon over his head. [Waters 1963:50]

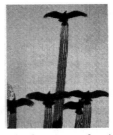

Turkey buzzards atop cardon in Baja California, Mexico

When the sun's rays begin to warm the morning air, turkey buzzards . . . can be seen perched atop the *cardon* (a cactus), heating their bodies and drying their wings. To the Cochimi, who worshiped *Ibo*, the sun god, with their uplifted arms . . . , they saw these birds as giving thanks to *Ibo* with their outstretched wings. [Smith 1985:41]

161

Pregnancy
(*See also* Birthing)

• Anthropomorph or zoomorph with small figure within body

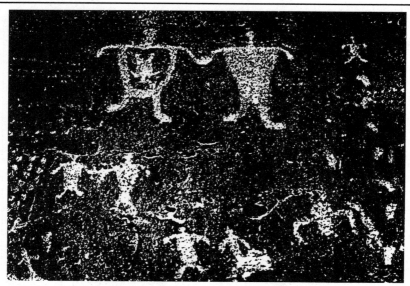

Petroglyphs, Gobernador Basin, New Mexico

A notable group of anthropomorphs occurs in a Gobernador Canyon Site. Dominating the panel are a pair of large human figures holding hands. A male and female seem to be represented. That the female figure is pregnant is indicated by the small upside-down form of a child within the torso. The couple is partially surrounded by smaller anthropomorpohic representations, and to the right are two series of small, perhaps children's footprints. The theme present here is reminiscent of a family scene in the Navajo Reservoir District, and it seems possible that petroglyph making in these instances was connected with fertility ritual.
[Schaafsma 1972:6]

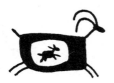

(Below) Petroglyph, Coso Range, California

A sheep within a sheep could be an attempt to depict pregnancy.
[Duffield 1981:53]

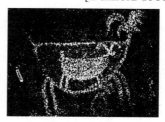

Comment on pregnancy in rock art

Hollow-bodied anthropomorphs (and zoomorphs) are commonly interpreted as pregnancy or fertility depictions. . . . (See Fig. A-55+56 under Birthing.)
[Wallace and Holmlund 1986:144]

(Left) Petroglyphs, Coso Range, California

Possible pregnancy depiction.
[Grant, Baird and Pringle 1968:21]

162

Quetzalcoatl

(*See also* Star, Cross, and Plumed Serpent)

• Single or double outlined cross
• Snake with head plume • Human head with tall hat; may have snake body

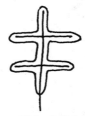

Petroglyphs, State of Sinoloa, Mexico

The most interesting type (of crosses) is that found at El Tecomate and at the foot of the Majada de Arriba, for these undoubtedly are similar to those crosses which in Tula, Hidalgo and other places (in Mexico) represent Quetzalcoatl under the designation "The Morning Star" or "Venus."

[Ortiz de Zarata 1976:62]

Comment on the outlined cross

(Quetzalcoatl) . . . is also symbolized by the morning star, often in the form of an outlined cross (Villagra 1954:80).

[Schaafsma 1980:238]

(Below) Petroglyphs, Three Rivers, New Mexico

Other masks with forward-reaching horns may represent special facets of this deity (Quetzalcoatl). The petroglyph of a death's head with such a horn (below left) suggests the Mexican portrayals of Quetzalcoatl with the Death God, Mictlantecuhtil, as his twin (Anton 1969:70). (Below right) may depict Quetzalcoatl in his alternate form as Ehecatl, the Wind God, identifiable by his projecting mask, which may take the form of a bird's beak (Caso 1958:22).

[Schaafsma 1980:217, Fig. 178 & 167A]

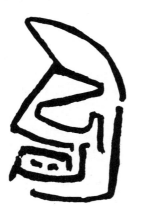 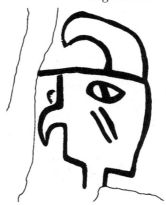

Rabbit

(Above and below) Petroglyphs, Oakley (Willow) Springs, Arizona

Fig. 1261 (above and below), comprising many of the Moki (Hopi) inscriptions at Oakley Springs, Arizona, is presented by Mr. G.K. Gilbert. These were selected from a large number of etchings for the purpose of obtaining the explanation, and they were explained to him by Tubi, a chief living at Oraibi, one of the Moki villages. Above: three jackass rabbits. Below: cottontail rabbit.

[Mallery 1893:749]

(Below) Pictograph, Bon Echo Park, Canada

. . . Dewdney identifies the motif as "rabbit-man" and suggests that, if the pictograph is Ojibwa in origin, one could make out a case for its representing Nanabozho . . . or Nanabush. . . . In Algonkian folklore and mythology he is . . . enigmatic. . . . Nanabush is a culture hero who taught man all his technological inventions such as arrow-points, snares, traps, and nets and the arts of trapping.

[Vastokas and Vastokas 1973:71]

(Below) Signature of Hopi workman

Tanakwaima (from Oraibi). Tabo gens (clan); totem, rabbit.

[Fewkes 1897:5]

(Below) Petroglyphs, Willow Springs, Arizona

Clan symbols—rabbit and rabbit ears—recognized by Edmund Nequetewa, a Hopi Indian.

[Colton 1946:4]

Rain

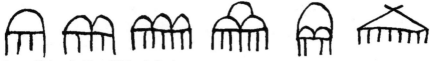

Petroglyphs, Oakley (Willow) Springs, Arizona

The Moki (Hopi) drawing for rain, i.e. a cloud from which the drops are falling is given in six variants taken from a petroglyph at Oakley Springs. [Mallery 1893:701]

Petroglyph, Hopi Mesas, Arizona

An ancient *Hu-mis-ka-tci-na* tablet (*na-tci*) is represented by a single pictograph found on a boulder on the east side of the trail to Hano. . . . In the ancient *Hu-mis-na-tci* the rainbow symbol occurs as in the Zuni. The *yok-i* or symbolic lines representing rain (at bottom) add new evidence to the statements of the Indians that a *na-tci*, and in fact the terraced tablet, is in reality a form of rain cloud.
[Fewkes 1892:19]

Hopi Symbol, Northern Arizona

Whirlwind signifying the coming of rain. [Viele 1980:6]

(Below) Face Painting, Huichol Indians, State of Sinaloa, Mexico

Face Painting of Grandfather Fire. . . . The descending parallel lines on the cheeks are tail-feathers of the royal eagle . . . and those below are raindrops.
[Lumholtz 1900:198]

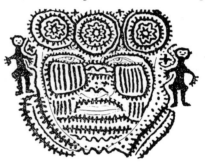

(Below) Pictograph, Shelter Rock, southern California

On the ceiling at the extreme eastern end of Shelter Rock is an element which appears to be a rain symbol, with seven lines descending from a horizontal line that may serve as the "sky line" from which rain can descend.
[Rafter 1987:29-30]

Rainbow

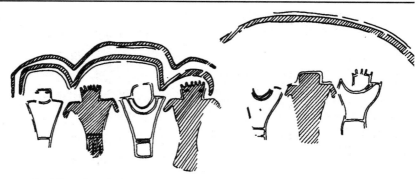

Pictographs, Horseshoe (Barrier) Canyon, Utah

Rainbow imagery at San Rafael sites (Schaafsma 1971:fig. 42, 1980:fig. 122) may symbolize a bridge between earth and sky.
[Schaafsma 1986b:226]

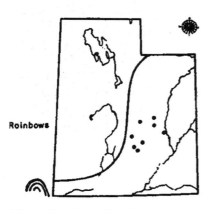

Map of location of rainbow symbol sites in Utah

Within the Fremont area, rainbow motifs are found only in that portion of the Colorado Plateau identified with the San Rafael Fremont.
[Castleton and Madsen 1981:173]

Comment on rainbow

The rainbow is a deified animal having the attributes of a human being, yet also the body and some of the functions of the measuring worm. . . . As the measuring worm consumes the herbage of the plants . . . so the rainbow which appears only after the rains is supposed to cause a cessation of the rains.
[Mallery 1893:612]

RAINBOW

RAINBOW

Symbols commonly used on kachina masks

[Colton 1946:18]

166

Rain God or Tlaloc

• Goggle-eyed anthropomorph, often with design on body • Vertical design of connected rectangles, often with "eyes"

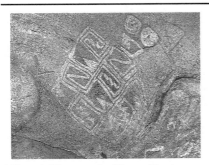

(Above) Pictograph, Hueco Tanks, New Mexico
(Below) Petroglyph, near Vado, New Mexico

Petroglyph, Alamo Mountain, New Mexico

What can be called "classic" Tlaloc or Rain God types in the eastern Jornada Style are abstracted anthropomorphic designs consisting of a trapezoidal or rectangular head above a similarly shaped, larger block representing the body (above and below). Their outstanding feature, in addition to their shape, is the large round or square eyes that occupy the top half of the head. The lower half may be solid or filled with vertical hachuring or geometric designs. The appendageless torso is commonly covered with decorative geometric motifs incorporating opposed stepped elements and angular blanket motifs.
[Schaafsma 1980:207-8]

A single distinctive Tlaloc at Alamo Mountain carrying a staff and wearing a rain kilt is a complicated design with Mexican stylistic affinities.
[Schaafsma 1980:208]

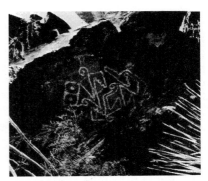

Petroglyphs, near Cook's Peak, New Mexico

The goggle-eyed figure, so prevalent in the rock art of the Jornada region, is depicted in abbreviated form at the Mimbres sites. His presence is signified by the eyes along or eyes attached to striking blanket motifs. This figure is believed to be a northern version of the Mesoamerican Rain God, Tlaloc.
[Schaafsma 1980:202-3]

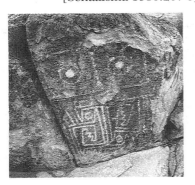

167

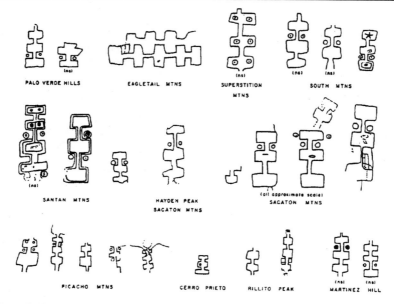

PALO VERDE HILLS EAGLETAIL MTNS SUPERSTITION MTNS SOUTH MTNS

SANTAN MTNS HAYDEN PEAK SACATON MTNS (all approximate scale) SACATON MTNS

PICACHO MTNS CERRO PRIETO RILLITO PEAK MARTINEZ HILL

Petroglyphs, from 11 sites in southern Arizona

Pipettes (above) are now known from throughout the range of the Hohokam with examples discovered at Gila style petroglyph sites southeast as far as Charleston on the San Pedro River, west to Painted Rocks, north to the Phoenix Basin, and south to the Tucson Basin. . . . Interpretation at present remains highly conjectural, although one hypothesis is currently under consideration. The significance attached to the design's spatial distribution within and between sites leads us to suspect that it might represent or relate to a deity significant to the Hohokam. With its rectangular box-like form and common eye-like circles, we see some resemblance to Tlaloc the goggle-eyed rain god of Mesoamerica. Given the occurrence of much clearer Tlaloc representations in the glyphs of the Jornada Mogollon to the east in New Mexico and Texas (Schaafsma 1980:203), where they occur at nearly every large site, it does not seem unreasonable to find a stylized form incorporated into Hohokam culture, particularly since other Mesoamerican traits have been documented (Haury 1976).
[Wallace and Holmlund 1986:151]

Phosphene Designs and Petroglyphs

a) phosphene (Oster 1970:82); b) Tukano art (Reichel-Dolmatoff 1978: Plate IV); c) rock painting, Montevideo, Baja California; d) petroglyph, South Mountain, Arizona; e) petroglyph, Grapevine Canyon, Nevada.

[Hedges 1987:20]

Rattle

• Vertical line bisected with line(s) or oval(s), usually carried by anthropomorph • Single or double ovals on vertical line

Puerco Ruin, Petrified Forest National Forest, Arizona

The human figure on the right may be holding a mace or wand; the one on the left may be holding a rattle or an abbreviated version of a mace or wand.
[Ritter and Ritter 1973:72]

Petroglyph, San Christobal, New Mexico

A . . . musician is shown shaking two rattles, a design not often found in the rocks.
[Sims 1949:Plate XIV]

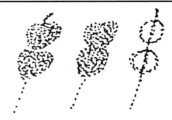

Petroglyphs, near Overton, Nevada

Double-gourd rattle, symbolizing corn meal. [Perkins n.d.]

(Below) Drawing of water rattles (three items at left) and gourd rattle (item at right), Hopi Mesas, northern Arizona

Si'mo produced some rattles, small globular gourds (below right), these he set beside Wi'nuta. Beside Si'mo are a (corn) meal tray and a very curious water rattle, *pa'aya* (below left). The four discs of gourd (*tawi'ya*) represent the four underworlds and are called *na'liyum ki'hu naach'vee*, four houses superincumbent. Each disc is double, i.e. two discs are sewed together. They are held in place on the rod with a thong of deerskin. At the back of the discs is attached a slender crook with shells . . . as a rattle. . . . This, Si'mo says, is to typify the roar and commotion of the waters at the early *si'papu*. Between this crook and the discs is a *hewakinpi* (*tumo'ala* is the pod they grow on), on an eagle wing feather. These, he says, are to hook the clouds this way (to Walpi) from all directions.
[Stephen 1936:772-3]

169

Red Ant

• Vertical line with dot head and dot body • Vertical line with "V" at top and circles below

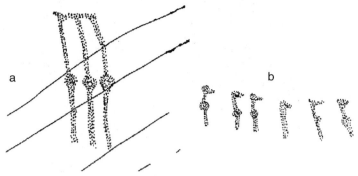

a

b

Comparisons of possible Red Ant Clan signs: a) Gold Butte Road, Nevada; b) Willow Springs, Arizona

This design (a) bears a close resemblance to the glyph of the Hopi Red Ant Clan, located at Willow Springs, Arizona (b).
[Bock and Bock 1983:38]

(Below) Petroglyphs, Willow Springs, Arizona

Red Ant Clan. Clan Symbols near Willow Springs recognized by Edmund Nequatewa, a Hopi Indian. [Colton 1946:4]

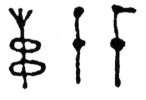

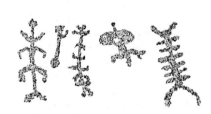

Petroglyphs, Zuni area, New Mexico

. . . red ants and other stinging insects. According to many Zunis, a panel of insect petroglyphs at the Village of the Great Kivas site was carved there for purposes of warfare. . . . They said the panel depicted poisonous insects that were carved on the rocks by the war chief so that they would sting the enemies of the Zunis.
[Young 1988:162 & 221]

(Below) Petroglyphs, Willow Springs, Arizona

Red Ant Clan symbols.
[Michaelis 1981:16 & 18]

River

(*See also* Snakes and Maps)

- Meandering line in complex design
- Snake-like figure, possibly with head

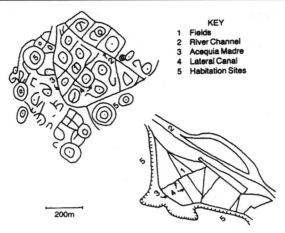

KEY
1 Fields
2 River Channel
3 Acequia Madre
4 Lateral Canal
5 Habitation Sites

200m

Drawing of a petroglyph (left) on boulder on Sonora River, Sonora, Mexico and drawing from aerial photograph (right), with number 2 indicating Sonora River channel in both drawings

Overlooked since it was first reported in an obscure Mexican publication in the early 1950s (Sandomingo 1955:352-355), the "map," found on the edge of the flood plain in the extreme northern end of the Valley of Sonora, a few kilometers north of Banamichi . . . does bear a strikingly similar likeness to the portion of the valley immediately surrounding the location of the glyph as seen from above. . . . Especially evident are the accurate locations of the main river channel, the *acequia madre* or principal irrigation ditch, fields, and the adjacent permanent habitation sites. The actual locations of fields are indicated on the glyph by dots within circles. This particular iconographic motif has been interpreted as maize, beans, or squash plants in another part of Mexico (Mountjoy 1982:119).

[Doolittle 1988:46-47]

(Below) Drawing of design on stone tablet belonging to Bear Clan, Hopi Mesas, Arizona

The front of the larger, second Bear Clan tablet (below) was marked with a cornstalk in the center, around which were grouped several animals, all surrounded by two snakes, and in each corner was the figure of a man with one arm outstretched The two snakes symbolized the two rivers that would mark the boundaries of the people's land (the Colorado and the Rio Grande Rivers).

[Waters 1963:32]

171

Petroglyph, Hopi Mesas, Arizona

On the side of the cliff just under Sitcumovi there is one of the few full-length figures found among the pictographs (sic) of this neighborhood. It represents *Pa'-buk-e*, who is said to appear in the *Wa-wac'-ka-tci'-na*. In the representations of the racing or *Wa'-wac* which I have seen no characters of this kind appeared. (The *Wa'-wac* is celebrated by a priesthood known as the *Tcu-ku'-wymp-ki-ya* or clowns, aided by a variety of *Ka-tci'-nas*.) It is a foot race in which members of the tribe are challenged to run for prizes of corn, paperbread, and similar food, the clowns flagellating the contestants if they overtake them. They also have the right to tear off the clothes of those running against them, or of cutting off a lock of his hair if he can overtake his opponent. [Fewkes 1892:23]

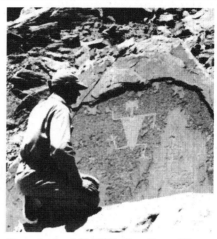

Petroglyphs, NA7238, San Juan River, Glen Canyon area, Utah

Style 4 (A.D. 900-1300) . . . Informant recognition: "Running like everything, person running a race."
[Turner 1963:50]

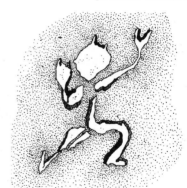

Petroglyph, Long House, Frijoles Canyon, Bandelier National Monument, New Mexico

This seemingly running stick figure pecked on the cliff face above Room 127-3 . . . probably depicts a kachina, perhaps a mudhead.
[Rohn et al. 1989:134]

(Left) Petroglyph, Hawley Springs, California

[Laird 1984:330]

172

Sandals
(*See also* Footprints)

• Foot-shaped designs, often with left and right shown; some have interior patterns

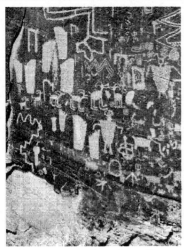

Petroglyphs, Smith Fork Bar, Glen Canyon, Utah

The carefully delineated patterns of sandal tracks, both the plain solid types and those in outline with decorative interior patterning, indicate an interest in aesthetic effect. [Schaafsma 1980:138]

Petroglyphs, Cha Canyon mouth, Glen Canyon, Utah

Style 4 is . . . definitely associated with Pueblo II-III pottery types. . . . Among others, designs include: . . . left and right hand and footprints . . . paired sandals.
 [Turner 1963:6-7]

(Above and below) Photographs of Basketmaker sandals from Canon del Muerto and Marsh Pass, Arizona

The sandals were flat, without uppers, square across the toe and rounded at the heel. They were held in place usually by a single toe-loop and a heel-loop, with a string passing from loop to loop around the ankle.
 [Amsden 1949:53-54]

(Below) Petroglyph, Zuni Reservation, Arizona

Figure 29. . . . footprints: . . . pecked, 15 cm x 25 cm. [Young 1988:72]

173

Shaman
(*See also* Bird-Headed Humans, Curing, and Patterned Body Anthropomorphs)

• Anthropomorphs with horns or special headdresses

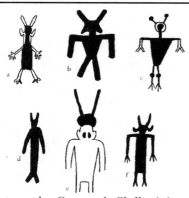

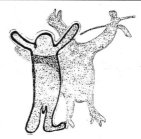

Pictograph, Cueva Pintada, Baja California, Mexico

Pictographs, Canyon de Chelly, Arizona

Many of the horned figures so common in rock art in many parts of the world certainly represent shamans. The idea is very ancient, first appearing in the Paleolithic caves of southern France. . . . Possible shamans wearing bighorn sheep horns appear in the petroglyphs of some Great Basin Shoshoneans (below) (Grant et al. 1968:40).
[Grant 1978:206]

The idea of magical flight, where the shaman flies like a bird, spreading his arms as a bird does its wings, is best illustrated at Cueva Pintada. The painting (above) shows the dynamic transformation of the man into bird. The blending of the two figures into one can be felt by the most casual observer. The painting is truly imagination in motion.
[Smith 1985:40]

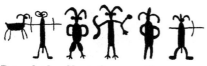

Petroglyphs, Sheep Canyon, Coso Range, California
[Grant et al. 1968:40]

Pictograph, Wild Horse Canyon, Utah

Ojibwa shamanistic symbols

Left . . . a spirit or man, enlightened from on high, having the head of the sun. Others are symbols for shamans. [Mallery 1893:474]

At first glance it is only a bird. . . . Yet it is more than just a bird. First of all it is connected to the ground by a long serpentine tail (which) is seen to end in two human legs with feet. The shaman then has his feet on the ground. He walks among us like ordinary men, but he has the . . . ability to leave this world and soar to worlds beyond.
[Hedges 1985:91]

174

Shell

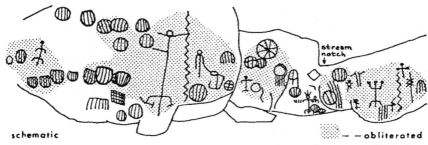

schematic — — obliterated

Petroglyphs, Tinaja Romero, Sierra Pinacate, Sonora, Mexico

(At Tinaja Romera in the Sierra Pinacate, Sonora, Mexico) . . . a most striking pattern stands out from all the rest (of the petroglyphs) representing typical Hohokam figures of snakes, humans, lizards, a zigzag, circles, a cross, etc. This, a shield-like outline containing vertical lines either parallel or radiating from a basal point on the circumference of the outline, is unlike any seen elsewhere in Hohokam territory. When Helen Hayden suggested that the figure might perhaps be that of a cardium or pecten shell (which certainly it most nearly resembles in modern eyes) the possibility that Tinaja Romero was a watering place on the Hohokam shell transportation route from the Gulf of California came immediately to mind. [Hayden 1972:76]

(Referring to Hayden's shell interpretation above) this is an intriguing hypothesis, but the higher degree of patination on the gridirons (shells) than on the Hohokam work on the same panel . . . argue against it.
[Schaafsma 1980:42]

(Below) Petroglyphs, San Blas, State of Nayarit, Mexico

Around San Blas, the persistent name for these designs is *caracoles* (spiral shells), and one petroglyph(bottom row, second from right) does look somewhat like a snail with a shell.
[Mountjoy 1974:27]

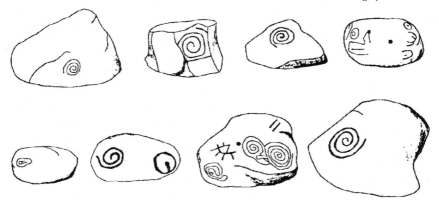

175

Shield

• Circle or oval, with interior design, often with head, legs, and spear shown around edge • Design in circle, oval, square, or rectangle

(Left to right) Petroglyphs and pictographs, Canyon del Muerto Arizona; Canyon de Chelly, Arizona; Writing-on-Stone Park, Alberta, Canada; and Grapevine Canyon, Nevada

One shield figure about three feet in diameter at Great Pueblo site CDC-229 is similar in size and style to several large shield figures at Bat Woman House and at Betatakin in the Tsegi Canyon region (Schaafsma 1966:13,16). These examples suggest that the shield idea had entered the Kayenta region at the end of the Great Pueblo period.

[Grant 1978:213]

(Below) Progressive stylization: shield motif

Symbols are often a shorthand and may be an obscurant which only the "learned" can interpret. . . . The shield-bearing figure is another example. To serve as a shorthand . . . the illustrated elements need to have some attributes which will prevent misidentification: 1) legs or appendages, or 2) designs on the shield. [Lee and Bock 1982:28]

(Below) Petroglyphs, Coso Range, California

The Late Period abstracts are chiefly confined to the handsome shield patterns. We have called them shields for want of a better term, but what they represent or why they were made is unknown.

[Grant et al. 1968:22]

176

Petroglyph, Hopi mesas,.Arizona

It is very common to find shields depicted on the rocks by the Tusayan pueblo people. A variety in form among these and a somewhat different symbolic decoration is known to me. Of the circular form the most elaborate (Pl. II, fig. 20 above) has the whole interior occupied by a cross with bars of equal length, in each of the four angles of which are to be seen a circle, the friendship sign and two smaller crosses. A face with a single *a-la* or horn is appended to the rim. The cross is the symbol of the sky god, *Co-tok-i-nung-wuh*, and has been observed by me on shields introduced in the *Ma-lo-ka-tci-na* dance at Cipaulovi.

[Fewkes 1892:23]

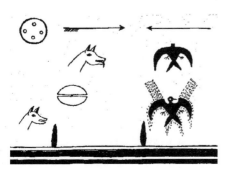

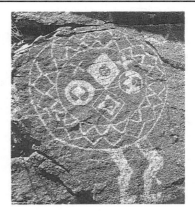

Petroglyph, Comanche Gap, Galisteo Basin, New Mexico

Large shield bearer—both star and sun symbolism are present on the shield.　　　[Schaafsma 1980:274]

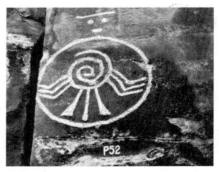

Petroglyph, Dry Fork Valley, Utah

Abstract shield figure, Classic Vernal style.　　　[Schaafsma 1980:174]

(Left) Kiva mural, Sikyatki, Arizona

Over the left (knife) is drawn the head of a coyote. Over the right (knife) is a swallow with V-shaped lines of rain falling upon it and water dripping from its wings and tail. . . . The oval with the line thru its center represents a *taweyah*, a magic shield upon which people could travel through the air.

[Waters 1963:101]

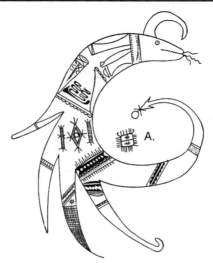

Painted design on Sikyatki bowl, Hopi Mesas, Arizona

The rectangular figure (A) that accompanies a representation of a great horned serpent may be interpreted as the shrine house of that monster, and it is to be mentioned that this shrine appears to be surrounded by radial lines representing curved sticks like those set around sand pictures of the Snake and Antelope altars of the Snake ceremonies at Walpi (Hopi Mesas).
[Fewkes 1903:161]

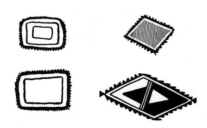

Further pottery designs at Sikyatki, Hopi Mesas, Arizona

General forms of . . . shrines.
[Fewkes 1903:161-162]

(Below) Petroglyphs, Hopi Mesas, Arizona

The device is an enclosure, or pen, in which ceremonial dances are performed. [Mallery 1893:746]

Comment on use of Navajo rock art sites as shrines in Gobernador Basin, New Mexico

It has been hypothesized that Gobernador Phase rock art sites functioned as shrines (Schaafsma 1963:64-65). Their sacred nature is implicit in both the subject matter and the use patterns, and their separateness from living areas is in keeping with this interpretation. There is a small amount of ethnographic evidence to confirm the idea that rock art sites, at least in certain instances, are regarded as holy places by the Navajo (Britt 1973a; Gardner 1940; Schaafsma 1963; Watson 1964).
[Schaafsma 1980:310]

Sipapu or Sipapuni or Place of Emergence

• Double-linked spiral • Rectangle with interior design

Petroglyphs, Pictograph Point, Mesa Verde National Park, Colorado

In 1942, four Hopi men from northeastern Arizona visited Pictograph Point and interpreted some of the glyphs. The following gives their interpretation.

A. "Sipapu," the place at which the Pueblo people emerged from the earth (near Grand Canyon).

[Mesa Verde Museum Assn. n.d.:9-10]

Kiva Mural, Kuaua ruins, west of Bernalillo, New Mexico

Above figure symbolizes the *sipapuni*, the Place of Emergence. The dark cloud terrace above represents the male power possessed by the boy twin, and the light cloud terrace to the left, the female power possessed by the girl (in the myth scenes being shown in the murals).

[Waters 1963:77-78]

(Below) Kiva mural, Kuaua ruins, west of Bernalillo, New Mexico

The *sipapuni* is shown again in the figure below at the feet of the girl who is carrying out part of the ritual developed by the Awl Clan.

[Waters 1963: 77]

179

Snakes (*See also* River, Lightning, and Diamond Chain)

• Wiggly line, with or without head at one end

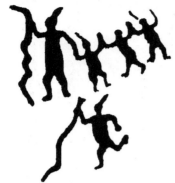

Petroglyphs, Cieneguilla, New Mexico

One (petroglyph) clearly represents a snake dance. A snake priest holds in his right hand a long snake, taller than himself. To his left three smaller acolytes hold each other's hands and form a chain with the snake priest, in a dancing attitude . . . we are witnessing a simplified representation of a snake dance somewhat like that practiced by the Hopi Indians.
[Renaud 1938:46]

(Below and below right) Drawings of Altars, Hopi Mesas, Arizona

Conventionally the pictured form of the snake, without the forked tongue, represents lightning; when the tongue is expressed, it represents the reptile.
[Stephen 1940:30]

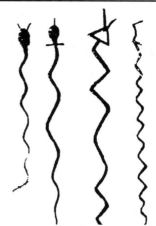

Petroglyphs, Hopi Mesas, Arizona

Figures of the lightning snakes, often called by the same name as that just described, are very common among the pictographs on the first mesa. One of the largest of these is ten feet long, the lines being incised an inch deep. This lies on the south of Hualpi, and is a very good example of rock figures. The head is triangular, with two projecting tongues similar to those represented on the heads of the snakes cut in the wooden handles of the so-called snake whips used by the snake priests. . . . I have also a pictograph . . . of a lightning snake with an oval head and a straight crossline on the neck at right angles to the length. [Fewkes 1892:18-19]

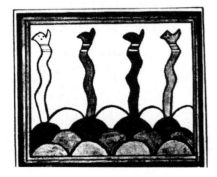

180

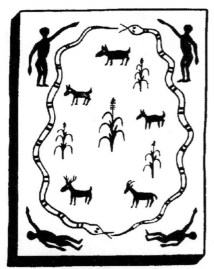

Pictographs, near Yucca Valley, San Bernardino Mountains, California

Drawing of Bear Clan sacred tablet, Hopi Mesa, Arizona

The front of the larger, second Bear Clan tablet was marked with a cornstalk in the center, around which were grouped several animals, all surrounded by two snakes, and in each corner was the figure of a man with one arm outstretched. The two snakes symbolized the two rivers that would mark the boundaries of the people's land (the Colorado and the Rio Grande Rivers). The outstretched arms of the four men signified that they were religious leaders holding and claiming the land for their people.
[Waters 1963:32]

The final event of the Luiseno (puberty) celebration consisted of a race, called a "hayie," to a certain rock where a relative of each girl awaited her with a little pot of red ochre paint. On arrival each initiate painted a design on this rock. Informants indicated that these designs were always diamond-shaped and represented the rattlesnake.
[Vuncannon 1977:97]

(Below) Face painting, Huichol Indians, State of Jalisco, Mexico

Face-Painting of Mother East-Water. The face is covered with serpents, or which is the same thing, the picture of a rainstorm.
[Lumholtz 1900:202]

Petroglyphs, Willow Springs, Arizona

Hopi Snake Clan symbols.
[Michaelis 1981:18]

Solstice or Equinox • Spirals • Concentric Circles

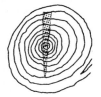
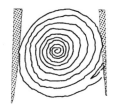

Redrawings of light "daggers" on petro-glyph at summer (left) and winter (right) solstices, Fajada Butte, Chaco Canyon, New Mexico

Near the top of Fajada Butte in Chaco Canyon rests an entirely different type of solar marker . . . three slabs of rock fell away from the east-facing . . . butte and came to rest in a vertical position on a ledge. . . . Behind them an unknown early Indian . . . carved a spiral petro-glyph onto the cliff wall . . . about the size of a dinner platter . . . sun-light at midday (on the summer sol-stice) . . . forms a narrow shaft of light . . . dubbed a "light dagger," (it) . . . descends vertically through the spiral, its point passing right through the center of the spiral. . . . The Fajada spiral also could be used to a certain extent to mark . . . the spring and fall equinoxes . . . and the winter solstice . . . when the spiral appears to be "embraced" by two vertical light beams tangent to its right and left edges.

[Frazier 1986:194-8]

Fajada Butte, Chaco Canyon, New Mexico

. . . marker . . . is on ledge below top of butte, facing east southeast.

[Frazier 1986:195]

(Below) Petroglyphs near Holly House, Hovenweep National Monument, Utah

The narrow corridor formed by these two large boulders lies along the direction of equinox. When the sunlight first falls along the corri-dor at sunrise, it is time to begin to prepare the fields for planting (about February 20). Shortly after the vernal equinox, the sun has moved too far north to light the entire corridor. Around the sum-mer solstice, in a dramatic display of light and shadow, sunlight forms two serpents of light, which fall across the two spirals and the three concentric circles (a com-mon Pueblo sun symbol) and meet between them.

[Williamson 1984:95]

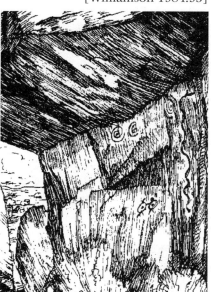

182

Speech

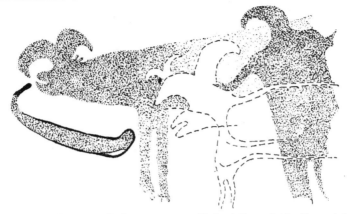

Pictographs, El Cacariso, Baja California, Mexico

What makes this site so rare is the symbolic representation of the animal's voice or soul coming from the mouth and extending back toward the "Lord of the Bighorn Mountain Sheep." In this instance we are seeing the metaphorical use of a symbol that stands for a complex act of communication between the human element and the animal counterpart. [Smith 1985:36]

(Below) Petroglyph, Cerro del Tecomate, State of Sinoloa, Mexico

The most interesting type (of cross) . . . represents Quetzalcoatl, under the aspect of the "Morning Star" or "Venus.". . . To add further weight to what has been shown about the aforementioned god, in one of the petroglyphs from El Tecomate (below), the god would seem for certain to be speaking, because of the commas which are exiting from the image.
 [Ortiz de Zarate 1976:61-62, 117]

(Below) Drawing taken from Mexican codex as reported by Kingsborough

Talk (Mexican).
 [Mallery 1893:719]

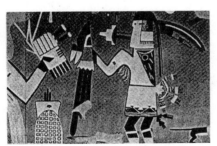

Kiva painting, Awatovi, Arizona

The cloud terrace symbol emerging from his mouth has been interpreted as a breath cloud or pipe, relating to the blowing . . . of either breath or smoke. [Brew 1979:520]

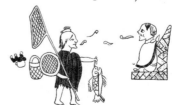

Spider or Spider Web

• Zoomorph with circular body and multiple legs • Design with radial spokes, connected around circumference

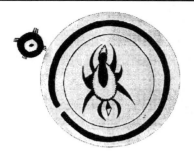

Design on Hopi pottery bowl

Kokyanwupti, the Spider Woman, is an important supernatural in the earliest (Hopi) mythologies . . . the picture of the spider with that of the sun (top left) suggests that the Spider Woman is a form of the earth goddess.
[Fewkes 1919:150 Plate 87c]

Petroglyphs, Willow Springs, Arizona

Symbols of spider or web representing Spider Clan.
[Michaelis 1981:17]

Petroglyphs, Willow Springs, Arizona

Spider Clan symbols . . . recognized by Edmund Nequatewa, a Hopi Indian. [Colton 1946:4]

Petroglyphs, northern Arizona area

Figure above shows the marking of a spider and one of the offspring which it hatches, indicating the presence of the Spider Clan.
[Waters 1963:61]

(Left) Petroglyph, Kayenta area, northern Arizona

Drawings (from petroglyphs) . . . spider.
[Colton 1946:7]

(Below) Petroglyphs, Renegade (Little Petroglyph) Canyon, Coso Range, California

. . . I photographed a . . . petroglyph of what appears to be a spiderweb pattern. . . . It also spread over two or three square feet of flat surface of blue-black basalt.
[Rafter 1989:11]

(Left) Petroglyph, Willow Springs, Arizona

Hopi Spider Clan . . . was recorded to have packed spiderweb designs. . . . If the radiating spokes . . . were not extended beyond the circle, the result would be . . . a squash blossom motif. [Rafter 1989:11]

184

Spirals

(*See also* Emergence, Migrations, Whirlwind and Solstice)

Petroglyphs, Zuni Reservation, Arizona

The spiral figure in particular has a number of related meanings, for both the Zunis and the Puebloans in general. The historic Puebloan peoples described spirals as representing wind, water, creatures associated with water such as serpents and snails, and the journey of the people in search of the Center. The most frequent interpretation of this figure I heard at Zuni was "journey in search of the Center;" . . . (they) referred the figure back to the myth time, narrating the part of the origin myth that describes the travels undertaken by the Zunis as they searched for the location as well as its discovery by the Water Skate. [Young 1988:136]

(Below) Petroglyphs, as indicated

As the migrations began to end, the record of the people's wanderings was left engraved on the rocks. . . . The circles record the number of rounds or *pasos* covered, north, east, south, and west . . . the second circle moves in the opposite direction showing the people returning.
[Waters 1963:103-4]

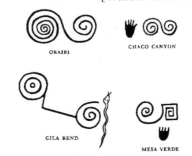

ORAIBI

CHACO CANYON

GILA BEND

MESA VERDE

185

Spirals (continued)

Petroglyphs, Keam's Canyon, Hopi Mesas, Arizona

Mr. Keam's manuscript describing (above) says: "It is a decoration of great frequency and consisting of single and double spirals. The single spiral is the symbol of the Ho-bo-bo, the twister who manifests his power by the whirlwind. It is also of frequent occurance as a rock etching in the vicinity of ruins, where also the symbol of Ho-bo-bo is seen. The myth explains that a stranger came among the people, when a great whirlwind blew all the vegetation from the surface of the earth and all the water from its courses. With a flint he caught these symbols upon a rock, the etching of which is now in Keam's Canyon. It is 17 inches long and 8 inches across. He told them he was the keeper of the breath. The whirlwind and the air which men breathe come from this keeper's mouth." [Mallery 1893:604-5]

Petroglyphs, Zion National Park, Utah

The first sign on the lower strata is a spiral, often associated with water and emergence (above) (Gunn 1917:110-111). Mankind came forth from the womb of the earth in water (Tyler 1964:105). . . . The second sign . . . is not unlike a vulva (Warner 1982a:110).

[Harris 1986:44]

Comment on spiral planting in farming

There are two main ways of planting a field. The planters might start in the center of a field and move out in circles as they planted. In Navajo that was called *ha'oolmaaz*. This was done before I was born, but I have heard about it. People used to say circular farming was fast. The second kind of farming was in rows. We called that *ool'aad*.

[Yellowman's Brother 1979:23]

(Left) Pen and ink drawing of complex imagery . . . by subject in early stages of hallucinogenic intoxication

The general pattern of drug-induced imagery is described below. . . . In the core experience patterns of the Near Death Experience, the drug-induced hallucinations, and the ecstatic shamanic trance . . . possibly no other artistic motif conveys the concept of the journey through a tunnel as effectively as concentric circles and spirals.

[Benson and Sehgal 1987:3-4]

186

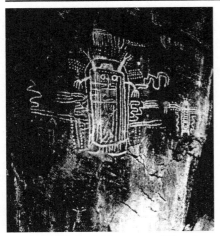

Petroglyph, Wind River area, Wyoming

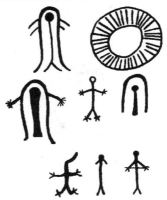

Pictographs, Hamlet Site #6, Kern River, California

Spiritual power radiates like electricity from *pandzoavits* (depicted here in a rock drawing–above), the dangerous, mysterious ogre and visionary spirit of the Shoshoni. (To the Wind River Shoshoni) the rock drawings are supposed to represent spirits and have been made in the winter by these spirits themselves. Each spirit draws his own picture. Indians have told me that in the spring and summer they have discovered new drawings on the rockface, apparently pecked by spirits since their last visit.

[Hultkrantz 1987:49-50]

(Right) Petroglyphs, Pictograph Point, Mesa Verde National Park, Colorado

In 1942 four Hopi men . . . visited Pictograph Point and interpreted the glyphs. The following text gives their interpretation:
H. Two interpretations:
1) Mountain Lion clan symbol.
2) Representation of an "all powerful" animal spirit watching over the people in their travels.

[Mesa Verde Museum Assn. n.d.:9-10]

. . . rocks (and) streams seem not so much supernatural in themselves, but serve as dwelling places for supernatural beings (in the region of the Tubatulabal tribe) . . . all these humanly shaped beings (were) referred to as *yu-mu-gi-wal*. . . . Included among these were small dwarfs or "brownies" *(ya'hi'iwal)* about 3 ft. high, who "looked like indians.". . . Pictographs in area also attributed to these "brownies." Many *yu-mu-gi-wal* are water spirits; in every spring, pool, river there dwells (a) spirit who owns that particular body of water. . . . A man fishing at Kernville had seen small person, *pa-nugis*, with human hands, fingernails two inches long, pulling at his line in water, whereupon the fisherman had fled.

[Voegelin 1938:61]

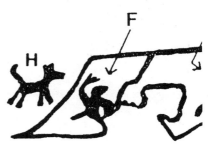

Spirit Helpers

Pictographs (?), west of Green River, Utah

Many shamanic practices and much of the symbolism associated with shamanism are held in common over vast areas (Furst 1974) and the Barrier Canyon Style anthropomorphs have attributes and associations characteristic of shamans throughout the world. Horns, which are one type of headdress occurring on Barrier Canyon Style figures, are almost universally emblematic of shamanic and supernatural power. Animal spirit helpers common to the shamanic realm (Furst 1974:135) may explain the many tiny animals and birds that approach these figures or appear on their heads and shoulders. Birds in this context may symbolize the shamanic power of magic flight; the bird may lead the soul in flight or the soul may actually change into a bird (Wellmann 1975). The large dog, a major figure in many Barrier Canyon Style panels, may be analogous to the jaguar whose form New World shamans commonly are believed to assume. [Schaafsma 1980:71]

(Below) Petroglyph, Petrified Forest, Arizona

At Petrified Forest a man is shown holding the tail of a coyote—in this case called a *poko*, "an animal who does things for you."
[Waters 1963:106]

PETRIFIED FOREST

(Below) Pictograph, Canyon de Chelly, Arizona

This . . . possibly represents power lines and spirits emanating from the head of a shaman.
[Grant 1978:247]

188

Squash and Squash Blossom

• Ship's wheel design
• Open flower in profile • Dots
• String of connected circles

Designs from Moki (Hopi), northern Arizona

Figures above represent the blossoms of melons, squashes.
[Mallery 1893:746]

Designs from Manuscript on Hopi Indians, northern Arizona

Mr. Keam in his manuscript describes above figures as two forms of the symbol of Aloseka, which is the bud of the squash. The form seen in the upper part of the figure, drawn in profile, is also used by the Moki (Hopi) to typify the east peak of the San Francisco mountains, the birthplace of the Aloseka; when the clouds circle, it presages the coming rain. In rock carvings the curving profile is further conventionalized into straight lines and assumes the lower form.
[Mallery 1893:662]

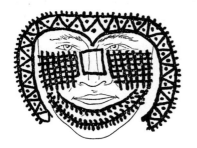

(Below) Pictographs from La Pena Pintada, State of Sinaloa, Mexico

The intertwined lines in the pictograph designs (below) were found by Lumholtz (1900:41, 126; 1904: plate xx, 291) to signify the root of the squash vine, the criss-crossing water gourd vine, the bean plant, or the double gourd. The double gourd is esteemed as medicine and used by peyote seekers to drink from as well as to carry home sacred water. Lumholtz (1904:281) found that "the magic double water gourd, even its most conventionalized form, means a prayer for water, the source of all life and health." [Mountjoy 1982:119]

(Below left) Face painting by Huichol Indians, Mexico

Face-Painting of the Setting Sun. . . . The square on the nose is the earth. . . . From it springs forth over the forehead the squash vine with its squashes (the dots) and flowers (the barbed edge). On each cheek is a heap of ears of corn in the harvest time. On the chin are barbed lines representing clouds.
[Lumholtz 1900:200]

189

Staff
(*See also* Crook)

• Long line, with object or curve at one end, often carried by anthropomorph

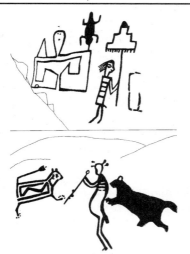

Petroglyphs, Three Rivers, New Mexico

Above (top) is a stylized phallic man in profile holding a cloud terrace on a staff. . . . The naturalistically portrayed figure with a staff (above bottom) is probably a shaman or other being with supernatural power closely affiliated with the animals flanking him. At Three Rivers, examples occur in which insects or animals holding staffs replace human beings.
[Schaafsma 1980:221-223]

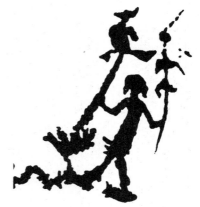

Cave of Life, Petrified Forest National Park, Arizona

. . . the shaman, shown with two ceremonial staffs as well as his erect penis. By these attributes he is labelled as a personage endowed with power. [Hunger 1982:3-4]

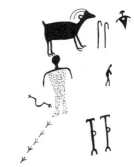

Petroglyphs, Kachina Bridge, Natural Bridges National Monument, Utah

The Twins have joined the gods or merged into humanity, but leave behind powerful scepters and canes to represent them and their powers through their priesthood "impersonators" (Tyler 1964:219). . . . It was through a cane that people emerged out of the flood and into the fourth (present) world.
[Harris 1981:172]

Petroglyphs, Cedar Mesa, San Juan County, Utah

(Above) shows a "copulating" couple and a crook, graphically emphasizing a symbolic association between crooks and fertility.
[Cole 1989:79-80]

190

Stars

(*See also* Cross
Planetarium, and Quetzalcoatl)

• Four isoceles triangles joined at
bases to form star • Equilateral cross,
often outlined • Dots

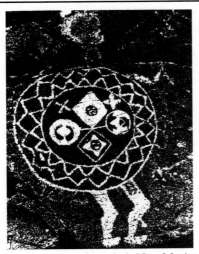

Petroglyph, San Cristobal, New Mexico

The outside of the shield may rep-
resent the rays of the sun. The cen-
ter of the shield carries Morning
Star and Evening Star, two other
bright stars, and two circles that
may represent the moon.
[Williamson 1984:176]

Design on Shield, Hopi Mesas, Arizona

Star (Aldebaran), eye of
Cotukinungwa (the Sky God).
[Stephen 1940:19]

Petroglyphs, Willow Springs, Arizona

Hopi Clan Symbols—Star Clan.
[Michaelis 1981:15-23]

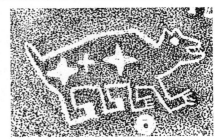

Petroglyph, San Cristobal, New Mexico

The enclosed stars are suggestive of
the idea of constellations.
[Del Chamberlain 1977:33]

*Petroglyphs, El Tecomate, State of
Sinoloa, Mexico*

The most interesting type (of cross)
is found in El Tecomate . . . for
without doubt they seem to be the
same type of crosses that in Tula,
Hidalgo and other places represent
Quetzalcoatl, under the aspect of
the "Morning Star" or "Venus."
[Ortiz de Zarate 1976:61-62, 117]

Drawing of Navajo Black God

According to . . . Navajo origin
myths, Black God, or Fire God,
created the stars. . . . Black God
carried the constellation *Dilyehe*
(Pleiades) on his ankle. . . . By
stamping his foot four times (he)
caused the constellation to settle on
his forehead.
[Williamson 1984:183]

191

Sun

(*See also* Solstice, Concentric Circles, and Pit)

• Circle with rays • Concentric circles, often with dot in center • Circle with face or designs • Circle with cross and rays • Pit

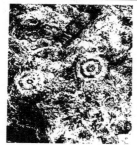

Pictographs, Arrow Grotto, Capitan, New Mexico

The primary source for identification of the Sun mask . . . is the symbol of three concentric circles drawn nearby. In the Pueblo explanation of this old symbol . . . the outer circle represents the ring of light around the Sun, the second represents the Sun itself, and the inner circle or dot, his umbillicus, which opens to provide mankind with game and other sustenance.

[Ellis and Hammack 1968:35]

Comment on Ellis and Hammack above

. . . I was informed by a knowledgeable Hopi that this symbol (two concentric circles with a dot in the center) represents the earth, the center circle or dot standing for the water at the earth's center . . . the apparent contradiction may be superficial. Heyden (1975:143) expresses the opinion that sky and earth were inseparable in ancient myth and thought in Mexico and he cites the fact that Sahagun (1969 IV:172) refers to the Sun-Earth as one. That this duality, also present in Pueblo thought, is made explicit by Ellis and Hammack in their reference to Arrow Grotto as a combined earth and sun shrine.

[Schaafsma 1980:11-12]

Petroglyphs, northern Arizona

(Rock) drawings from three different areas compared. The forms have been classified as: Sun. Top row: Kayenta area; middle row: Sinagua area; and bottom row: Cohonina area (Arizona).

[Colton 1946:7]

Painting on Hopi pottery, northern Arizona

Dau-wimpka emblem. Dawa (Sun) from ceremonial vessel.

[Stephen 1940:18]

Signatures of Hopi workmen

36) Honcoho Tawa(Sun) gens (clan); totem, sun's disk.
40) Kelhouniwa Tawa gens; totem, sun's disk. [Fewkes 1897:4]

192

Pictographs, Santa Barbara area, California

There are also certain unifying attributes in the Santa Barbara painted style, although not all of them are always present at each site. The most ubiquitous element is the sun-wheel, or mandala form (above).

[Hudson and Lee 1984:27-28]

Petroglyphs, Willow Springs, Arizona

Hopi Clan Symbols: Sun Clan (circle + face), Sun Forehead Clan (rising sun half circle).

[Michaelis 1981:15-23]

(Below) Pictograph, Shelter Rock, Mojave Desert, California

. . . a mythic event: a lone woman who lived in a cave went to a mountain and exposed her vagina to the rising equinox sun, who impregnated her with his rays (described as his "whiskers" in myth of Chemehuevi Indian origin). . . . Support for the interpretation of this site as Woman Cave is the pair of pictographs shown. They resemble a sun and a vulva and the pairing of designs strongly hints of the mythic concept of the union between sun and earth.

[Rafter 1987:28]

(Left) Petroglyphs, San Cristobal, New Mexico

The face(s) surrounded with four straight rays . . . and the gear-like pattern . . . are sun symbols.

[Sims 1949:9 Pl. XVII]

Supernova

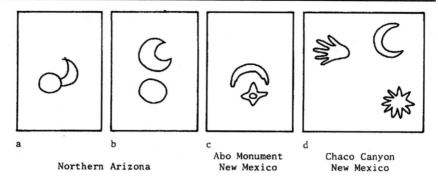

a b c d

Northern Arizona Abo Monument Chaco Canyon
 New Mexico New Mexico

Petroglyphs and pictographs from locations indicated

This painting (a) was found in northern Arizona about twenty years ago. . . . Not far away, in a canyon, also in Arizona, a similar drawing was found (b). What could that be? . . . There was a bright supernova that exploded in the year 1054 on July 5. . . . When it was first seen, the moon was in the bright position in the sky, such that the star was very near to the crescent moon, close to the horizon. . . . Later similar pictures were found in New Mexico (c and d).

[Eddy in Berger 1984:110-111]

(Below) Drawings of suspected symbols of supernova and their locations

Both (glyphs in northern Arizona) seemed to represent the moon and some other celestial object, perhaps a star. The pictographs, however, presented an impossible physical situation. Stars can never come between the moon and the earth. Perhaps the images were an attempt to depict the near conjunction of an extremely bright star and the moon . . . (seen in the USA) . . . on July 4, 1054 . . . the crescent moon came within 2 degrees of the (supernova).

[Williamson 1984:185-187]

194

Swallower

• Anthropomorph swallowing arrow, stick or bough

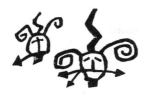

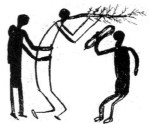

Drawing on pottery from Sikyatki Ruin, Hopi Mesas, Arizona

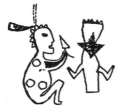

Petroglyphs, Galisteo dyke and Comanche Gap, New Mexico

Depictions of arrow-swallowing on Galisteo dyke and at Comanche Gap. [Sims 1963:218]

The middle figure in this group is represented as carrying a branched stick, or cornstalk, in his mouth. (In the Antelope dance at Walpi [Hopi Mesas] a stalk of corn instead of a snake is carried in the mouth on the day before the Snake Dance.). . . Another interpretation of the central figure . . . is that he is performing the celebrated stick-swallowing act which was practiced at Walpi. [Fewkes 1898:223]

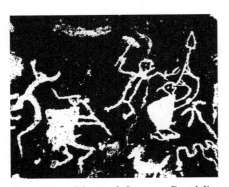

Cave Kiva, Mortand Canyon, Bandelier National Monument, New Mexico

The other two figures are Kokopellis with thick humped bodies, bent knees, erect penises, and a feather flowing backward from the head. One flute is held pointing toward the ground. The other flute points upward ending in an arrow and is held with three-fingered hands. [Rohn et al. 1988:104]

Photo of Sword Swallowers, Zuni, New Mexico

. . . he takes a bit of root which he places in the fraternity father's mouth . . . and soon the fraternity father swallows the sword, having the root medicine still in his mouth. [Stevenson 1904:457, Pl. CXVIII]

195

Swastika *(See also*
Friendship and Migrations)

• Swastika, with arms pointing either
clockwise or counter clockwise

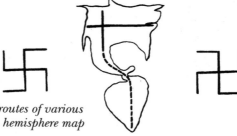

*Drawings of migration routes of various
Hopi clans and western hemisphere map*

We can see now that the complete
pattern formed by the migrations
was a great cross whose center
Tuwanasavi (Center of the Universe)
lay in what is now the Hopi country
in the southwestern part of the
United States and whose arms
extended to the four directional
pasos (middle figure above). . . .
Three *pasos* for most of the clans
were the same: the ice-locked Back
Door to the north, the Pacific to
the west, and the Atlantic Ocean to
the east. Only seven clans migrated
through South America to the
southern *paso* at its tip. . . . Upon
arriving at each *paso* all the leading
clans turned right before retracing
their routes (above left). . . . This
transformed the cross into a great
swastika rotating counterclockwise
to indicate the earth. . . . The rest
of the clans turned left (above
right). These minor clans did not
have complete ceremonies.
[Waters 1963:113-4]

*(Below) Petroglyph, Paiute Creek
mouth, Glen Canyon area, Utah*

Style 4 design. Informant recogni-
tion: The spiral ended swastika is a
symbol meaning friendly or peace
making.
[Redrawn from Turner 1963:49]

*(Below) Drawing of Hopi kachina
dancers*

A'YA. This katcina appears in pairs
in the *Wawac*, or Racing Katcina,
and is readily recognized by the
rattle (*a'ya*), which has swastika
decorations on both sides, forming
the head.
[Fewkes 1903:114]

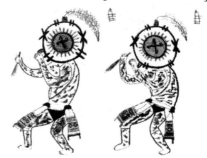

Drawing of Hopi symbols

Ai'veni, rattle (*a'ya*) decoration:
I am led to think from a hint of
Pauwatk'wa that the (symbol right)
is a development of the *nakwach*
(friendship) symbol (left).
[Stephen 1936:217]

196

T-Shaped

10b

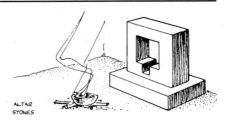

ALTAR
STONES

Petroglyph on loose building stone, Pipeshrine House, Mesa Verde National Park, Colorado

T-shapes, suggestive of the T-doors present in many of the cliff houses, do not occur as frequently as one might expect. . . . Figure 10b (above) shows an example of the T-shaped design which is quite superior to the others in both accuracy of proportion and neatness of execution. . . . T-shaped doorways were found to exclusively offer ingress and egress to and from rooms immediately adjoining kivas and towers, or situated in towers (at Mesa Verde). In sum, there is some evidence to support an opinion that T-shaped doorways were present only in ceremonial chambers or rooms used by shamans, priests or similar personages.

[McKern 1978:13, 41]

Drawing of supposed altar stones, excavated at Casas Grandes, State of Chihuahua, Mexico

Three large thick rectangular slabs with flat surfaces and edges and sharp squared corners are believed to have served as altar stones. . . . Two of the slabs had centrally placed T-shaped openings through them. . . . The resemblance in this T-shape to those of the actual doorways . . . suggested that these holes were possibly made as "spirit entrances," vaguely analogous to the *kachinki* and the altar screens for the water serpent ceremonies of the modern Pueblo groups.

[DiPeso (7) 1974:324-325]

Comment on the T-Shape doorways

The purpose of this shape is a mystery. The Anasazi may have found it easier to enter the room when carrying loads on their backs. Or they hung a piece of hide over the upper wider part of the door for warmth, and still had a small opening for ventilation at the bottom. Or people may have used the projections for balance when stooping to enter small doorways. Other explanations are possible.

[Viele 1980:49]

(Left) Drawing of Hopi wall opening from Nabokov and Easton 1989: 372

197

Tablet, Tableta, or Tabla

• Stepped pyramid design worn on top of the head or mask • Rectangular design on wooden board used by shaman

Petroglyphs, Hopi Mesas, Arizona

Figure 10. Ancient *hu-mis'-ka-tci'-na na'-tci* (tablet). Antiquated style not now used in ceremonial dances. Symbol of falling rain below.

Figure 11. Modern *hu-mis'-ka-tci'-na na-tci* (tablet). Similar in form to that worn in the May celebration of the *hu'-mis* dance.

Figure 16. *Na'-tci* (tablet) (ancient) In strict language, the *na'-tci* or tablet worn on the helmet of the *Hu-mis'-ka-tci'-na* is an *O'-mow-uh* (cloud) figure. There is a beautiful *Hu-mis'-ka-tci'na* tablet (Pl. I, fig. 11) cut in the rocks on the right of the carriage road to Hano, near Wal-la. . . . An ancient *Hu-mis'-ka-tci'-na* tablet (*na'-tci*) is represented by a single pictograph (16) found on a boulder on the east side of the trail to Hano.

[Fewkes 1892:17, 19, 25]

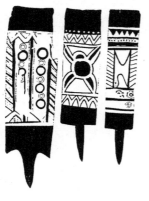

(Below) Petroglyphs, Three Rivers, New Mexico

Another example is a full-stepped fret or tableta, often represented with an enclosed arc attached to the baseline. This is generally taken to represent rain clouds and an enclosed rainbow. Others believe this to represent a rock or mesa with hollow caverns containing water holes like Hueco Tanks, Texas. [Warner 1982b:9]

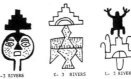

J-3 RIVERS K- 3 RIVERS L- 3 RIVERS

(Below left) Drawing of tablas found in rock shelter in Baja California, Mexico

Figure at left illustrates *tablas* found in a rock shelter in northern Baja California where they appear to have been associated with mourning practices. . . . *Tablas* . . . were peculiarly the property of the shamans, and bore designs or markings carved or painted on their surfaces. (Aschmann 1967:115-116). Venegas (1759:100) described these designs as ". . . grotesque figures, affirmed to be the true copy of the *tabla*, which the visiting spirit left with them (the shamans) at his departure to heaven."

[Smith 1986b:113-4]

198

Thunderbird

(*See also* Eagle)

• Flying bird, wings outstretched, feathers often prominent

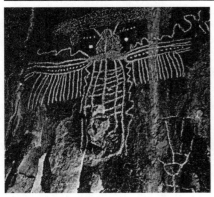

Petroglyph, Wind River area, Wyoming

Thunderbird depicted on a rock wall at Dinwoody Lake, Wind River Mountains. Observe the zig-zag lines which represent lightning. The most powerful (of the *puha* or guardian spirits) is lightning whose force is the very essence of every vision. Next comes the thunderbird . . . (which) is sometimes represented as an eagle but most commonly as a hummingbird. . . . The Shoshone Indian prepares to meet the spirits. . . . He seeks out a place immediately below the rock carvings, spreads his blanket on the ground and sits on it. . . . At the same time he prays to the spirit, reproduced in the rock-carving, whose particular favor he seeks.

[Hultkrantz 1981:33-35]

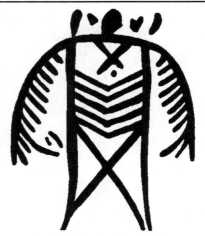

Petroglyph, Alamakee County, Iowa

This supernatural being was well known in many areas of North America. Thunderstorms were believed to be caused by an enormous bird that made thunder by flapping its wings and lightning by opening and closing its eyes. The rock drawings of the thunderbird vary from quite naturalistic in the Southwest to highly stylized in the Northwest . . . , but wherever they are found, the bird is always represented with the head to the side and the wings extended in "spread-eagle" position. . . . Many tribes used the motif as a clan symbol. . . . He was a clan ancestor and guardian spirit bringing success in war and long life. Powerful shamans sometimes claimed to be a reincarnation of this benevolent deity.

[Grant 1967:59]

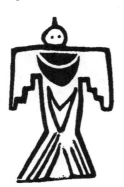

(Left) Petroglyph, Three Rivers, New Mexico

. . . highly stylized thunderbird.
[Schaafsma 1980:230]

199

Turkey

- Bird in profile, with drooping nose
- Three-toed footprint

Pictographs of turkeys, Canyon de Chelly and Canyon del Muerto, Arizona

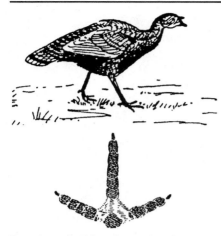

Drawing of wild turkey and turkey track (in mud) [Murie 1954:327]

Comment on pictographs of turkeys at Tsegi Canyon and Canyon de Chelly, Arizona

The turkey, a creature of the earth (as opposed to the sky), is bound to embody a different set of symbolic concepts, although this bird too is found in the same set of relationships to human figures in the rock art. The turkey was domesticated by the Anasazi by A.D. 700. Its feathers were used for robes and ritual purposes at least by that time and perhaps even earlier. Among the modern Pueblo Indians, the turkey is symbolically associated with the earth, springs, streams and mountains, which are the homes of the cloud spirits. It follows that the turkey is viewed as an intermediary between these mountain water sources and the rain clouds that form on the peaks. He is also regarded as a teacher and helper, and he is associated with the dead, who must return to earth before rising as clouds to the spiritual realm. [Schaafsma1986a:27-28]

The most interesting Modified Basketmaker-Developmental Pueblo animal figures in Canyon de Chelly relate to the turkey (*meleargris gallopavo intermedia*). An important source of food since Basketmaker times, the turkey became invaluable after its domestication by the Early Developmental Pueblo Anasazi. . . . Zuni legends describe Turkey People who could be summoned through prayer sticks bearing turkey feathers. . . . Zuni also had a Turkey Clan. At the ruins of Kuaua, the keeping of immense numbers of domestic turkeys is evidenced by pens, eggs, guano, and bones (Dutton 1963: 7-9, 67, 111, 201).
[Grant 1978:189-190]

Petroglyph, Zion National Park, Utah

The appearance of turkey indicates completion of the emergence.
[Harris 1981:170]

200

Twin War Gods

(*See also* Bow,
Handprint, and Hourglass)

• Two small anthropomorphs, without facial features, often with "pony tails"
• Two parallel lines, often on cheeks of anthropomorph • Bow and hourglass
• Red hand

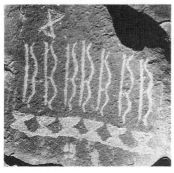

Petroglyphs, Largo Canyon drainage, New Mexico

The War Twins . . . are major deities in Navajo mythology. They have many names but the elder twin is most often called Monster Slayer and the younger Born-for-Water. . . . Dance impersonators of Monster Slayer are painted with a symbol of the bow. . . . Supernaturals carrying the bow may in some cases represent this deity. . . . Both the hourglass (symbol for Born-for-Water, the younger twin war god) and the bow (the elder twin) also occur apart from anthropomorphic contexts in rock art.

[Schaafsma 1980:315-31]

Comment on Twin War Gods

The Twins are represented in the sky by the morning and evening star. [Williamson 1984:99]

Signature of Hopi workman, Arizona

Kanu(Walpi)—Pakab gens (clan); totem head and body of Puukonhoya (little war god).

[Fewkes 1897:4]

Petroglyphs, Hopi Mesas, Arizona

The pictograph here dealt with (above) is said to show where the children of the Sityatki woman sat when she left them their food. It is about two and one-half feet square, the seat of the girl being represented by the female sign (A) and that of the boys by parallel lines (B).

[Fewkes 1906:364]

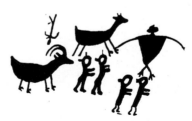

Petroglyphs, Rock Ruin, Kachina Bridge, Natural Bridges National Monument, Utah

(Twins) killing monsters. It is interesting to observe that the Twins lose their feathers as they move to the right through various adventures. Their feathers are powers given them by Father Sun and they no doubt had to use them in the accomplishment of their missions. (Above middle, each Twin has one feather, below to the right, both twins are featherless.)

[Harris 1981:172]

Two-Headed
(*See also* Birthing)

• Zoomorph with head at both ends

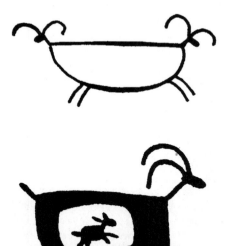

Petroglyphs, Coso Range, California

The odd two-headed sheep that often occur during the Late Period had completely puzzled us. A friend who had been raised on a farm has suggested it may symbolize a sheep birth. One head is always drawn much smaller than the other and might represent the invariable head-first appearance of many animals at birth. This would tie in with the hope for an increase in the numbers of sheep. The pictures of sheep inside sheep would also fit this theory.

[Grant, Baird and Pringle 1968:40]

Vulva

• Oval or triangle vertically bisected by line

Drawing of rock formation

Southern California natural geological formation near Lyon's Peak, which resembles a human vulva and on which the radiating lines have been enhanced.

[McGowan 1978:34]

Petroglyph, Hopi Mesas, Arizona

La-wa (female genitals).

[Fewkes 1892a:20-21]

Petroglyphs, Shelter Rock, California

Various types of vulva symbols found at Shelter Rock.

[Rafter 1987:30]

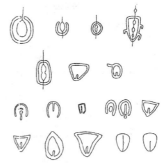

Petroglyphs qne pictographs from Peterborough, Ontario, Canada and other sites around the world

. . . the seven renderings of female vaginas (top two rows above) at the Peterborough Petroglyphs have parallels in the iconography of rock art throughout the world. In North America they occur in the British Columbia Plateau (in sequence above), in Washington, California, Missouri, Mexico (next two), . . . in Siberia (next two), Norway, and Paleolithic France.

[Vastokas and Vastokas 1973:80-81]

(Below) Petroglyphs, near Chalfont, California

The varied types of vulva symbols found at the Chalfont site are illustrated (below). In general vulva drawings are scattered over the entire cliff face, but on one rock they are thickly clustered. In this one vulva colony, all stages of patination appear, and a number of the symbols are re-abraded.

[Vuncannon 1985:121]

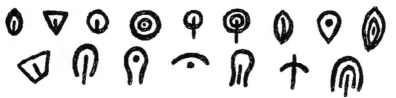

Warriors

(*See also* Combat and Four Circles)

Photograph of war ceremony in kiva at Hopi Mesas, Arizona

Soyal Priests. Priests around the medicine tray in the war ceremony. The man standing is Koyoyainiwa, the *Kaichtaka,* or warrior; the one holding the spear point *natsi* is Yeshiwa.

[Dorsey and Voth 1901:Plate X]

Petroglyph, Lower Cha Canyon, Glen Canyon area, Utah, redrawn from Turner 1963

Style 4 (A.D. 1050–1250). Informant recognition: Anthropomorphs are "Warrior Gods" since they are wearing helmets with the single feather sticking up. [Turner 1963:50]

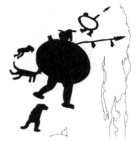

(Above) Petroglyphs, Tenabo, New Mexico; (Below) Petroglyphs, Los Lunas, New Mexico

War symbolism is relevant in the rock art, particularly in the Tano region in the Galisteo Basin and in the northern Tewa province. The most obvious figures in this connection are the shield and the shield bearer. . . . Depictions of warriors with shields, horns or pointed caps, carrying clubs or other weapons, may be figures with a ritual meaning. The guardian role of the warrior in the Underworld or in connection with the Wuwuchim ceremony at Hopi was discussed previously. The petroglyph scenes near Los Lunas and at Tenabo in which the shielded warriors are engaged in combat with the horned serpent (below) appear to portray ceremonies like that held in the Hopi Soyaluna kiva at winter solstice.

[Schaafsma 1980:297, 263, 283]

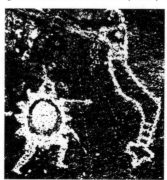

204

Water

(See also Friendship)

a

b

Drawings of water symbols, Hopi Mesa area, northern Arizona

The upper design above taken from the manuscript catalogue of T.V. Keam is water wrought into a meandering device, which is the conventional generic sign of the Hopi. The two forefingers are joined as in the lower design in the same figure. . . . Mr. Keam says: "At the close of the religious festivals the participants join in a parting dance called the 'dance of the linked finger.' They form a double line, and crossing their arms in front of them they lock the forefingers of either hand with those of their neighbors . . . singing their parting song. The meandering designs are emblems of this friendly dance."

[Mallery 1893:643]

Petroglyphs, Willow Springs, Arizona

Hopi Clan Symbols—Water (Rain) Clan, Water House Clan, Water Plant Clan (cloud with lightning).

[Michaelis 1981:15-23]

Petroglyphs on building stones in ruin near Springerville, Arizona

On the large stones were several signatures of the Water Clan, as shown in Figure above. The one on the left, representing water, is also found in color in Chaco Canyon. The figure with a protruding tail, shown to the right, represents a tadpole before it drops its tail to become a frog, a symbol of the Water Clan. [Waters 1963:64]

Petroglyphs, Zion National Park, Utah

. . . the first symbol in the Fourth World consists of five squares with sprouts protruding, emerging from their upper surface and a line with a spiral at its extremity. The spiral consists of just three and one-half loops, suggesting a flood of beneficial proportions for the flood plain farmers. Together these signs suggest growth, water, and possibly the spiral, ceremonial planting practices of some Pueblo peoples (Packard 1974:15).

[Harris 1986:44-45]

205

Water Gourd

- Round object, enclosed in a carrying net, often carried by anthropomorph
- Double-round objects connected one to the other

Petroglyph, San Cristobal, New Mexico

The carving . . . shows, in quite a realistic manner, some of the ceremonial paraphernalia used by the San Cristobal people. In his left hand the man holds two prayer sticks, one with a feather and one made of bent reed; a gourd water jar is suspended from his wrist.
[Sims 1949:6 Pl. VI]

(Below) Drawing of ceremonial objects on Hopi Nima'n altar, IV day, northern Arizona

(Four) netted gourds.
[Stephen 1936:561, Fig. 313]

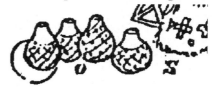

(Below) Double Water Gourd Designs, Huichol Indians, State of Jalisco, Mexico

. . . a succession of double water gourd designs, the result of the study of . . . pouches, girdles, ribbons, etc. The first figure to the left in the upper row is a fair representation of the double water gourd . . . (with) successive stages until it finally becomes simply a triangle. [Lumholtz 1904:200]

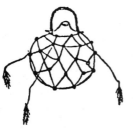

Drawing of netted gourd water jar Pueblo culture
[Sims 1949:6]

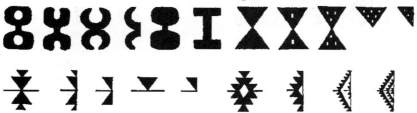

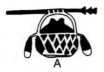
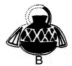

A B

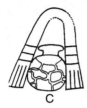
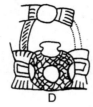

C D E

Pueblo IV Hopi and Teotihuacan (Valley of Mexico) mural representations of netted, hoop-handled aspersion vessels

A. Gourd vessel with probable aspersion stick and pendant feathers from Kawaika, Hopi (After Smith 1952: Plate G).
B. Hopi gourd vessel with pendant elements, from Awatovi (After Smith 1952: fig. 78b).
C, D, E. Teotihuacan aspersion vessels, held by individuals casting liquid (After Miller 1973: figs. 270, 351; Villagra-Caleti 1971: fig. 6).
[Taube 1983:189]

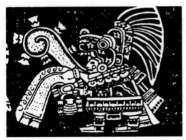

Mural from Teopanacazco, Teotihuacan, Valley of Mexico

Individual . . . engages in ritual aspersion (with netted gourd).
[Taube 1983:162]

(Below) Double Water Gourd of the Hikuli (Peyote) Seeker, Huichol Indians, Mexico

The large oval water gourds . . . are used by the women for carrying water to the house. The lower part is enclosed in a netting of strong twine made of bark fibre. The loop by which the gourd is carried is attached to two opposite sides of the netting. . . . Other water gourds are round in shape. . . . Such gourds are entirely incased in a netting of bark fibre. . . . The hikuli (peyote) seekers use double water gourds on their journey as drinking vessels, as well as to hold the sacred water they take home with them. . . . (It) is considered magical and has become the strongest symbol of water. [Lumholtz 1900:269-70]

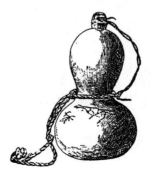

Water Skate

• Zoomorph with dot head and horns; arms and legs bent down at elbows and knees; also has tail

Drawing of a Water Skate (left) and kachina design of Water Skate (right)

The water skate, family *Gerridae*, is found throughout the Southwest on almost every body of water. . . . Because of this timid behavior they are known to many Native Americans as water deer. Although the body shape appears to be a four-legged linear form, two other legs, pointing forward lie along the body and are not noticeable. Cushing consistently speaks of the water skate as a six-legged creature and consequently a being that should be associated with the six directions. . . . The image of the water skate does appear frequently on the back of kachina masks and as a petroglyph where it is frequently mistaken for a lizard. It is quite likely that the water skate was chosen for the task of locating the Middle as much for its affinity to water as for its directional shape. Certainly its habit of raising and lowering its body fits well with the story.

[Wright 1988:152-3]

Drawing of Sio Hemis or Zuni Jemez Kachina (note Water Skates)

Case mask with face painted half red and half green; tableta with cloud symbols and flowers.

[Colton 1949:56]

Petroglyphs, Glen Canyon area, San Juan River, Utah

Style 2. Informant recognition: "Looks like water antelope (*Paathivio*) which is drawn on back of Hunter (*Kihila*) or Rabbit Kachina mask as well as the Sehohemis (Sio Hemis) and Blackhead Kachina mask." [Turner 1963:56]

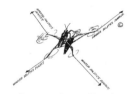

Drawing of water skate, Zuni Reservation area, New Mexico

The importance of these directions is established in the origin myth; the center place was finally found when the Water Skate, given magical powers of extension by the Sun Father, stretched out his four legs to those same solstice points (above). The place where his heart and navel then rested marked the Center, the heart and navel of the Earth Mother. This is the place where the present-day Zuni was built. . . . Stretched with limbs extending to the solstice points, the Water Skate appears to form a figure "X," with his heart at the center. Any "X," therefore, can be seen to symbolize this.

[Young 1988:100]

Waving Person

• Anthropomorph with one hand upraised

Petroglyph, Alamo Canyon, Texas

According to my Apache informant . . . various groups and tribes set special people aside and designated them as Storytellers. In some groups this would be a man; in others, a woman. . . . She sits, our Storyteller Woman, at the far north of the frieze (panel), gesturing for attention.
[Apostolides 1984:17]

GILA BEND

ORAIBI

Petroglyphs at indicated sites, Arizona

Near almost every ruin is found the figure of a man who represents the religious leader of the principal clan which occupied the village. . . . The figures at Oraibi and Gila Bend have their right hands upraised, indicating that they are responsible men religiously carrying out their ceremonies to insure bountiful moisture. [Waters 1963:107]

Petroglyph, Peterborough, Canada

. . . the rendering of the raised arm and the emphasis on gesturing hands carry a specific meaning in Algonkian pictography; the gesture is always associated with shamans. . . . All denote gestures of reverence, supplication or communication with the sky and more specifically to the Great Spirit, *Kitchi-Manitou.*
[Vastokas and Vastokas 1973:70-71]

Comments on Waving Person gesture

William H. Corbusier, surgeon, U.S. Army in Arizona in the 1870s: "(Among the Yavapai Indians) . . . in beckoning to a person to approach, they raise a hand with the palm forward, high up when the person is far off, and then swing it forward and down."
[Corbusier 1886:24]

Further comment on Waving Person

Terrell quotes the Spanish explorer Onate in July 1601: "(We) . . . came to a branch of the Canadian River (Texas). Here we were met by some Indians of the nation called Apache, who welcomed us with a demonstration of peace. (They) . . . confirmed their peaceful disposition by raising their hands to the sun, which is their sign of friendship."
[Terrell 1972:76]

Weeping Eye

• Anthropomorph with slant lines descending from eyes

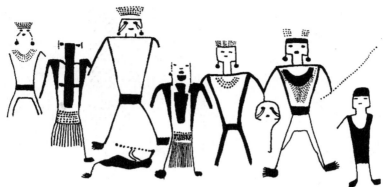

Petroglyphs, Ashley-Dry Forks, Utah

The Classic Vernal Anthropomorph. . . . Further head decoration consists of earrings or earbobs and facial designs. Tear-streaks, also known as the "weeping eye" motif, are the most usual elaboration of the latter sort.

[Schaafsma 1971:10, 15]

Rock Painting, Tule River, California

. . . a person weeping. The eyes have lines running down to the breast, below the ends of which are three short lines on either side. The arms and hands are in the exact position for making the gesture for rain. . . . The . . . character for weep . . . is also made by the Indian gesture of drawing lines by the index (finger) repeatedly downward from the eye.

[Mallery 1893:642-3]

(Below) Pictographs, La Pena Pintada, State of Jalisco, Mexico

(Among the Huichol Indians) when such designs (vertical undulating lines) are painted on the face of a peyote seeker (in yellow, the color of fire) they may signify a rainstorm. Occasionally, in these facial paintings rain serpents are shown as pendant from the area of the eyes. . . . In one case the water serpent design occurs as streaks on a disc dedicated to Grandfather Fire—i.e. as tear streaks on his face. This is also the case on one stone figure of Elder Brother and Lumholtz (1902[II]: 198) recorded: "When a deer is brought in, one of the sons takes a little deer-blood in his hands, dips a stick into it, and paints five lines (rain symbols) down the right cheek of his Father.". . . In four or more cases in the pictographs (below) tear streaks as water serpents are shown flowing from what appear to be eye symbols.

[Mountjoy 1982:118]

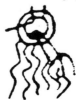

Whirlwind

(*See also* Breath and Spirals)

• Spirals • Anthropomorph with spirals attached or within

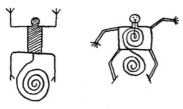

Petroglyphs, Hopi Mesas, Arizona

Mr. Keam's manuscript describing figure (above) says: "It is a decoration of great frequency and consisting of single and double spirals. The single spiral is the symbol of the Ho-bo-bo, the twister who manifests his power by the whirlwind. It is also of frequent occurrence as a rock etching in the vicinity of ruins, where also the symbol of Ho-bo-bo is seen. The myth explains that a stranger came among the people, when a great whirlwind blew all the vegetation from the surface of the earth and all the water from its courses. With a flint he caught these symbols upon a rock, the etching of which is now in Keam's Canyon. It is 17 inches long and 8 inches across. He told them he was the keeper of the breath. The whirlwind and the air which men breathe come from this keeper's mouth."
[Mallery 1893:604-5]

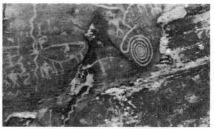

Petroglyphs, Paiute Creek, Glen Canyon area, Utah

Informant recognition: "Watchspring scroll is symbol of cyclone or cyclone's home." [Turner 1963:53]

Design on Hopi basketry

Since a whirlwind may precede rain, always sought and prayed for in Hopi ceremonies, the design has a happy and cherished significance.
[Viele 1980:6]

(Left) Petroglyphs, Hopi Mesas, Arizona

Of coiled spirals which are regarded as whirlwind symbols there are many represented in pictographs. . . . In their simplest forms (9) these are continuous coils curved throughout, but a somewhat modified form . . . gives a pictograph found on an isolated rock at the south base of the mesa under Hual-pi (10). The coil is here flattened on four sides, as (11) *ho-bo-bo* or whirlwind symbol is crosier-shaped, with a straight shaft and several coils. On the first tier of the cliffs on the south side below Sitcumovi there is a combination of the spiral, the rectangular, and the curved line (12).
[Fewkes 1892:20]

211

X-Incurved

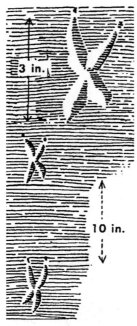

Roadrunner and its tracks from Murie 1954:326

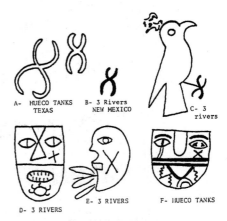

Petroglyphs at designated locations

Comment on "X" symbol and others

A very interesting combination of two specific motifs is repeatedly found within the sites of the Mimbres and Jornada Mogollon. These items are the "bow tie" or incurved "X" along with an animal-like print with long claws. These are reported on shaft smoothers, marine shell from the mesoamerican Pacific coast and as pictographs and petroglyphs. These depictions are often located with other elements such as plumed serpents, rain terraces and masked representations (Green 1967:35-44; Sutherland 1976:1-33). This combination may be clan related in the eastern Mogollon region as Green suggested in 1965 (Brook 1985:68-77).

[Bentley 1988:62]

Many elements in particular contexts have their own sets of peculiarities. It is the combinations of these peculiarities that need to be considered. The fewer the peculiarities the less positive the identification. With more well-defined contexts identification becomes easier and more accurate. . . . consider the elements in A above. Without ever seeing a road runner track one would have no idea what this glyph's simple identity was. . . . C above provides a concrete concept association. This is definite because the association is possible. It leaves no doubt as to its identity. When an "X" form is seen on a face or mask the concept association is not concrete (D, E, F above). The "X" form that occurs on the face may also be a planetary sign similar to those which occur on the face of Ahola, a Hopi deity. . . . Many believe the "X" symbol to represent water instead of the bird or its track, since this bird is often associated with the location of water.

[Warner 1982:7]

212

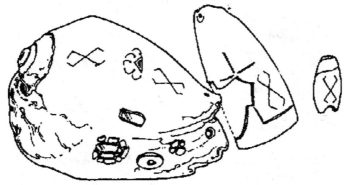

Drawings of "X" symbol and other designs on shell artifacts excavated at Casas Grandes, Chihuahua, Mexico and dated in Medio Period (circa A.D. 1200)

[DiPeso 1974(6):404, Fig. 504.6]

(Below) Designs on weaving work by Huichol Indians, State of Jalisco, Mexico

Root of bean plant. (Top below) Series of Conventional Forms . . . (bottom below) From a ribbon . . . root of bean plant and flower toto.
[Lumholtz 1904:313]

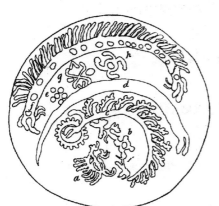

(Left) Drawing of Disk of the Setting Sun, Sakaimoka (reverse) done by Huichol Indians, State of Jalisco, Mexico

(g) The root of the squash plant, painted in green.
(h) The root of a young bean plant.
[Lumholtz 1900:40-41]

X-Ray Style
(*See also* Heart Line)

• Anthropomorph with bones and internal organs showing

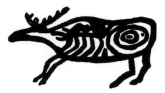

Petroglyph, Reindeer, Eastern Siberia, and (below) pottery decoration, Pueblo Indians, North America

The X-ray style is without doubt an expression of the shamanistic view current among the early hunters that animals could be brought back to life from certain vitally important parts of the body. The mere portrayal of these vitally important parts or of the life line—a single line running from the mouth to the heart region—brought about the resuscitation or increase of animals . . . (the artists) no longer remembered the original meaning of the lines inside the outline, but gradually abstracted them; thus the drawing of the intestines became concentric circles or spirals (above) . . . the X-ray style . . . finds its dying echo in the ornamental art of the Pueblo Indians (below).
[Lommel 1967:129-132]

(Right) Petroglyphs, West Creek Canyon, Glen Canyon area, Utah

Style 2. . . . Heart is drawn on this (sheep) as it was on deer and antelope petroglyphs around Oraibi (Hopi Mesas, Arizona).
[Turner 1963:48]

Petroglyphs, Washington State

Anthropomorph (with skeleton body) formerly located 10 miles from The Dalles on the Columbia River, has been destroyed by vandals. . . . Strong (1959:120) identifies this common stylistic element as the exposed rib motif.
[Ritter and Ritter 1972:102, 106-107]

Comment on X-ray style in rock art

A common theme in shamanism is the death, dismemberment, and rebirth that the shaman experiences in the initial trance states that occur when he is "called" by the supernatural powers. The experience sometimes is horrendous. The shaman, in his vision, may see himself reduced to bones, which are then reassembled and transformed into a new body. In this way the shaman is reborn into his new role as intermediary between his people and the spirit world. The skeletal motif is common in worldwide shamanic art and shamanic beings often are represented with their skeletons exposed. Contrary to common belief these are not death images, but symbols of shamanic rebirth.
[Hedges 1983:56]

GENERAL LOCATION
OF ROCK ART SITES

ARIZONA

1 Awatovi, Hopi mesas
2 Betatakin Ruin, Tsegi Canyon drainage
3 Camp Verde
4 Canyon de Chelly
5 Canyon del Muerto
6 Cave of Life, Petrified Forest National Park
7 Cerro Prieto
8 Cohonina area
9 CWC13, Cottonwood Canyon
10 Crack in the Rock, Wupatki National Monument
11 Eagletail Mountains
12 First Mesa
13 Four Corners (New Mexico, Colorado, Arizona, and Utah)
14 Gila Bend
15 Han'lipinkia, Zuni area
16 Hopi Mesas or area
17 Inscription Point, Wupatki National Monument
18 Kayenta area
19 Keam's Canyon
20 Marsh Pass
21 Newspaper Rock, Petrified Forest National Park
22 North Mesa, Wupatki National Park
23 Oakley Springs (Same as Willow Springs)
24 Oraibi
25 Owl Springs, Monument Valley
26 Palo Verde Hills
27 **Painted Rocks State Park**
28 Petrified Forest National Park
29 Picacho Mountain
30 Pima area
31 **Puerco Ruin, Petrified Forest National Park**
32 Rillito Peak
33 San Carlos Agency, Apache Indian area
34 San Francsico Mountains
35 Santan Mountains
36 **Signal Mountain, Tucson Mountain Park**
37 Sityatki Ruin
38 Snaketown
39 Sinagua area
40 South Mountains
41 Springerville
42 Superstition Mountains
43 Tsegi Canyon
44 Vemtama Cave
45 Willow Springs (Same as Oakley Springs)
46 Winona
47 Yavapai Indian area

Martinez Hill and Hayden Peak, Sacaton Mountains, not shown.

Directions to **bold** sites may be found under "Directions to 18 Rock Art Sites . . ."

ARIZONA—ROCK ART SITES

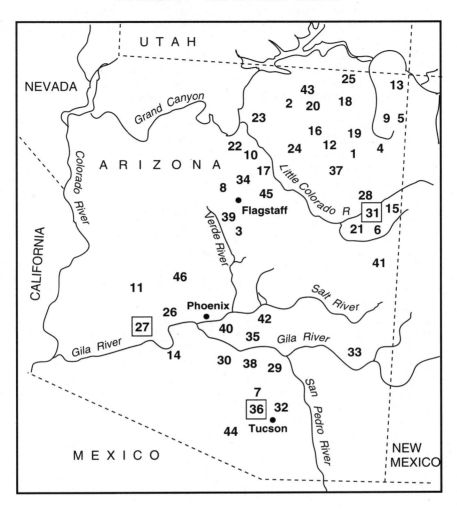

CALIFORNIA

1 Baker Dam area, Joshua Tree National Monument
2 Burro Flats
3 Chalfont Canyon site
4 Chumash Indian area
5 **Coso Range** (includes Little Petroglyph Canyon, Renegade Canyon, and Sheep Canyon)
6 Hamlet Site #6, Kern River
7 Hawley Lake, Sierra County
8 Hawley Springs
9 McCardle Flat site (Sha-511)
10 Painted Cave, near Santa Barbara
11 Pinehurst Site, North Fork of the American River
12 Pit River
13 Santa Barbara area
14 Shelter Rock site, Mojave Desert
15 Smuggler's Canyon, Anza Borrego State Park
16 Tule River
17 Yucca Valley, San Bernardino Mountains

NEVADA

1 **Grapevine Canyon**
2 Hickson Summit and Northumberland sites
3 Overton
4 Pahranagat Lake vicinity
5 **Valley of Fire State Park**

Lyon's Peak, California, and Gold Butte Road, Nevada, not shown.

Directions to **bold** sites may be found under "Directions to 18 Rock Art Sites . . ."

CALIFORNIA AND NEVADA—ROCK ART SITES

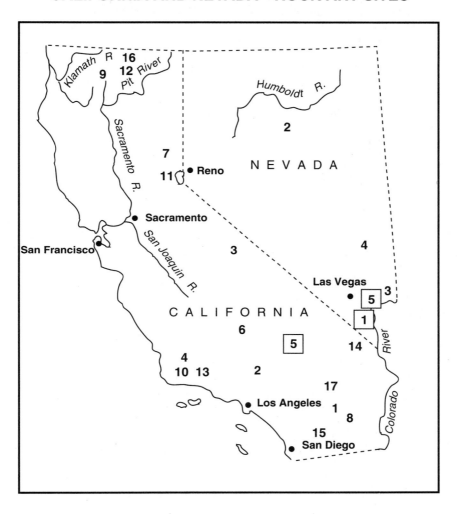

COLORADO

1 Hidden Valley Cave, Durango
2 Mancos Canyon
3 Pictograph (Petroglyph) Point, Mesa Verde National Park

UTAH

1 Ashley–Dry Fork Canyons
2 Butler Wash, San Juan River
3 Cedar Mesa
4 Colorado River west of Moab
5 Defiance House, Forgotten Canyon
6 Glen Canyon area (includes Cha Canyon mouth, Desha Canyon mouth, Lower Cha Canyon, NA2681, San Juan River, NA7136 Oak Canyon mouth, NA7179, NA7238, San Juan River, Paiute Creek mouth, Smith Fork Bar— most sites under water)
7 Green Mask site, Grand Gulch
8 Horseshoe (Barrier) Canyon, Canyonlands (West) National Park
9 Holly House, Hovenweep National Monument
10 Indian Creek
11 McKee Springs, Dinosaur National Monument
12 Cottonwood Canyon
13 Moab
14 Newspaper Rock
15 Nine Mile Canyon
16 Parawan Gap
17 Pleasant Creek Canyon, Capital Reef National Park
18 Rock Ruin (Kachina Bridge), Natural Bridges National Monument
19 Sand Island
20 San Juan River
21 Venice
22 West of Green River
23 Wild Horse Canyon
24 Zion National Park

Clear Creek and Short Canyon, Utah, not shown.

Directions to **bold** sites may be found under "Directions to 18 Rock Art Sites . . ."

COLORADO AND UTAH—ROCK ART SITES

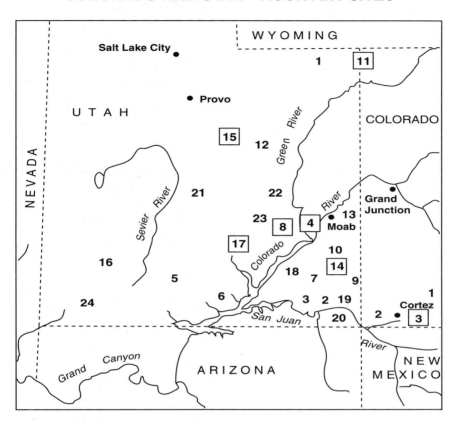

NEW MEXICO

1 Abo, Abo Gap, Abo Ruins
 Wash, Abo Monument
2 Alamo Mountain
3 Alamo Hueco Mountains
4 Arrow Grotto, Feather Cave,
 Capitan
5 Bandelier National Monument
 (includes Cave Kiva, Morland
 Canyon, Frijoles Canyon, Long
 House, Frijoles Canyon, Sandia
 Canyon, etc.)
6 Chaco Canyon
7 Cienaguilla, Cienegilla,
 Lacieneguilla
8 Comanche Gap
9 Cook's Peak
10 **El Morro National Monument**
11 Galaz Ruin
12 Galisteo and Galisteo Dyke

13 Zuni Reservation
14 **Hueco Tanks State Park**
15 Kuaua Ruins, Bernalillo
16 Largo Canyon Drainage,
 Gobernador Basin
17 Los Lunas
18 Mimbres Area
19 Navajo Reservoir Area
20 Painted Grotto, Guadalupe
 Mountains
21 **Petroglyph National Monument**
 (Includes Petroglyph [State]
 Park and West Mesa)
22 Pueblo Blanco
23 San Cristobal
24 **Three Rivers State Park**
25 Vado
26 Waterflow

Tenabo not shown.

Directions to **bold** sites may be found under "Directions to 18 Rock Art Sites . . ."

NEW MEXICO—ROCK ART SITES

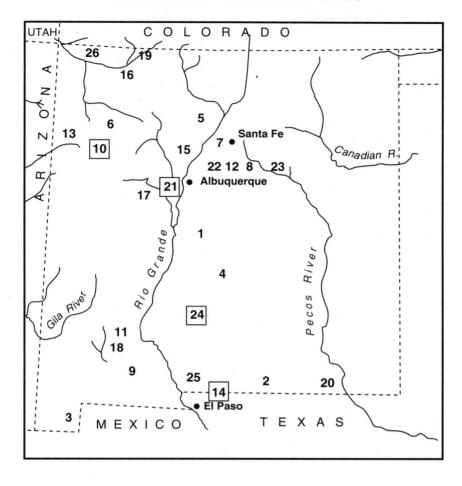

TEXAS

1 Alamo Canyon (Same as Diablo Dam)
2 **Seminole Canyon State Park** (Same as Alamo Canyon)
3 Eagle Cave, Pecos Canyon, Val Verde County
4 **Hueco Tanks**
5 Oldham County
6 Satan Canyon, Val Verde County

MEXICO

1 Banamichi, Sonora River, State of Sonora
2 Candelaria Peaks, State of Chihuahua
3 Cara Pintada, State of Sonora
4 Casas Grandes, State of Chihuahua
5 Cenote Cave, Tancah, Yucutan
6 Cerro del Tecomate, State of Sinoloa (Same as El Tecomate)
7 Baja California (includes Cueva La Palma, Cueva Pintada, El Cacariso, Montivideo, etc.)
8 Tula (Ruins)
9 Huichol Indian area, State of Jalisco
10 La Pena Pintada, Tomatlan River, State of Jalisco
11 San Blas, State of Nayarit
12 Teopanacazco, Teotihuacan, Valley of Mexico
13 Teotihuacan, Valley of Mexico
14 Tinajo Romero, Sierra Pinocate, State of Sonora
15 Tomatlan River, State of Jalisco

Directions to **bold** sites may be found under "Directions to 18 Rock Art Sites . . ."

ALL OTHER STATES AND CANADA—ROCK ART SITES

1 Alamakee County, Iowa
2 The Dalles, Columbia River, Washington State
3 Ojibwa area, USA/Canada
4 Peterborough, Ontario, Canada
5 West Virginia
6 Wind River area, Wyoming
7 Writing-on-Stone Park, Alberta, Canada

TEXAS AND MEXICO—ROCK ART SITES

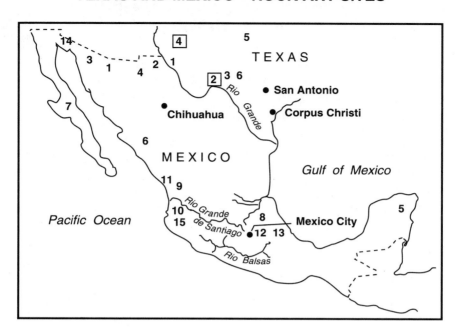

DIRECTIONS TO 18 ROCK ART SITES IN NATIONAL PARKS, STATE PARKS, AND AREAS SET ASIDE FOR PUBLIC VIEWING

Arizona

1. Painted Rocks State Park — South central Arizona; West of Gila Bend — Turn north off I-8 at Exit 102; follow signs to park. — 27

2. Puerco Ruins, Petrified Forest National Park — East central Arizona. East of Holbrook — Enter park from I-40 and proceed to Visitors' Center. Ask directions. — 31

3. Signal Mountain, Tucson Mtn. Park/ Sahauro Nat. Mon. — South central Arizona West of Tucson — From Tucson take 86 west; turn north to Tucson Mtn. Park/Saguaro Nat. Park. Ask at Visitors' Center. — 36

California

4. Little Petroglyph Cyn. Coso Range, China Lake Naval Weapons Range — Southern California East of Ridgecrest — Call or write Maturango Museum, Ridgecrest, CA for schedule of visits and make reservation. Spaces limited. Visits on certain Sundays only. — 5

Colorado

5. Pictograph Point, Mesa Verde National Park — Southwestern Colorado — Take 160 east from Cortez to Park; ask at Visitors' Center. Buy Petroglyph Trail Guide. — 3

Nevada

6. Grapevine Canyon — Southern Nevada — Take 163 west from Davis Dam (north of Bullhead City), turn north at sign. — 1

7. Valley of Fire State Park — Southern Nevada — Take I-93 north from Las Vegas; at Exit 75 turn east to park. Ask at Visitors' Center. — 5

New Mexico

8. Three Rivers State Park — South central New Mexico North of Tularosa — Go north on 54 from Tularosa 17 mi. to Park sign, turn east to campground; follow signs and trail to petroglyphs. — 24

9. Boca Negro Canyon Unit, Petroglyph National Monument	West of Albuquerque	Take I-40 west from Albuquerque; turn north at Coors Road to Montaño, left to Unser Blvd., right to park.	21
10. El Morro National Monument	West central New Mexico East of Zuni	Take Exit 81 south off I-40 onto 53 and follow signs. Ask at Visitors' Center.	10

Texas

11. Hueco Tanks State Park	Extreme west TX East of El Paso	Take 62-180 East from El Paso, turn north on 2775 to park. Ask at Visitors' Center.	4
12. Seminole Canyon State Park	Southwest Texas Northwest of Del Rio	Take 90 north out of Del Rio; at sign, turn left into park. Ask at Visitors' Center. Guided tours.	2

Utah

13. Horseshoe Canyon Canyonlands Nat'l Park (West Section)	East central Utah	Get directions from Visitors' Center in east section of park. Strenuous—consult with ranger before attempting.	8
14. Nine Mile Canyon	Northeast Utah	Take 6-191 3 mi. east of Wellington; take road north toward Myton. After sign, rock art north of road for miles.	15
15 Colorado River west of Moab	Southeast Utah	Take 191 north out of Moab, turn south on 279 along Colorado River, note signs on right.	4
16. Pleasant Creek Cyn Capitol Reef Nat. Pk.	South central Utah	Take 24 west out of Hanksville to Park Visitors' Ctr.; ask directionns to rock art at Pleasant Creek Canyon.	17
17. McKee Springs, Dinosaur National Monument	Extreme northeast Utah and northwest Colorado.	Go east on 40 from Vernal, turn north on 149 to Park Visitors' Ctr. Ask directions to McKee Springs.	11
18. Newspaper Rock	Southeast Utah	Take 191 north from Monticello; turn left on 211 for 19 miles to signs for site.	14

RECOMMENDED READING

General Rock Art

Grant, Campbell. 1967. *Rock Art of the American Indian.* Thomas Y. Crowell Co. Broad introduction to rock art.

Mallery, Garrick. Originally published in 1893–Reprinted 1972. *Picture-Writing of the American Indians.* Dover Publications, New York. First major work on rock art.

Schaafsma, Polly. 1980. *Indian Rock Art of the Southwest.* University of New Mexico Press. Outstanding work in the field.

Site- or Area-specific Rock Art

Castleton, Kenneth B. 1984–87. *Petroglyphs and Pictographs of Utah.* Two Volumes. Utah Museum of Natural History, Salt Lake City. Very thorough catalogue.

Cole, Sally J. 1990. *Legacy on Stone—Rock Art of the Colorado Plateau and Four Corners Region.* Johnson Books. Major work on these areas.

Grant, Campbell. 1978. *Canyon de Chelly—Its People and Rock Art.* University of Arizona Press. Impressive study, beautiful art work.

Grant, Campbell, J.W. Baird, and J.K. Pringle. 1969. *Rock Drawings of the Coso Range, Inyo County, California.* Maturango Museum, Ridgecrest, California. Thoughtful analysis.

Heizer, Robert F., and Martin A. Baumhoff. 1962. *Prehistoric Rock Art of Nevada and Eastern California.* University of California Press, Berkeley. Major analysis on Great Basin area.

Schaafsma, Polly. 1975. *Rock Art of New Mexico.* University of New Mexico Press. Thorough work on New Mexico.

Young, M. Jane. 1988. *Signs from the Ancestors—Zuni Cultural Symbolism and Perceptions of Rock Art.* University of New Mexico Press. Careful research with the Zuni people.

ORGANIZATIONS TO JOIN AND EVENTS TO ATTEND

American Rock Art Research Association (ARARA)—established 1974
 Arizona State Museum, University of Arizona, Tucson, AZ 85721-0026
 Annual Seminar—usually May, with field trips to nearby rock art sites.
 Annual publication—*American Indian Rock Art* (papers from seminar).
 Quarterly newsletter—*La Pintura.*

San Diego Museum of Man
 1350 El Prado, Balboa Park, San Diego, CA 92101
 Annual Seminar—usually in November.
 Annual Publication—*Rock Art Papers* (papers from seminar).
 Occasional field trips.

Utah Rock Art Research Association (URARA)—established 1980
 P.O. Box 511324, Salt Lake City, UT 84151-1324
 Annual Seminar—usually September, with field trips to nearby rock art sites.
 Annual Publication—*Utah Rock Art* (papers from seminar)
 Monthly newsletter—*Vestiges,* meetings and field trips.

BIBLIOGRAPHY

Amsden, Charles Avery
1949 *Prehistoric Southwesterners from Basketmaker to Pueblo.* Southwest Museum, Los Angeles.

Anderson, Keith
1971 Excavations at Betatakin and Kiet Siel. In *The Kiva* 37(1):1-29.

Anton, Ferdinand
1969 *Ancient Mexican Art.* Thames & Hudson, London.

Anyon, Roger, and Steven A. LeBlanc
1984 *The Galaz ruin: A prehistoric Mimbres village in southwestern New Mexico.* Maxwell Museum of Anthropology, Albuquerque.

Apostolides, Alex
1984 The Story Teller Woman Panel. In *The Artifact* 22(2). The El Paso Archaeological Society, El Paso.

Aschmann, Homer
1967 *The Central Desert of Baja California: Demography and Ecology.* Manessier Publishing Co., Riverside.

Aveni, Anthony, F. H. Hartung, and B. Buckingham
1978 The pecked cross symbol in Ancient Mesoamerica. In *Science* 202(4365): 276–279.

Barnes, F.A., and Michaelene Pendleton
1979 *Canyon Country—Prehistoric Indians—Their Cultures, Ruins, Artifacts and Rock Art.* Wasatch Publishers, Inc., Salt Lake City.

Benedict, Ruth
1935 *Zuni Mythology.* Columbia University Contributions to Anthropology 21(1 & 2). Columbia University Press, New York.

Bentley, Mark T.
1988 The Mimbres Butterfly Motif (The Rejuvenation of an Old Idea). In *The Artifact* 26(1). El Paso Archaeological Society, El Paso.

Benson, Arlene, and Linda Sehgal
1987 The Light at the End of the Tunnel. In *Rock Art Papers* vol. 5, edited by Ken Hedges, 1–16. San Diego Museum of Man.

Bilbo, Michael, and Kay Sutherland
1986 Stylistic Evolution of Rock Art in the Jornada Region. In *The Artifact* 24(3):11–29.

Blackburn, Thomas
1975 *December's Child.* University of California Press, Berkeley.

Bock, Frank, and A.J. Bock
1983 The Unexplored Canyons of Lake Mead: Possible Western Extension of Pueblo Rock Art. In *Rock Art Papers* vol. 1, edited by Ken Kedges. San Diego Museum Papers No. 16.

Brew, J. O.
1979 Hopi Prehistory and History to 1850. In *Handbook of North American Indians,* vol. 9, edited by Alfonso Ortiz. Smithsonian Institution, Washington, D.C.

Britt, Claude Jr.
1973 An Old Navajo Trail with Associated Petroglyph Trail Markers, Canyon de Chelly, Arizona. In *Plateau* 46(1):6-11. Flagstaff.

Brook, Vernon R.
1985 Some Jornada Clan Symbols and a Possible Shrine. *Views of the Jornada Mogollon: Proceedings of the Second Jornada Mogollon Archaeology Conference,* edited by Colleen M. Beck, 68-77. Contributions in Anthropology vol. 12, Eastern New Mexico University.

Burland, Cottie A.
1953 *Magic Books of Mexico.* Penguin Books, Middlesex, England.

Burland, Cottie A., and Werner Forman
1975 *Feathered Serpent and Smoking Mirror.* G.P. Putnam's Sons, New York.

Carr, Pat
1979 *Mimbres Mythology.* Univ. of Texas, Southwestern Studies, Monograph No. 56, El Paso.

Caso, Alfonso
1958 *The Aztecs–People of the Sun.* Univ. of Oklahoma Press, Norman.

Castleton, Kenneth B., and David B. Madsen
1981 The Distribution of Rock Art Elements and Styles in Utah. In *Journal of California and Great Basin Anthropology* 3(2):163–175.

Catlin, George
1844 *North American Indians.* Originally published in London with an introduction by Marjorie Halpin. Reprinted by Dover Publications, New York, 1973. Two Volumes.

Cole, Sally
1984a *Grand Gulch: The Outdoor Museum 1984.* Report prepared for White Mesa Institute, Blanding, Utah.
1984b Analysis of a San Juan (Basketmaker) style painted mask in Grand Gulch, Utah. In *Southwestern Lore* 50(1):1–6.
1985 Additional information on Basketmaker masks or face representations in rock art of southeastern Utah. In *Southwestern Lore* 51(1):4–18.
1989 Iconography and Symbolism in Basketmaker Rock Art. In *Rock Art of the Western Canyons,* edited by Jane S. Day, Paul D. Friedman, and Marcia J. Tate. *Colorado Archaeological Society Memoir* 3, jointly published by Denver Museum of Natural History and Colorado Archeological Society, Denver.

Colton, Harold S.
1946 Fools' names like fools' faces: Petroglyphs in northern Arizona. In *Plateau* 19(1):1–8.
1949 *Hopi Kachina Dolls, with a key to their identification.* Univ. of New Mexico Press, Albuquerque.

Colton, Harold S., and Mary Russel Colton
1931 Petroglyphs, the Record of a Great Adventure. In *American Anthropologist* 33:33–37.

Corbusier, William H.
1886 The Apache-Yumas and Apache-Mojaves. In *American Antiquarian,* Sept. 1886. Jameson & Morse, Chicago.

Crosby, Harry
1975 *The Cave Paintings of Baja California.* Copley Books, San Diego.

Cushing, Frank Hamilton
1883 Zuni Fetishes. In *Second Annual Report of the Bureau of Ethnology, 1880–81,* printed by the Government Printing Office, Washington, D.C. (Reprinted 1966, K.C. Publications, Las Vegas, Nevada.)
1886 A Study of Pueblo Pottery as Illustrative of Zuni Culture Growth. In *Fourth Annual Report of the Bureau of American Ethnology for the Years 1882–83,* 467–521. Government Printing Office, Washington, D.C.

1888 *Daily Report, Monday 5th March 1888.* From Hemenway Southwestern Archaeological Expedition, Daily Report of the Director, Camp Hemenway, Arizona. Located in the Library of the Museum of the American Indian, Bronx, New York.

1979 *Zuni: Selected Writings of Frank Hamilton Cushing.* Edited with an introduction by Jesse Green. University of Nebraska Press, Lincoln, Nebraska and London.

Daniels, Helen Sloan
1964 In *Basket Maker II Sites near Durango, Colorado.* Earl H. Morris and Robert F. Burgh, 87–88. Publication 604, Carnegie Institution of Washington, Washington D.C.

Davis, E.L.
1961 The Mono Craters Petroglyphs, California. In *American Antiquity* 27(2): 236–239.

Del Chamberlain, Von
1977 Sky Symbol Rock Art. In *American Indian Rock Art* vol. 5, edited by E. Snyder, A.J. and Frank Bock.

DiPeso, Charles C.
1974 *Casas Grandes—A Fallen Trading Center of the Gran Chichimeca.* Amerind Foundation, Dragoon, Arizona.

Dockstader, Frederick J.
1954 *The Kachina and the White Man.* Cranbrook Institute of Science, Bloomfield Hills, Michigan.

Doolittle, William E.
1988 *Pre-Hispanic Occupance in the Valley of Sonora, Mexico: Archaeological confirmation of Early Spanish Reports.* Anthropologic Papers of the University of Arizona, Number 48. University of Arizona Press, Tucson.

Dorn, Ronald I.
1990 Rock Varnish Dating of Rock Art: State of the Art Perspective. In *La Pintura* 17(2).

Dorsey, George A., and H.R. Voth
1901 *The Oraibi Soyal Ceremony.* Field Colombian Museum, Publication 55, Anthropological Series 3(1), Chicago.

DuBois, Constance Goddard
1908 The religion of the Luiseño and Diegueño Indians of Southern California. In *University of California Publications in American Archaeology and Ethnology* 8:69–186.

Duffield, Anne
1981 Petroglyphs of the Coso Range. In *Desert* 44(5):50–53.

Dunne, Peter Masten
1968 *Black Robes in Lower California.* University of California Press, Berkeley.

Dutton, Bertha
1963 *Sun Father's Way: Kiva Murals of Kuaua.* Univ. of New Mexico Press, Albuquerque.

Eastvold, Isaac
1987 Ethnographic Background for the Rock Art of the West Mesa Escarpment. In *Las Imagines, the Archaeology of Albuquerque's West Mesa Escarpment.* Matthew F Schmader and John D. Jays. Privately printed, Albuquerque.

Edberg, Bob
1985 Shamans and Chiefs: Visions of the Future. In *Earth and Sky*, edited by Arlene Benson and Tom Hoskinson. Slo'w Press, Thousand Oaks, California.

Eddy, John
1981 Astroarchaeology. In *Insights into the Ancient Ones*, edited by Joanne H. and Edward F. Berger. Mesa Verde Press, Cortez, Colorado.

Eliade, Mircea
1964 *Shamanism: Archaic Techniques of Ecstacy*. Translated from the French by William R. Trask. Routledge and K. Paul, London.
1972 *Shamanism, Archaic Techniques of Extacsy*. Princeton Univ. Press, Princeton.

Ellis, Florence Hawley, and Laurens Hammack
1968 The Inner Sanctum of Feather Cave, a Mogollon Sun and Earth Shrine linking Mexico and the Southwest. In *American Antiquity* 33(1):25–44.

Faris, Peter K.
1986 A fertility ceremony illustrated in the Cave of Life, Petrified National Park, AZ. In *Southwestern Lore* 52(1):4–6.
1987 Post-classic vernal abstraction: The evolution of a unique style in late Fremont rock art in Dinosaur National Monument, Utah. In *Southwestern Lore* 53(1):28–41.

Fewkes, Jesse Walter
1892 A Few Tusayan Pictographs. In *American Anthropologist* 5:5–20.
1897 Tusayan Totemic Signatures. In *American Anthropologist* 10(1))1–11.
1898 Sikyatki and its Pottery. Excerpt from "Archeological Expedition to Arizona in 1895," 631–728. In *Seventeenth Annual Report of the Bureau of American Ethnology to the Secretary of the Smithsonian Institution 1895–6*. J.W. Powell, Director. Government Printing Office, Washington D.C. (Reprinted 1973, Dover Publications, New York.)
1903 Hopi Kachinas drawn by native artists. In *Annual Report of 1903. Bureau of American Ethnology*. (Reprinted 1969, Rio Grande Press, Glorieta, New Mexico.)
1906 Hopi Shrines near the East Mesa, Arizona. In *American Anthropologist* 8:346–371.
1919 Designs on Prehistoric Hopi Pottery. *Thirty-third Annual Report of the Bureau of American Ethnology to the Secretary of the Smithsonian Institution 1911–12*. Government Printing Office, Washington, D.C. (Reprinted 1973, Dover Publications, New York.)

Frazier, Kendrick
1986 *People of Chaco: A Canyon and Its Culture*. W.W. Norton, New York.

Furst, Peter T.
1969 Myth in Art: A Huichol Depicts His Reality. In *Los Angeles County Museum of Natural History Quarterly* 7(3):16–25. Winter 1968-69. Reprint No. 11, UCLA Latin American Center.
1974 Ethnographic Analogy in the Interpretation of West Mexican Art. In *The Archaeology of West Mexico*, edited by Betty Bell. West Mexican Society for Advanced Study, Ajijic, Jalisco.
1986 Shamanism, the Ecstatic Experience, and Lower Pecos Art. In *Ancient Texans*, edited by Harry J. Shafer. Texas Monthly Press, San Antonio.

Gardner, W.A.
1940 Place of the Gods. In *Natural History* 45:40–43, 54–55.

Gortner, Willis A.
1988 Evidence for a Prehistoric Petroglyph trail map in the Sierra Nevada. *North American Archaeologist* 9(2):147–154.

Grant, Campbell
1967 *Rock Art of the American Indian*. Thomas Y. Crowell, New York.
1976 Some Painted Rock Art Sites in the Sierra Libre, Sonora, Mexico. In *American Indian Rock Art* vol. VII, edited by A.J. and Frank Bock, John Cawley.
1978 *Canyon de Chelly: Its People and Its Rock Art*. Univ. of Arizona Press, Tucson.

1979 The occurence of the atlatl in rock art. In *American Indian Rock Art* vol. 5, edited by Frank G. Bock etc., 1–21. ARARA, El Toro, California.

Grant, Campbell, and J.W. Baird, and J.K. Pringle
1968 *Rock Drawings of the Coso Range.* Maturango Museum, China Lake, California.

Green, John W.
1967 Rock Art of the El Paso Southwest: Reinvestigation of the Fusselman Canyon Petroglyph Sites: EPAS-44. In *The Artifact* 5(2):35–44. The El Paso Archaeological Society, El Paso.

Grieder, Terence
1966 Periods in Pecos Style Pictographs. In *American Antiquity* 31(5):710–720.

Gunn, J.
1917 *Schat-Chen: History, Traditions and Narratives of the Queres Indians of Laguna and Acoma.* Albright and Anderson, Albuquerque.

Harris, James R.
1981 The War Twins Petroglyph and a Tentative Interpretation. In *American Indian Rock Art* vol.7 and 8, edited by Frank G.Bock, 65–178. ARARA, El Toro, California.
1986 Zion Park Petroglyph Canyon panel. In *American Indian Rock Art* vol. 10, edited by A.J. Bock, etc., 40–47. ARARA. El Toro, California.

Haury, Emil W.
1976 *The Hohokam: Desert Farmers and Craftsmen: Excavations at Snaketown, 1964–65.* University of Arizona Press, Tucson.

Hayden, Julian D.
1972 Hohokam Petroglyphs of the Sierra Pinacate, Sonora and the Hohokam Shell Expeditions. In *The Kiva* 37(2):74+.

Hayes, Alden C. and James A. Lancaster
1975 *Badger House Community—Mesa Verde National Park.* National Park Service, U.S. Dept. of the Interior, Washington, D.C.

Hedges, Ken
1981 Phosphenes in the Context of Native American Rock Art. In *American Indian Rock Art* vol. VII, VIII, edited by F. G. Bock.
1985 Rock Art Portrayals of Shamanic Transformation and Magical Flight. In *Rock Art Papers* vol. 2, edited by Ken Hedges, 83–94. San Diego Museum of Man.
1987 Patterned body anthropomorphs and the concept of phosphenes in rock art. In *Rock Art Papers* vol. 5, edited by Ken Hedges, 17–24. San Diego Museum of Man.

Heizer, Robert F., and Martin A. Baumhoff
1962 *Prehistoric Rock Art of Nevada and Eastern California.* Univ. of Los Angeles Press, Berkeley and Los Angeles.

Heizer, Robert F., and Thomas R. Hester
1978 Two Petroglyph Sites in Lincoln County, Nevada. 1-44 in *Four Rock Art Studies.* William C. Clewlow, Jr., ed. Ballena Press Publications on North American Rock Art 1. Socorro, New Mexico.

Heyden, Doris
1975 An Interpretation of the Cave Pyramid Underneath the Pyramid of the Sun in Teotihuacan, Mexico. In *American Antiquity* 40:131–47.

Hodge, Frederick W.
1907 The Narrative of Alvar Nuñez Cabeça de Vaca and the Narrative of the Expedition of Coronado, by Pedro de Castañeda. In *Spanish Explorers in the Southern United States, 1528–1543,* edited by Frederick W. Hodge and Theodore H. Lewis, 1–126; 273-387. Charles Scribner's Sons, New York.

Hudson, Travis
1979 A rare account of Gabrielino shamanism from the notes of John P. Harrington. In *Journal of California and Great Basin Anthropology* 1(2):356–362.

Hudson, Travis, and Georgia Lee
1984 Function and Symbolism in Chumash Rock Art. In *Journal of New World Archaeology* 6(3).

Hudson, Travis, and Ernest Underhay
1978 *Crystals in the Sky: An Intellectual Odyssey Involving Chumash Astronomy, Cosmology, and Rock Art.* Ballena Press Anthropological Papers No. 10, Socorro, NM.

Hultkrantz, Ake
1981 *Belief and Worship in Native North America.* Edited by Christopher Vecsey. Syracuse University Press, Syracuse, NY.
1987 *Native Religions of North America: The Power of Visions and Fertility.* Harper and Row, San Francisco.

Hunger, Heinz
1982 Ritual Coition as Sacred Marriage in the Rock Art of North America. In *American Indian Rock Art* vol. IX, edited by F.G. Bock.
1983 Ritual Coition With and Among Animals. In *American Indian Rock Art* vol. X, edited by A.J. and Frank Bock.

Jackson, William H., and William H. Holmes
1981 *Mesa Verde and the Four Corners: Hayden Survey 1874–76.* Reproduced from First Edition 1876 by Bear Creek Publishing, Ouray, Colorado.

Jennings, Jesse D.
1978 Prehistory of Utah and the Eastern Great Basin. In *Anthropological Papers* No. 98, University of Utah, Salt Lake City.

Johnson, Boma
1986 *Earth Figures of the Lower Colorado and Gila River Deserts: A Functional Analysis.* Arizona Archeological Society, Phoenix.

Johnson, Leroy, Jr.
1964 The Devil's Mouth Site: A Stratified Campsite at Amistad Reservoir, Val Verde County, Texas. In *Archaeology Series* No. 6, Department of Anthropology, University of Texas, Austin.

Kellogg, Rhoda, M. Knoll, and J. Kugler
1965 Form Similarity Between Phosphenes of Adults and Pre-School Children's Scribblings. In *Nature* 208(5015):1129–1130.

Kidder, A.V., and S.J. Guernsey
1919 Archaeological Explorations in Northeastern Arizona. *Bureau of American Ethnology Bulletin 65*, Washington, D.C.

Klüver, Heinrich
1942 Mechanisms of Hallucinations. In *Studies in Personality. Contributed in Honor of Lewis M. Terman,* Quin McNemar and Maud A. Merrill, eds., 175–207. McGraw-Hill Book Co., New York.

Kirkland, Forrest, and W.W. Newcomb
1967 *The Rock Art of Texas Indians.* University of Texas Press, Austin.

Kurath, Gertrude, and Samuel Marti
1964 *Dances of the Anahuac.* Viking Fund Publications in Anthropology No. 38, New York.

Laird, Carabeth
1984 *Mirror and Pattern: George Laird's World of Chemehuevi Mythology.* Malki Museum Press. Banning, California.

Lee, Georgia, and A.J. Bock
1982 Schematization and symbolism in American Indian rock art. In *American Indian Rock Art* vol. 7 and 8, edited by F.J. Bock, 26–32. ARARA El Toro, California.

Levi-Bruhl, Lucian
1985 *How Natives Think*. Princeton Univ. Press, Princeton.

Lewis-Williams, J.D., and T.A. Dowson
1988 The Signs of All Times: Entoptic Phenomena in Upper Palaeolithic Art. *Current Anthropology* 29(2).

Lommel, Andress
1967 *The World of the Early Hunters*. Evalyln Adams and MacKay, London.

Lumholtz, Carl
1900 Symbolism of the Huichol Indians. In *Memoirs of the American Museum of Natural History*. Anthropology II. Vol. III. May 1900. New York.
1902 *Unknown Mexico: A record of five years' explorations among the tribes of the western Sierra Madre in the terra caliente of Tepic and Jalisco; and among the Tarascans of Michoacan*. Vols. I and II. Rio Grande Press (1973 edition), Glorieta, New Mexico.
1904 Decorative Art of the Huichol Indians. In *Memoirs of the American Museum of Natural History*. Anthropology II. Vol. III. Dec. 1904. New York.

Mails, Thomas
1974 *A People called Apache*. Prentice-Hall, Englewood Cliffs.
1980 *The Pueblo Children of Earth Mother 2 Vols*. Doubleday & Colorado, Garden City.

Mallery, Garrick
1886 On the pictographs of the North American Indians. In *Fourth Annual Report of the Bureau of Ethnology*, 13–256. Washington, D.C.
1893 Picture Writing of the American Indians. *Bureau of Ethnology, Tenth Annual Report 1888–89*. Government Printing Office, Washington, D.C.

Malotki, Ekkehart, and Michael Lomatuway'ma
1987a *Maasaw: Profile of a Hopi God*. University of Nebraska Press (American Tribal Religions, vol. 11), Lincoln.
1987b *Stories of Maasaw; A Hopi God*. University of Nebraska Press (American Tribal Religions, vol. 10), Lincoln.

Manning, Steven J.
1990 Comprehensive Rock Art Literature Search through the files of the Division of State History, a summary. In *Utah Archaeology 1990, vol. 3(1)*, edited by Joel C. Janetski and Steven J. Manning. Published by Utah Statewide Archaeological Society, Utah Professional Archaeological Council and Utah Division of State History, Salt Lake City.

Martin, Donald E.
1976 Introduction to the Rock Art of Death Valley. In *American Indian Rock Art* vol. 3, 3rd Annual ARARA Symposium. Edited by A.J. Bock, Frank Bock, and John Cawley.

Martin, Paul S., and Fred Plog
1973 *The Archaeology of Arizona: A Study of the Southwest Region*. Doubleday and Natural History Press, Garden City.

Martynec, R.J.
1985a An Analysis of Rock Art at Petrified Forest National Park. In *Rock Art Papers* vol. 2, edited by K. Hedges. San Diego Museum Papers 18.

McCarthy, F.C.
1938 *Australian Aboriginal Decorative Art*. Australian Museum, Sydney.

McCreery, Pat and Jack McCreery
 A Petroglyph site with possible Hopi ceremonial association. In *American Indian Rock Art* vol.ll, edited by William D. Snyder etc., 1–7. ARARA, El Toro, California.

McGowan, Charlotte
1978 Female Fertility and Rock Art. In *American Indian Rock Art* vol. 4, edited by Ernest Snyder etc., 26–40. ARARA, El Toro, California.

McKern, W.C.
1978 *Western Colorado Petroglyphs.* Bureau of Land Management, Colorado Cultural Research Series 8.

Mesa Verde Museum Association
n.d. *Petroglyph Trail Guide: Pictograph Point, Mesa Verde National Park.* Published as *Aid to the National Park Service.* Mesa Verde Museum Association, Cortez, Colorado.

Michaelis, Helen
1981 Willow Springs: A Hopi Petroglyph Site. In *Journal of New World Archaeology* 4(2):1-23.

Miller, Arthur G.
1973 *The Mural Painting of Teotihuacan.* Dumbarton Oaks, Washington, D.C.
1977 The Maya and the Sea: Trade and Cult at Tancah and Tulum, Quintana Roo, Mexico. In *The Sea in the Pre-Columbian World,* edited by Elizabeth P. Benson. Dumbarton Oaks Research Library and Collections Trustees for Harvard Univ., Washington, D.C.

Minor, Rick
1975 *The Pit-And-Groove Petroglyph Style in Southern California.* Ethnic Technology Notes 15. San Diego Museum, San Diego, CA.

Montgomery, C.M.
1964 Corn shrine of the Tanos: Galisteo Basin, New Mexico. In *Desert* 27(l2): 26–28.

Morris, Ann A.
1930 *Rock Paintings and Petroglyphs of the American Indian. The Pictograph Project.* New York American Museum of Natural History.

Mountjoy, Joseph B.
1974 Some Hypotheses Regarding the Petroglyphs of West Mexico. In *Meso American Studies,* Univ. Museum of Southern Illinois, Carbondale.
1982 An interpretation of the Pictographs at La Pena Pintada, Jalisco, Mexico. In *American Antiquity* 47(1):110–126.
1987 *Proyecto Tomatlán de Salvamento Arqueológica: El Arte Rupestre.* Instituto Nacional de Antropologia e Historia, Mexico, D.F.

Mundy, Jr., W. Joseph
1981 An Analysis of the Chalfont Rock Art Site, Mono County, California. In *Messages from the Past: Studies in California Rock Art,* edited by Clement W. Meighan. Monograph XX, Institute of Archaeology UCLA.

Munn, Nancy D.
1973 Spatial Presentation of Cosmic Order in Walbiri Iconography. In *Primitive Art and Society,* edited by Anthony Forge, 193–220. Oxford University Press for the Wenner-Gren Foundation for Anthropological Research, London.

Murie, Olaus J.
1954 *Field Guide to Animal Tracks.* Houghton Mifflin, Boston.

Nabokov, Peter, and Robert Easton
1989 *Native American Architecture.* Oxford University Press, New York.

Newcomb, Jr., W.W.
1976 Pecos River Pictographs: The Development of an Art Form. In *Cultural Change and Continuity*, edited by Charles E. Cleland. Academic Press, New York.

Nissen, Karen M.
1974 The Record of a Hunting Practice at Petroglyph Site NV-Ly-1. In *Contributions to the University of California Archaeological Research Facility* 20:53-81.

Nissen, Karen M., and Eric W. Ritter
1986 Cupped Rock Art in north-central California: Hypotheses regarding age and social-ecological context. In *American Indian Rock Art* vol. ll, edited by William D. Hyder et al. ARARA, El Toro, California.

O'Kane, Walter Collins
1950 *Sun in the Sky*. Univ. of Oklahoma Press, Norman.

Olsen, Nancy H.
1985 *Hovenweep Rock Art: An Anasazi Visual Communication System*. Occasional Paper 14, Institute of Archaeology, Univ. of California, Los Angeles.

Ortiz de Zarate, Gonzalo
1976 *Petroglifos de Sinoloa*. Fomento Cultural Banamex, Mexico, DF.

Oster, Gerald
1970 Phosphenes. In *Scientific American* 222(2):82–87.

Packard, Gar, and Maggy Packard
1974 *Suns and Serpents: The Symbolism of Indian Rock Art*. Packard Publishing, Santa Fe.

Palmer, Gary B.
1980 *Karok World Renewal and Villages Sites: A Cultural and Historical District*. Ms. on file with the Klamath National Forest, Yreka, California.

Perkins, R.F "Chick"
n.d. *Petroglyphs*. Pueblo Grande de Nevada, Lost City Museum of Archaeology, Overton, Nevada.

Parsons, Elsie Clews
1923 The Origin Myth of Zuni. In *Journal of American Folk-Lore* vol. 36, 135–161, G.E. Stechert & Colorado, Lancaster, PA, and New York.
1926 Tewa Tales. In *Memoirs of the American Folk-Lore Society* vol. XIX, New York.
1939 *Pueblo Indian Religion*. University of Chicago Press, Chicago.
1985 Hopi and Zuni Ceremonialism. In *Memoirs of the American Anthropological Association* 39. Kraus Reprint Company. Millwood, New York.

Payen, L.A.
1968 A Note on Cupule Sculptures in Exogene Caves from the Sierra Nevada, California. In *Caves and Karst* 10(4):33–39.

Rafter, John
1987 Shelter Rock in the Providence Mountains. In *Rock Art Papers* 5, edited by K. Hedges, San Diego Museum Papers 23.
1989 Spiderweb Petroglyphs. In *La Pintura* 15(4):11–12. San Miguel, California.

Reichard, Gladys A.
1950 *Navaho Religion: A Study of Symbolism,* vols. 1 & 2. Bollingen Series 18. Stratford Press, New York.

Reichel-Dolmatoff, Gerardo
1978 *Beyond the Milky Way*. UCLA Latin American Center Publications, Los Angeles.

Renaud, Etienne B.
1938 The Snake Among the Petroglyphs from North-Central New Mexico. In *Southwestern Lore* 4(3):42–47.

Ritter, Dale W., and Eric W. Ritter
1970 Sympathetic Magic of the Hunt as Suggested by Petroglyphs and Pictographs of the Western United States. In *Valcamonica Symposium. Acts of the International Symposium on Prehistoric Art*, pp. 397, 399, 402, 403, figs. 195, 198, 200–202. Centro Camuno di Studi Preistorici, Capo di Ponte, Italy.
1972 Medicine men and spirit animals in rock art of western North America. In *Acts of the International Symposium on Rock Art, Lectures at Hanko 6–12 August 1972.*
1973 Prehistoric pictography in North America of medical significance. In *IXth International Congress of Anthropological and Ethnological Sciences*, Chicago.
1976 The Influence of the Religious Formulator in Rock Art of North America. In *American Indian Rock Art* vol. III, edited by A.J. and Frank Bock, and John Cawley.

Rohn, Arthur H., William M. Ferguson, and Lisa Ferguson
1989 *Rock Art of Bandelier National Monument.* University of New Mexico Press, Albuquerque.

Russell, Edward
1906 The Pima Indians. In *26th Annual Report, US Bureau of American Ethnology,* Washington, D.C.

Sahagun, Bernardino de
1969 *Historia general de las Cosas de Nueva Espana.* Annotated by Angel Maria Garibay. Editorial Porrua, Mexico City.

Sayles, E.B.
1935 An Archaeological Survey of Texas. In *Medallion Papers* 17, Gila Pueblo, Globe, Arizona.

Sandomingo, Manuel
1953 *Historia de Sonora (Pusolana): Tiempos Prehistoricos.* M. Sandomingo, Sonora.

Schaafsma, Polly
1963 Rock Art in the Navajo Reservoir District. In *Museum of New Mexico Papers in Anthropology* 7, Santa Fe.
1966 *Early Navajo Rock Paintings and Carvings.* Museum of Navaho Ceremonial Art, Arizona.
1971 The Rock Art of Utah. In *Papers of the Peabody Museum of Archaeology and Ethnology,* Harvard 65. Cambridge, Massachusetts.
1972 *Rock Art of New Mexico.* State Planning Office, Santa Fe.
1975 *Rock Art in New Mexico.* Cultural Properties Review Committee, University of New Mexico Press, Albuquerque.
1977 *Rock Art of the San Juan Drainage: From Pre-Horticultural Hunter-Gatherers Through the Anasazi.* Abstracted from her forthcoming book *Southwest Indian Rock Art* to be published by the Univ. of New Mexico Press.
1980 *Indian Rock Art of the Southwest.* School of American Research and University of New Mexico Press, Santa Fe and Albuquerque.
1981 Kachinas in Rock Art. In *Journal of New World Archaeology* 4(2):25–32.
1984 Rock Art in Chaco Canyon. In *New Light on Chaco Canyon*, ed. David Grant Noble. The School of American Research, Santa Fe, NM.
1986a Anasazi Rock Art in Tsegi Canyon and Canyon de Chelly: A View behind the Image. In *Tse Yaa Kin: Houses beneath the Rock*, edited by David Grant Noble. The School of American Research, Santa Fe.
1986b Rock Art. In *Handbook of North American Indians* vol.ll, Great Basin, edited by Warren D'Azevedo. Smithsonian Institution, Washington, D.C.

1987 Rock Art at Wupatki: Pots, Textiles, Glyphs. In *Wupatki and Walnut Canyon—New Perspectives on History, Prehistory, Rock Art,* edited by David Grant Noble. The School of American Research, Santa Fe.

Schaafsma, Polly, and M. Jane Young
1983 Early Masks and Faces in the Southwest Rock Art. In *Collected Papers in Honor of Charlie R. Steen, Jr.,* edited by Nancy L. Fox, 1–33. Archeological Society of New Mexico, Albuquerque.

Schele, Linda, and Mary Ellen Miller
1986 *The Blood of Kings: Dynasty and Ritual in Maya Art.* George Brazillier, Inc., New York, in association with Kimbell Art Museum, Ft. Worth.

Seler, Eduard
1902–3 *Codex Vaticannus 3773 (B).* Published by the Duke of Loubat, Berlin and London.
1963 *Codex Borgia—Commentarios al Codex Borgia.* Fondo de Cultura Economica, Mexico City, Mexico.

Siegel, Ronald K.
1977 Hallucinations. In *Scientific American* 237(4):132–140.

Siegel, Ronald K., and Murray E. Jarvik
1975 Drug-Induced Hallucinations in Animals and Man. In *Hallucinations: Behavior, Experience and Theory,* edited by Ronald K Siegel and Louis Jolyon West. John Wiley & Sons, New York.

Sims, Agnes C.
1949 *San Cristobal Petroglyphs.* Pictograph Press, Santa Fe.
1963 Rock Carvings: A record of folk history. In *Sun Father's Way,* by Bertha Dutton, 215–220. Univ. of New Mexico Press, Albuquerque.

Smith, Ron
1985 Rock Art of the Sierra de San Francisco: An Interpretive Analysis. In *Rock Art Papers* vol. 2, edited by K. Hedges. San Diego Museum.
1986a Serpent Cave. In *Rock Art Papers* vol. 3, edited by K. Hedges. San Diego Museum Papers 20.
1986b Male and Female Symbolism in the Great Mural Paintings of the Sierra de San Francisco, Baja California. In *Rock Art Papers* vol. 4, edited by K. Hedges. San Diego Museum Papers 21.

Smith, Watson
1952 *Kiva Mural Decorations at Awatovi and Kawaika-a.* Peabody Museum, Cambridge, Massachusetts.

Soustelle, Jacques
1967 *Arts of Ancient Mexico.* Viking Press, New York.

Steed, Jr., Paul P.
1980: Rock Art in Chaco Canyon. In *The Artifact* 18(3).

Steinbring, Jack and Gary Granzberg
1986 Ideological and Cosmological Inferences from North American Rock Art: An Exploratory Discussion. In *Rock Art Papers* 3, edited by K. Hedges. San Diego Museum Papers 20.

Stephen, Alexander MacGregor
1936 *Hopi Journal of Alexander M. Stephen* vols. 1 & 2. Columbia Univ. Contributions to Anthropology. Edited by Elsie Clews Parsons. Reprint 1969. AMS Press Inc., New York.
1940 *Hopi Indians of Arizona.* Southwest Museum Leaflets 14, Highland Park, Los Angeles.

Stevenson, Matilda Coxe
1904 The Zuni Indians. *23rd Annual Report 1901–02, Bureau of American Ethnology.* Reprinted 1985. Rio Grande Press, Glorieta, New Mexico.

Steward, J.H.
1933 Ethnography of the Ownes Valley Paiute. In *University of California Publications in American Archaeology and Ethnology* 33(3).

Strong, Emory
1959 *Stone Age on the Columbia River.* Portland, Oregon.

Sutherland, Kay
1976 A Survey of Picture Cave in the Hueco Mountains. In *The Artifact* 14(2). The El Paso Archaeological Society.
1977 A comparison of Jornada Mogollon mask motifs with contemporary kachina masks. In *American Indian Rock Art* vol. 3, edited by A.J. Bock etc., 24–143. ARARA, Whittier, California.

Sutherland, Kay, and Paul Steed
1974 The Fort Hancock Rock Art Site Number One. *The Artifact* 12:1–64.

Sutton, Mark Q.
1982 Kawaiisu Mythology and Rock Art: One Example. In *Journal of California and Great Basin Anthropology* 4(1).

Taraval, Sigismundo
1931 *The Indian Uprising in Lower California, 1734–1737, as described by Father Sigismundo Taraval.* Translated by Marguerite Eye Wilbur. The Quivira Society, Los Angeles.

Taube, Karl A.
1983 The Teotihuacan Spider Woman. In *Journal of Latin American Lore* 9(2):107–189.

Terrell, John Upton
1972 *Apache Chronicle.* World Publishing, New York.

Thomas, Jesse James
1981 Rock Art and the Religion of the Sky. In *American Indian Rock Art* vol. VII and VIII. Edited by F.G. Bock.

Thomas, Trudy
1976 Petroglyph distribution and the hunting hypothesis in central Great Basin. In *Tebiwa Journal of Idaho State Museum of Natural History* 18(2):65–78.

Thompson, J. Eric S
1970 *Maya History and Religion.* University of Oklahoma Press, Norman.

Turner II. Christy G.
1963 *Petroglyphs in the Glen Canyon Region: Styles, Chronology, Distribution and Relationship from Basketmaker to Navajo.* Museum of Northern Arizona Bulletin 38, Glen Canyon Series Number 4, Flagstaff.

Tyler, Hamilton A.
1964 *Pueblo Gods and Myths.* University of Oklahoma Press, Norman.

Vasquez, Pedro Ramirez
1968 *Mexico: The National Museum of Anthropology.* Harry N. Abrams Inc., New York.

Vastokas, Joan M., and Romas K. Vastokas
1973 *Sacred Art of the Algonkians: A Study of the Peterborough Petroglyphs.* Mansard Press, Peterborough, Ontario.

Venegas, Miguel
1759 *A Natural and Civil History of California* vol. I. James Rivington and James Fletcher, London. Reprint edition 1966. March of America Facsimile Series 38, University Microfilms, Inc., Ann Arbor, Michigan.

Viele, Catherine W.
1980 *Voices in the Canyon.* Southwest Parks and Monuments Association, Flagstaff.

Villagra, Agustin
1954 *Las Pinturas de Tetitla, Atetelco e Ixtapantongo.* Artes de Mexico, Mexico City.

Villagra-Caleti, Agustin
1971 Mural Painting in Central Mexico. In *Handbook of Middle American Indians* vol. 10, pt. 1, 135–156. Edited by Robert Wauchope. University of Texas Press, Austin.

Voegelin, Erminie W.
1938 Tubatulabal Ethnology. In *Anthropological Records* 2:1. University of CA Press, Berkeley.

Vuncannon, Delcie H.
1977 Do diamond chain patterns found on the high-desert indicate puberty practices? In *American Indian Rock Art* vol. III, 96–100. Papers presented at the 3rd Annual ARARA Symposium, ARARA, Whittier, California.
1985 Fertility Symbolism at the Chalfant Site, California. In *Rock Art Papers* vol. 2, edited by Ken Hedges, San Diego Museum of Man, 119–126.

Walker, Jearl
1981 About Phosphenes: Luminous Patterns That Appear When the Eyes Are Closed. In The Amateur Scientist (Column). *Scientific American* 244(5):174–184.

Wallace, Henry D., and James P. Holmlund
1986 *Petroglyphs of the Picacho Mountains: South Central Arizona.* Institute for American Research, Anthropological Papers 6.

Warner, Jesse E.
1982a The "Enclosure" Petroglyph Motif: One Possible Interpretation. In *American Indian Rock Art* vol. VII and VIII 1980-81, edited by F.G. Bock, 104–116.
1982 Figurines and Their Similarity to Rock Art Figures. In *Utah Rock Art* vol. II, 2nd Annual Symposium, Rock Art of Utah. Edited by Phil Gray and Cindy Everett.
1982b Concrete Concept Associations. In *Utah Rock Art* vol. II, 2nd Annual Symposium, Rock Art of Utah. Edited by Phil Gray and Cindy Everett.

Warner, Judith S.
1983 An Intuitive View of Waterflow, New Mexico. In *American Indian Rock Art* vol X. Edited by A.J. Bock and Frank Bock.

Waters, Frank
1963 *Book of the Hopi.* Viking Press, New York.

Watson, Editha L.
1964 *Navajo Sacred Places.* Navajoland Publications, Series 5, Window Rock.

Wellmann, Klaus F.
1975 Some Observations on the Bird Motif in North American Indian Rock Art. In paper presented at the symposium on American Indian Rock Art, El Paso.

White, Leslie A.
1932 The Acoma Indians. In *Bureau of American Ethnology, Forty-seventh Annual Report 1029–30,* Washington, D.C.

Whitley, David S.
1982 Notes on the Coso Petroglyphs, the Etiological Mythology of the Western Shoshone, and the Interpretation of Rock Art. In *Journal of California and Great Basin Anthropology* 4(2):262–272.

Wilbert, Werner
1981 Two Rock Art Sites in Calaveras County. In *Messages From the Past: Studies in California Rock Art,* edited by Clement W. Meighan. UCLA Institute of Archaeology, Monograph XX, University of California, Los Angeles.

Williamson, Ray A.
1984 *Living the Sky: The Cosmos of the American Indian.* University of Oklahoma
 Press, Norman.

Wright, Barton
1988 *The Mythic World of the Zuni: As Written By Frank Hamilton Cushing.* University of New Mexico Press, Albuquerque.

Yellowman's Brother, Navajo Farmer, Rock Point, Arizona
1979 *Navajo Farming.* Rock Point Community School, Chinle, Arizona.

Young, M. Jane
1982 Images of Power, Images of Beauty: Contemporary Zuni Perceptions of
 Rock Art. *Dissertation in Folklore and Folklife.* University of Pennsylvania.
1985 Images of Power and Power of Images: The Significance of Rock Art for
 Contemporary Zunis. In *Journal of American Folklore* 98(187):3–48.
1988 *Signs From the Ancestors: Zuni Cultural Symbolism and Perceptions of Rock Art.*
 University of New Mexico Press, Albuquerque.

Zigmond, Maurice L.
1977 The Supernatural World of the Kawaiisu. In *Flowers of the Wind: Papers on
 Ritual, Myth and Symbolism in California and the Southwest,* edited by
 Thomas Blackburn. Ballena Press Anthropological Papers 8:59–95.

CREDITS

Dating of Rock Art
Dorn 1990. Ronald I. Dorn, "Rock Varnish Dating of Rock Art: State of the Art Perspective" In *La Pintura*, published by ARARA, San Miguel, CA. Used with permission of the publisher.

Arrow
Grant, Baird & Pringle 1968. Campbell Grant, J.W. Baird, and J.K. Pringle, *Rock Drawings of the Coso Range*, published by the Maturango Museum, Ridgecrest, CA. Copyright © Campbell Grant 1968. Used with the permission of the copyright holder.
Grant 1967. Campbell Grant, *Rock Art of the American Indians* published by Thomas Y. Crowell, New York, 1967. Copyright © Campbell Grant, 1978. Used with the permission of the copyright holder.
Grant 1978. Campbell Grant, *Canyon de Chelly: Its People and Its Rock Art* published by the University of Arizona, Tucson, AZ. Copyright © University of Arizona Press 1978. Used with permission of the publisher..
Schaafsma 1980. Polly Schaafsma *Indian Rock Art of the Southwest*, published by the School of American Research, Santa Fe, NM and University of New Mexico Press, Albuquerque, NM. Used with permission of author and copyright holder.

Atlatl or Spear Thrower
Grant, Baird & Pringle 1968. *See* Arrow.
Grant 1979: Campbell Grant, "The Occurrence of the Atlatl in Rock Art" In *American Indian Rock Art*, Volume 5, published by American Indian Rock Art Association (ARARA), El Toro, CA. Used with permission of the publisher.
Castleton and Madsen 1981. Kenneth B. Castleton and David B. Madsen, "The Distribution of Rock Art Elements and Styles in Utah". In *Journal of California and Great Basin Anthropology, Volume 3, #2.* Copyright 1981 Malki Museum Editorial Press Board. Used with permission.
Newcomb 1976 W.W. Newcomb, jr. "Pecos River Pictographs—The Development of an Art Form." In *Cultural Change and Continuity* Editor: Charles E. Cleland. Published by the Academic Press. Used with permission of the publisher and author.
Wallace & Holmlund 1986. Henry Wallace and James P. Holmlund, *Petroglyphs of the Picacho Mountains; South Central Arizona.* published by the Institute of American Research, Tucson, AZ. Used with permission of the authors.

Badger
Colton 1946 Harold S. Colton, "'Fools' names like fools' faces—' Petroglyphs of Northern Arizona." In *Plateau* Vol. 19, No.1. Used by permission of the publisher.
Murie 1954. Olaus J. Murie, *Field Guide to Animal Tracks* published by Houghton Mifflin, Boston. Copyright © 1950 by Olaus J. Murie, copyright © 1974 by Margaret E. Murie. Reprinted by permission of Houghton Mifflin Company. All rights reserved.
Packard 1974. Gar and Maggy Packard, *Suns and Serpents: the Symbolism of Indian Rock Art* published by Packard Publishing, Santa Fe, NM. Used with permission.
Schaafsma 1980. *See* Arrow. Photograph by Karl Kernberger. Copyright © by Karl Kernberger 1980.

Beans
Colton 1949. Harold S. Colton, *Hopi Kachina dolls, with a key to their identification.* Published by the University of New Mexico Press, Albuquerque, NM. Used with permission of the publisher. Copyright © 1949, 1959. All rights reserved.
Doolittle 1988. William E. Doolittle, *Pre-Hispanic Occupance in the Valley of Sonora, Mexico: Archaeological Confirmation of Early Spanish Reports* Published by University of Arizona Press, Tucson, AZ, Anthropological Papers of the University of Arizona Press Number 48. Used by permission.
Mountjoy 1982. Joseph B. Mountjoy, "An interpretation of the Pictographs at La Pena Pintada, Jalisco, Mexico." In *American Antiquity* Vol. 47(1). Used with permission of the publisher and author.
Stephen 1936. Alexander MacGregor Stephen, *Hopi Journal of Alexander M. Stephen* Vols. 1 & 2. In Columbia University Contributions to Anthropology. Edited by Elsie Clews Parsons. Copyright © Columbia University Press, 1936. Used with permission.

Bear
Grant 1967. *See* Arrow.
Murie 1954 *See* Badger
Rohn 1989. Arthur H. Rohn, William M. Ferguson and Lisa Ferguson, *Rock Art of Bandelier National Monument* published by University of New Mexico Press, Albuquerque, NM. Copyright ©1989 by University of New Mexico Press, all rights reserved. Photographs courtesy of William M. Ferguson. Used with permission.
Schaafsma 1980. *See* Arrow. Fig. 162—photograph by Karl Kernberger. Copyright © by Karl Kernberger 1980.

Bird-Headed Humans
Grant 1978. *See* Arrow.
Schaafsma 1986a. Polly Schaafsma, "Anasazi Rock Art in Tsegi Canyon and Canyon de Chelly: A View behind the Image." In *Tsé Yaa Kin: Houses beneath the Rock* Editor David Grant Noble. Published by the School of American Research, Santa Fe, NM. Used with permission of the author, publisher, and photographer. Photograph by David Noble. Copyright ©1985.

Birthing
Cole 1984b. Sally Cole, "Analysis of a San Juan (Basketmaker) style painted mask in Grand Gulch, Utah" In *Southwestern Lore* Vol. 51, no. 1. Used by permission of the publisher.
Martynec 1985. R.J. Martynec, "An Analysis of Rock Art at Petrified National Park," in *Rock Art Papers*, Vol. 2, Edited by Ken Hedges, SAn Diego Museum Papers #18, 1985. Permission in process.
Ritter & Ritter 1973. "Prehistoric pictography in North America of medical significance" In *IXth International Congress of Anthropological and Ethnological Sciences*, Chicago, IL. Copyright © reserved for authors Ritter and Ritter.
Wallace and Holmlund 1986. *See* Atlatl or Spear Thrower.

Blanket Designs
Schaafsma 1980. *See* Arrow. Fig. 153. Photograph by Karl Kernberger. Copyright © Karl Kernberger 1980.
Seler 1963. Eduard Seler, *Codex Borgia—Commentarios al Codex Borgia*. 1963, p. 191. Published by Fondo de Cultura Económica, Mexico City, Mexico. Copyright © 1963, Fondo de Cultura Económica, S.A. de C.V.
J. Warner 1983. "An Intimate View of Waterflow, New Mexico." In *American Indian Rock Art* Vol. X. Editors A.J. and Frank Bock. Published by ARARA. Used with permission..

Boat
Grieder 1966. Terence Grieder, "Periods in Pecos Style Pictographs." In *American Antiquity* Vol. 31, No. 5. Used with permission.
Ritter & Ritter 1973. *See* Birthing.

Bow
Ritter & Ritter 1973. *See* Birthing.
Grant, Baird & Pringle 1968. *See* Arrow.
Schaafsma 1980: *See* Arrow. Fig. 261—photograph by Karl Kernberger. Copyright © Karl Kernberger 1980.

Breath
Cushing in Green 1979. Frank Hamilton Cushing, *Zuni : Selected Writings of Frank Hamilton Cushing*. Editor: Jesse Green. Published by University of Nebraska Press, Lincoln, Nebraska. Copyright © 1979 by the University of Nebraska Press. Used by permission.
Young 1988. M. Jane Young, *Signs of the Ancestors: Zuni Cultural Symbolism and Perceptions of Rock Art*. Published by University of New Mexico Press, Albuquerque, NM. Copyright © 1988 by the University of New Mexico Press, all rights reserved. Used with permission.

Bullroarer
Bilbo and Sutherland 1986. Michael Bilbo and Kay Sutherland, "Stylistic Evolution of Rock Art in the Jornada Region." In *The Artifact*, Vol. 24, No. 3. Used with permission.
Mails 1974. Thomas Mails, *A People Called Apache* Published by Prentice-Hall, Englewood Cliffs, NJ. Used with permission of the author.

Butterfly
Bentley 1988. Mark T. Bentley, "The Mimbres Butterfly Motif (The Rejuvenation of an Old Idea)" In *The Artifact* Vol. 26, #1. Used with permission of the publisher.
Colton 1946. *See* Badger.
Michaelis 1981. Helen Michaelis, "Willow Springs: A Hopi Petroglyph Site." In *Journal of New World Archaeology*, Vol. 4, No. 2. Copyright © UCLA Institute of Archaeology. Used with permission.
Vasquez 1968. Pedro Ramirez Vasquez, *Mexico: The National Museum of Anthropology* Published by Harry N. Abrams Inc. New York. Copyright © Pedro Ramirez Vasquez, 1968. Courtesy The National Museum of Anthropology, Mexico City.
Waters 1963. Frank Waters, *Book of the Hopi* Published by Penguin Books, New York. Copyright © 1963 by Frank Waters. All rights reserved. Used by permission of Viking Penguin, a division of Penguin Books USA Inc.
Wallace & Holmlund 1986. *See* Atlatl.

Centipede
Benson & Sehgal 1987. Arlene Benson and Linda Sehgal, "The Light at the End of the Tunnel" In *Rock Art Papers* Vol. 5. Published by the San Diego Museum of Man. Used with permission..
Colton 1946. *See* Badger.
Ritter & Ritter 1973. *See* Birthing

244

Steinbring & Granzberg 1986. Jack Steinbring and Gary Granzberg, "Ideological and Cosmological Inferences from North American Rock Art; An Exploratory Discussion." In *Rock Art Papers* Vol. 3. Published by the San Diego Museum of Man, San Diego, CA. Used with permission of publisher and authors.

Wallace & Holmlund 1986. *See* Atlatl

Warner 1982a. Jesse E. Warner, "The Enclosure Petroglyph Motif: One possible interpretation." In *American Indian Rock Art* Vol. VII, Editor: F.G. Bock, published by ARARA. Used with permission of the author and publisher.

Young 1988. *See* Breath.

Cloud

Colton 1946. *See* Badger.

Schaafsma 1980. *See* Arrow.

Stephen 1936. *See* Beans.

Waters 1963. *See* Butterfly

Coitus

Faris 1986. Peter K. Faris, "A fertility ceremony illustrated in the Cave of Life, Petrified National Park, Arizona." In *Southwestern Lore,* Vol. 52, No. 1. Used with permission.

Hunger 1983. Heinz Hunger, "Ritual Coition with and among Animals." In *American Indian Rock Art.* Vol. X. Editors: A.J. Bock and Frank Bock. Published by ARARA. Used with permission of the publisher.

Ritter & Ritter 1973. *See* Birthing.

Vastokas & Vastokas 1973. Joan M. and Romas K. Vastokas, *Sacred Art of the Algonkians: A Study of the Peterborough Petroglyphs* Published by the Mansard Press, Peterborough, Ontario, Canada. Used by permission of the authors.

J. Warner 1983. *See* Blanket Designs.

Combat

Castleton & Madsen 1981. *See* Atlatl.

Grant 1976. *See* Arrow.

Jennings 1978. Jesse D. Jennings, "Prehistory of Utah and the Eastern Great Basin" In *Anthropological Papers,* No. 98, University of Utah, Salt Lake City, UT. Copyright © 1978 Jesse D. Jennings. Used with permission of University of UT Press.

Ritter & Ritter 1973. *See* Birthing.

Comet

Hudson & Lee 1984. Travis Hudson and Georgia Lee, "Function and Symbolism in Chumash Rock Art." In *Journal of New World Archaeology* Vol VI, No. 3. Copyright © UCLA Institute of Archaeology. Reprinted with permission of the UCLA Institute of Archaeology.

Rafter 1987. John Rafter, "Shelter Rock in the Providence Mountains." In *Rock Art Papers* Vol. 5 Editor: Ken Hedges. Published by the San Diego Museum of Man, San Diego, CA. Used with permission.

Concentric Circles

Benson & Sehgal 1987. *See* Centipede.

Daniels 1964. Helen Sloan Daniels in *Basket Maker II Sites near Durango, Colorado* by Earl H. Morris and Robert F. Burgh. Published by Carnegie Institution of Washington, Washington, DC. Used by permission.

Doolittle 1988. *See* Beans.

Edberg 1985. Bob Edberg, "Shamans and Chiefs: Visions of the future." In *Earth and Sky* Editors: Arlene Benson and Tom Hoskinson. Thousand Oaks, CA; Slo'w Press. Used with permission.

Ellis & Hammack 1963. Florence Hawley Ellis and Laurens Hammack, "The Inner Sanctum of Feather Cave, a Mogollon Sun and Earth Shrine linking Mexico and the Southwest." In *American Antiquity,* Vol. 33, No. 1. Used with permission.

Hedges 1981. Ken Hedges, "Phosphenes in the Context of Native American Rock Art." In *American Indian Rock Art,* Vol VII, VIII, Editor: F.G. Bock. Published by ARARA. Used with permission.

Stephen 1940. Alexander MacGregor Stephen, *Hopi Indians of Arizona* Leaflet #14, Published by the Southwest Museum, Los Angeles, CA. Courtesy of the Southwest Museum, Los Angeles.

Corn

Colton 1946. *See* Badger.

Colton 1949. *See* Beans.

Mountjoy 1982. *See* Beans.

Sims 1949. Agnes C. Sims, *San Cristobal Petroglyphs.* Published by Pictograph Press, Santa Fe, NM. Used with permission.

Schaafsma 1966. Polly Schaafsma, *Early Navajo Rock Paintings and Carvings.* Museum of Navajo Art, Arizona. Used with permission of the author.

Coyote, Dog, or Wolf

Grant, Baird & Pringle 1968. *See* Arrow.

Hudson & Lee 1984. *See* Comet.

Mundy in Meighan 1981 W. Joseph Mundy, Jr. "An Analysis of the Chalfont Rock Art site, Mono County, California." In *Messages from the Past: Studies in California Rock Art.* Editor: Clement W. Meighan, Monograph XX. Published by the Institute of Archaeology, UCLA. Copyright © UCLA Institute of Archaeology. Reprinted with permission of the UCLA Institute of Archaeology.

Schaafsma 1980. *See* Arrow. Photograph by Karl Kernberger. Copyright © by Karl Kernberger 1980.

Stephen 1936. *See* Beans.

Waters 1963. *See* Butterfly.

Whitley 1982. David S. Whitley, "Notes on the Coso Petroglyphs, the Etiological Mythology of the Western Shoshone, and the Interpretation of Rock Art." In *Journal of California and Great Basin Anthropology*, Vol. 4, No. 2. Copyright © 1982, Malki Museum Press Editorial Board. Used by permission.

Crane

Grant 1978. *See* Arrow.

Murie 1954. *See* Badger.

Vastokas & Vastokas 1973. *See* Coitus.

Creator or Sky God

Colton 1949. *See* Beans.

Stephen 1936. *See* Beans.

Crook

Cole 1989. Sally Cole, "Iconography and Symbolism in Basketmaker Rock Art" In *Rock Art of the Western Canyons* Editors: Jane S. Day, Paul D. Friedman & Marcia J. Tate. Colorado Archaeological Society Memoir #3. Jointly published by Denver Museum of Natural History and Colorado Archaeological Society, Denver, CO. Used with permission.

Sims 1949. *See* Corn.

Cross

Aveni, Hartung & Buckingham 1978. Anthony Aveni, F.H. Hartung and B. Buckingham, "The Pecked Cross Symbol in Ancient Mesoamerica." In *Science* Vol 202, no. 4365. Copyright © by the AAAS. Used with permission of the publisher and the author.

Haury 1976. Emil W. Haury, *The Hohokam: Desert Farmers and Craftsmen—Excavations at Snaketown 1964-65* Published by the University of Arizona Press, Tucson, AZ. Copyright © 1976. Used with permission of the publisher.

Schaafsma 1980. *See* Arrow. Photograph by Karl Kernberger. Copyright © by Karl Kernberger 1980.

Seler 1963. *See* Blanket Designs.

Stephen 1936. *See* Beans.

Curing

Grant 1978. *See* Arrow.

Schaafsma in Noble 1986a. Polly Schaafsma, "Anasazi Rock Art in Tsegi Canyon and Canyon de Chelly: A View behind the Image." In *Ysé Yaa Kin: Houses beneath the Rock* Editor: David Grant Noble. Published by the School of American Research, Santa Fe, NM. Used with permission of publisher and author. Photographs copyright © 1985 by David G. Noble. Used by permission of David G. Noble.

Wallace & Holmlund 1986. *See* Atlatl.

Dancers in Row

Cushing 1888. Frank Hamilton Cushing, *Daily Report, Monday 5th March 1888.* From Hemenway Southwestern Archaeological Expedition, Daily Report of the Director, Camp Hemenway, Arizona. Copyright © 1987 by the Huntington Free Library. Courtesy of the Huntington Free Library, Bronx, NY. Used with permission.

Schaafsma 1963. Polly Schaafsma, "Rock Art in the Navajo Reservoir District" In *Museum of New Mexico Papers in Anthropology* Number 7. Published by the Museum of New Mexico Press, Santa Fe, NM. Used with permission.

Sutherland 1977. Kay Sutherland, "A comparison of Jornada Mogollon mask motifs with contemporary kachina masks." In *American Indian Rock Art*, Vol III. Editor: A.J. Bock. Published by ARARA. Used with permission of the publisher.

Datura

Furst 1986. Peter T. Furst, "Shamanism, the Ecstatic Experience, and Lower Pecos Art" In *Ancient Texas,* Editor: Harry J Shafer. Copyright © 1986 by Gulf Publishing Company, Houston, Texas. Used with permission. All rights reserved.

Hudson & Lee 1984. *See* Comet.

Death

Hudson & Lee 1984. *See* Comet.

Wallace & Holmlund 1986. *See* Atlatl.

Waters 1963. *See* Butterfly.

Deer
Young 1988. *See* Breath.

Diamond Chain
Mountjoy 1982. *See* Beans.
Schaafsma 1980. *See* Arrow. Fig. 29. Photograph by Karl Kernberger. Copyright © by Karl Kernberger 1980.
Vuncannon 1977. Delcie H. Vuncannon, "Do diamond chain patterns found on the high-desert indicate puberty practices?" In *American Indian Rock Art*, Vol. III. Published by ARARA. Used with permission.

Dots
Hudson & Lee 1984. *See* Comet.
Lewis-Williams & Dowson 1988. J.D. Lewis-Williams and T.A. Dowson, "The Signs of All times: Entoptic Phenomena in Upper Palaeolithic Art." In *Current Anthropology* Vol. 29, No. 2. Used with permission.
Mountjoy 1982. *See* Beans.

Dragonfly
Harris 1986. James R. Harris, "Zion Park Petroglyph Canyon panel." In *American Indian Rock Art,* Vol. 10, Editor: A.J. Bock et al. Published by ARARA. Used with permission.
W. Smith 1952. Watson Smith, *The Mural Decorations at Awatovi and Kawaika-a,* Peabody Museum Papers, Vol. 37, figs. 9 and 81 with the permission of the Peabody Museum, Harvard University.
Wright 1988. Barton Wright, *The Mythic World of the Zuni: as Written by Frank Hamilton Cushing.* Published by University of New Mexico Press. Copyright © 1988 University of New Mexico Press. Used with permission of the publisher.

Dumbbell
Apostolides 1984. Alex Apostolides, "The Story Teller Woman Panel" In *The Artifact* Vol 22, #2. Published by the El Paso Archaeological Society, El Paso, Texas. Used with permission.
Mountjoy 1987. Joseph B. Mountjoy, "Proyecto Tomatlán de Salvamento archeológico: el arte rupestre" In *Instituteo National de Antropolgia e Historia,* Mexico, D.F. Used with permission of the author.

Eagle
Mesa Verde Museum Association n.d. *Petroglyph Trail Guide—Pictograph (Petroglyph) Point, Mesa Verde National Park.* Published by the Mesa Verde Museum Association, Cortez, Colorado. Used with permission of the publisher.
Rohn et al 1988. *See* Beans.
Sims 1949. *See* Corn.
Young 1988. *See* Breath.

Ear Extensions
Grant 1978. *See* Arrow.
Schaafsma 1980. *See* Arrow. Photograph by Karl Kernberger. Copyright © by Karl Kernberger 1980.

Emergence
Carr 1979. Pat Carr, *Mimbres Mythology* Southwestern Studies, Monograph #56. Published by University. of Texas Press, El Paso, Texas. Copyright © by Texas Western Press of the University of Texas at El Paso. Used with permission.
Harris 1981. James R. Harris, "The War Twins Petroglyph and a Tentative Interpretation." In *American Indian Rock Art* Vol. 7+8, Editor: Frank G. Bock. Published by ARARA. Used with permission.
Mesa Verde Museum Association. *See* Eagle.

Enclosures
Warner 1982a. *See* Centipede.
Schaafsma 1986b. Polly Schaafsma, "Rock Art" In *Handbook of North American Indians Vol. 11. Great Basin* Editor: Warren D'Azevedo. Series Editor: William C. Sturtevant. Published by Smithsonian Institution Press, Washington, DC. Copyright © Smithsonian Institution 1986. pp. 216, 219, 226. Used with permission.
Thomas 1981. Trudy Thomas, "Petroglyph distribution and the hunting hypothesis in central Great Basin" In *Tebiwa* Vol. 18, no. 2. Used with permission.

Facing Birds
Eastvold 1987. Isaac Eastvold, "Ethnographic Background for the Rock Art of the West Mesa Escarpment" In *Las Imagines, the Archaeology of Albuquerque's West Mesa Escarpment* by Matthew F. Schmader and John D. Jays. Albuquerque, NM. Privately printed. Used with permission.
Schaafsma 1980. *See* Arrow.
Sims 1949. *See* Corn.

Family
Grant 1967. *See* Arrow

Schaafsma 1972. Polly Schaafsma, *Rock Art in New Mexico* Published by the State Planning Office, Santa Fe, NM. Used with permission.

J. Warner 1983. *See* Blanket Designs

Feathers

Sims 1949. *See* Corn.

W. Smith 1952. *See* Dragonfly.

Female Figure

Grant 1978. *See* Arrow.

McGowen 1978. Charlotte McGowan, "Female Fertility and Rock Art" In *American Indian Rock Art* Vol. 4. Editor: Ernest Snyder. Published by ARARA. Used with permission.

Stephen 1936. *See* Beans.

Vastokas & Vastokas 1973. *See* Coitus.

Fish

Grieder 1966. *See* Boat.

Mountjoy 1982. *See* Beans.

Schaafsma 1980. *See* Arrow. Fig. 191. Photograph by Karl Kernberger. Copyright © by Karl Kernberger 1980.

Stephen 1936. *See* Beans.

Flute Player

Daniels 1964. *See* Concentric Circles.

Dockstader 1954. Frederick J. Dockstader, *The Kachina and the White Man* Published by the Cranfield Institute of Science, Bloomfield Hills, Michigan. Used with permission of the author.

Grant 1978. *See* Arrow.

Ritter & Ritter 1973. *See* Birthing.

Sims 1949. *See* Corn.

Waters 1963. *See* Butterfly.

Footprints

Schaafsma 1980. *See* Arrow.

Turner 1963. Christy G. Turner II, *Petroglyphs in the Glen Canyon Region: Styles, Chronology, Distribution and Relationship from Basketmaker to Navajo* Published by the Museum of Northern Arizona—Northern Arizona Society of Science and Art, Inc. Used with permission of the author.

Four Circles

Grant, Baird & Pringle 1968. *See* Arrow.

Laird 1984. Carabeth Laird, *Mirror and Pattern: George Laird's World of Chemehuevi Mythology* Published by the Malki Museum Press, Banning, CA. Copyright © 1984 by Malki Museum, Inc. Used with permission.

Miller 1977. Arthur G. Miller, "The Maya and the Sea: Trade and cult at Tancah and Tulum, Quintana Roo, Mexico" In *The Sea in the Pre-Columbian World* Editor: Elizabeth P. Benson. Published by Dumbarton Oaks Research Library and collections. Trustees for Harvard University, Washington, DC. Drawing by K. Grootenboer. Used with permission.

Schele & Miller 1986. Linda Schele and Mary Ellen Miller, *The Blood of Kings: Dynasty and Ritual in Maya Art* Published by George Brazillier Inc. in association with Kimbell Art Museum, Ft. Worth, Texas. Permission in process.

Friendship

Stephen 1936. *See* Beans.

Waters 1963. *See* Butterfly.

Frog, Lizard, or Toad

Schaafsma 1984. Polly Schaafsma, "Rock Art in Chaco Canyon" In *New Light on Chaco Canyon* Editor: David Grant Noble. Published by the School of American Research, Santa Fe, NM. Photograph by David Noble, © 1984. Used by permission of the publisher, author and photographer.

Young 1988. *See* Breath.

God of Death

Malotki & Lomatuway'ma 1987. Ekkehart Malotki & Michael Lomatuway'ma, *Maasaw: Profile of a Hopi God* Published by the University of Nebraska Press (American Tribal Religions Vol 11), Lincoln Nebraska. Reprinted by permission of University of Nebraska Press. Copyright © 1987 by the University of Nebraska Press. Used with permission.

Schaafsma 1980. *See* Arrow. Fig. 109—photograph by Karl Kernberger. Copyright © by Karl Kernberger 1980.

Stephen 1936. *See* Beans.

Stephen 1940. Alexander MacGregor Stephen, *Hopi Indians of Arizona* Southwest Museum Leaflet #14. Published by the Southwest Museum, Highland Park, CA. Used with permission..

Grid
Hedges 1981. *See* Concentric Circles.
Lewis-Williams & Dowson 1988. J.D. Lewis-Williams and T.A. Dowson, "The Signs of All Times: Entoptic Phenomena in Upper Palaeolithic Art" In *Current Anthropology* Vol. 29, No. 2. Used with permission of the publisher.
Wallace and Holmlund. 1986. *See* Atlatl

Handprint
Grant 1978. *See* Arrow.
Levy-Bruhl 1985. Lucian Levy-Bruhl, *How Natives Think* Published by the Princeton University Press, Princeton, NJ. Copyright © 1985 Princeton University Press. Reprinted by permission of the Princeton University Press.
Ritter & Ritter 1973. *See* Birthing.
Schaafsma 1986a. *See* Bird-Headed Humans
Schaafsma & Young 1983. Polly Schaafsma and M. Jane Young, "Early Masks and Faces in the Southwest Rock Art" In *Collected papers in honor of Charlie R. Steen, Jr.* Editor: Nancy L. Fox. Published by the Archaeological Society of New Mexico, Albuquerque, NM. Copyright © Archaeological Society of New Mexico 1983. Used with permission.
Stephen 1936. *See* Beans.

Headdress
Cole 1984b. Sally Cole, "Analysis of a San Juan (Basketmaker) style painted mask in Grand Gulch, Utah" In *Southwestern Lore* Vol. 51, no. 1. Used with permission.
Grant, Baird & Pringle 1968. *See* Arrow.
Grant 1978. *See* Arrow
Turner 1963. *See* Footprint.

Head Hunting
Castleton & Madsen 1981. *See* Atlatl
Cole 1984b. *See* Headdress
Cole 1985. Sally Cole, "Additional information on basketmaker masks or face representations in rock art of southeastern Utah" In *Southwestern Lore* Vol. 51, no. 1. Used with permission.
Faris 1987. Peter K. Faris, "Post-classic vernal abstraction; the evolution of a unique style in late Fremont rock art in Dinosaur National Monument, Utah" In *Southwestern Lore* Vol. 53, No. 1. Used with permission.
Stephen 1936. *See* Beans.
Schaafsma 1971. Polly Schaafsma, *The Rock Art of Utah—from the Donald Scott Collection.* In Papers of the Peabody Museum of Archaeology and Ethnology Volume 65, Cambridge, MA. Copyright © 1971 by the President and Fellows of Harvard College.

Headless
Benson & Sehgal 1987. *See* Centipede.
Hudson & Lee 1984. *See* Comet
Newcomb 1976. *See* Atlatl.

Heart Line
Grant 1967. *See* Arrow
Ritter & Ritter 1976. *See* Hocker..
Schaafsma 1963. *See* Dancers in Row.
Young 1988. *See* Breath.

Hocker
Caso 1958. Alfonso Caso, *The Aztecs: People of the Sun* Published by University of Oklahoma, Norman, OK, 1958, p. 55., originally published by Fondo de Cultura Económica. Copyright © 1958 Fondo de Cultura Económica, S.A. de C.V. Drawing from Codex Borbonicus 13, an ancient Mexican book.
Ritter & Ritter 1976. Dale W. Ritter and Eric W. Ritter, "The Influence of the Religious Formulator in Rock Art of North America." In *American Indian Rock Art,* Vol. III, Editors: A.J. and Frank bock and John Cawley. Published by ARARA. Used with permission.
Schaafsma 1980. *See* Arrow.
Vastokas & Vastokas 1973. *See* Coitus.

Horns
Grant, Baird & Pringle 1968. *See* Arrow
Grant 1978. *See* Arrow.
Michaelis 1981. *See* Butterfly.
Schaafsma 1980. Photograph by Karl Kernberger. Copyright © by Karl Kernberger 1980.
Vastokas & Vastokas 1973. *See* Coitus.
Waters 1963. *See* Butterfly.

Horsemen
Grant 1976. *See* Arrow.
Grant 1978. *See* Arrow.
Schaafsma 1980. *See* Arrow.

Hourglass
Schaafsma 1980. *See* Arrow. Fig. 261 Photograph by Karl Kernberger. Copyright © by Karl Kernberger 1980.
Williamson 1984. Ray A. Williamson, *Living the Sky: The Cosmos of the American Indian*. Copyright © 1984 by Ray A. Williamson. Line illustrations copyright © 1984 by Snowden Hodges. Reprinted by permission of Houghton Mifflin Company. All rights reserved.

Human Figure
Mesa Verde Museum Association. *See* Eagle.
Schaafsma 1963. *See* Dancers in Row.
Schaafsma 1980. *See* Arrow. Photograph by Karl Kernberger. Copyright © by Karl Kernberger 1980.

Hunter's Disguise
Rohn et al 1989. *See* Bear.

Hunting
Grant 1978. *See* Arrow.
Ritter & Ritter 1976. *See* Hocker.
Schaafsma 1980. *See* Arrow.
Thomas 1976. *See* Enclosures
Warner 1981. *See* Enclosures.
Young 1988. *See* Breath.

Irrigation
Doolittle 1988. *See* Beans.

Katcina–Ahole
Colton 1949. *See* Beans.
Ritter & Ritter 1973. *See* Birthing.

Katcina–Cha'veyo
Colton 1949. *See* Beans.
Stephen 1936. *See* Beans.

Katcina–Cholawitze
Colton 1949. *See* Beans.
Sims 1963. Agnes Sims, "Rock Carvings: A record of folk history" In *Sun Father's Way* by Bertha Dutton. Published by University of New Mexico Press, Albuquerque, NM. Copyright © 1963. University of New Mexico Press. Used with permission.

Katcina–Cloud
Colton 1949. *See* Beans.
Stephen 1936. *See* Beans.

Katcina–Deer
Colton 1949. *See* Beans
Sims 1949. *See* Corn.

Katcina–Dumas
Colton 1949. *See* Beans.
Stephen 1936. *See* Beans.

Katcina–Hehea
Colton 1949. *See* Beans.
Schaafsma 1980. *See* Arrow.

Katcina–Hemis
Colton 1949. *See* Beans.

Katcina–Mudhead Clowns
Martynec 1985b. *See* Birthing.
Sims 1949. *See* Corn.
Young 1988. *See* Breath.

Katcina–Planet
Sutherland 1977. *See* Dancers in Row.

Katcina–Sayathlia
Colton 1949. *See* Beans.
Mesa Verde Museum Association. *See* Eagle.

Ritter & Ritter 1973. *See* Birthing.
Sims 1949. *See* Corn.

Katcina–Shalako
Young 1988. *See* Breath.

Katcina Clan
Colton 1946. *See* Badger.
Michaelis 1981. *See* Butterfly.

Kinship Lines
Jackson & Holmes 1876. William H. Jackson and William H. Holmes, *Mesa Verde and the Four Corners: Hayden Survey 1874-76.* Reproduced from First Edition of 1876 by Bear Creek Publishing, P.O. Box 254, Ouray, Colorado 81427. Copyright © 1981 Bear Creek Publishing. All rights reserved. Used by permission.
Ritter & Ritter 1976. *See* Hocker.

Kwataka
Stephen 1936. *See* Beans.
Waters 1963. *See* Butterfly.

Lightning
Stephen 1936. *See* Beans.
Stephen 1940. *See* God of Death.

Maps
Gortner 1988. Willis A. Gortner, "Evidence for a Prehistoric Petroglyph trail map in the sierra Nevada." In *North American Archaeologist* Vol. 9 (2). Copyright © 1988 Baywood Publishing Co. Inc. Used with permission.
Wallace and Holmlund 1986. *See* Atlatl.

Masks
Cole 1984b. *See* Birthing.
Daniels 1964. *See* Concentric Circles.
Schaafsma 1980. *See* Arrow.

Mastodon
Barnes and Pendleton 1976. F.A. Barnes & Michaelene Pendleton, *Canyon Country—Prehistoric Indians—Their Cultures, Ruins, Artifacts and Rock Art.* Published by Wasatch Publishers, Inc., Salt Lake City. Copyright © 1979 by Wasatch Publishers, Salt Lake City, Utah. Photograph and text by F.A. Barnes, Moab, Utah.
Grant 1967. *See* Arrow.

Maze
Grant 1967. *See* Arrow.
Stephen 1936. *See* Beans.
Waters 1963. *See* Butterfly.

Medicine Bag
Grant, Baird & Pringle 1968. *See* Arrow.
Newcomb 1976. *See* Atlatl.

Migrations
Mesa Verde Museum Association. *See* Eagle.
Waters 1963. *See* Butterfly.

Mirror Images
Grant 1978. *See* Arrow.
Waters 1963. *See* Butterfly.

Moon
Colton 1946. *See* Beans.
Colton 1949. *See* Beans.
Eddy 1981. John Eddy, "Astroarchaeology" In *Insights into the Ancient Ones* Editors: Joanne H. and Edward F. Berger. Published by the Mesa Verde Press, Cortez, Colorado. Used with permission.
Michaelis 1981. *See* Butterfly.
Stephen 1936. *See* Beans.

Mother of Animals
McCreery & McCreery 1986. Pat McCreery and Jack McCreery, "A Petroglyph site with possible Hopi Ceremonial Association." In *American Indian Rock Art,* Vol. 11. Edited by William d. Snyder et al. Published by ARARA. Used with permission.
Schaafsma 1980. *See* Arrow. Fig. 109. Photograph by Karl Kernberger. Copyright © by Karl Kernberger 1980.
Turner 1963. *See* Footprints.

Mountain Lion
Grant 1967. *See* Arrow
Murie 1954. *See* Badger.
Johnson 1986. Boma Johnson, *Earth Figures of the Lower Colorado and Gila River Deserts: A Functional Analysis.* Published by the Arizona Archaeological Society, Phoenix, AZ. Used with permission.
Young 1988. *See* Breath.

Mountain Sheep
Grant, Baird & Pringle 1968. *See* Arrow.
Grant 1978. *See* Arrow.
Waters 1963. *See* Butterfly.
Young 1988. *See* Breath.

Parrot
Colton 1946. *See* Beans.
Mesa Verde Museum Association. *See* Eagle.
Michaelis 1981. *See* Butterfly.
Young 1988. *See* Breath.

Patterned Body Anthropomorphs
Grant, Baird & Pringle 1968. *See* Arrow.
Grant 1976. *See* Arrow.
Hedges 1985. Ken Hedges, "Rock Art Portrayals of Shamanic Transformation and Magical Flight" In *Rock Art Papers,* Vol. 2. Editor: Ken Hedges. Published by the San Diego Museum of Man, San Diego, CA. Used by permission of the author.

Phallic Figure
Ritter & Ritter 1972. Dale W. Ritter and Eric W. Ritter, "Medicine men and spirit animals in rock art of western North America" In *Acts of the International Symposium on Rock Art, Lectures at Hanko 6-12 August 1972.* Copyright © reserved for authors Ritter and Ritter.
Ritter & Ritter 1973. *See* Birthing.

Phosphenes
Hedges 1981. *See* Concentric Circles.

Pit and Groove
Minor 1975. Rick Minor, *The Pit-And-Groove Petroglyph Style in southern California.* San Diego Museum, Ethnic Technology Notes #15, San Diego, CA. Used with permission.
Nissen & Ritter 1986. Karen M. Nissen and Eric W. Ritter, "Cupped Rock Art in north-central California; hypotheses regarding age and social-ecological context." In *American Indian Rock Art* Vol. 11, Editors: William D. Hyder et al. Published by ARARA. Used with permission.
Schaafsma 1986b. *See* Enclosures.

Planetarium
Grant 1978. *See* Arrow.
Schaafsma 1963. *See* Dancers in row.

Plumed Serpent
Grant 1967. *See* Arrow.
Schaafsma 1980. *See* Arrow. Fig. 187—Photograph by Karl Kernberger © 1980 Karl Kernberger and Fig. 155—Photograph by New Mexico State Planning Office and Curtis Schaafsma. Redrawn from these photographs.
Sims 1949. *See* Corn.

Pottery Designs
Grant 1978. *See* Arrow.
Jackson & Holmes 1876. *See* Kinship Lines.
Schaafsma 1987. Polly Schaafsma, "Rock Art at Wupatki; Pots, Textiles, Glyphs" In *Wupatki and Walnut Canyon—New Perspectives on History, Prehistory, Rock Art.* Edited by David Grant Noble. Published by the School of American Research, Santa Fe, NM. Used with permission. Photograph by David Noble copyright © 1986. Used with permission. Quotation from M. Jane Young, dissertation 1982— *Images of Power, Images of Beauty: Contemporary Zuni Perceptions of Rock Art.* Copyright © Mary Jane Young 1982. Used with permission.

Power Lines
Grant 1978. *See* Arrow.
Newcomb 1976. *See* Atlatl.

Praying Person
DiPeso 1974. Charles C. DiPeso, *Casas Grandes—A Fallen Trading Center of the Gran Chichimeca* Published by the Amerind Foundation, Dragoon, AZ. All illustrations and text used through the courtesy of the Amerind Foundation, Dragoon, AZ.
Waters 1963. *See* Butterfly

Pregnancy
Grant, Baird & Pringle 1968. *See* Arrow.
Schaafsma 1972. *See* Family.
Wallace & Holmlund 1986. *See* Atlatl.

Quetzalcoatl
Schaafsma 1972. *See* Pregnancy.

Rabbit
Colton 1946. *See* Beans.
Vastokas & Vastokas 1973. *See* Coitus.

Rain
Rafter 1987. *See* Comet.
Viele 1980. Catherine W. Viele, *Voices in the Canyon* Published by Southwest Parks & Monuments Association, Flagstaff, AZ. Permission courtesy of Southwest Parks and Monuments Association, Publisher and Catherine W. Viele, author.

Rainbow
Castleton & Madsen 1981. *See* Atlatl.
Colton 1946. *See* Beans.

Rain God
Hedges 1987. Ken Hedges, "Patterned body anthropomorphs and the concept of phosphenes in rock art." In *Rock Art Papers*, Vol. 5, edited by Ken Hedges, pp. 17-24, San Diego Museum of Man. Used with permission.
Schaafsma 1980. *See* Arrow. Figure 163 and Plate 17—Photographs by Karl Kernberger. Copyright © by Karl Kernberger 1980.
Wallace & Holmlund 1986. *See* Atlatl.

Rattle
Perkins n.d. R.F. "Chick" Perkins, *Petroglyphs* From an exhibit. Used with the permission of the Lost City Museum of Archaeology, Pueblo Grande de Nevada, Overton, NV.
Ritter and Ritter. *See* Birthing.
Sims 1949. *See* Corn.
Stephen 1936. *See* Beans.

Red Ant
Bock and Bock 1983. Frank and A.J. Bock, "The Unexplored Canyons of Lake Mead: Possible Western Extension of Pueblo Rock Art" In *Rock Art Papers* Vol. 1. Editor: Ken Hedges. Published by the San Diego Museum of Man, San Diego, CA. Used with permission.
Colton 1946. *See* Beans.
Michaelis 1981. *See* Butterfly.
Young 1988. *See* Breath.

River
Doolittle 1988. *See* Beans.
Waters 1963. *See* Butterfly.

Runner
Laird 1984. *See* Four Circles.
Rohn et al 1989. *See* Bear.
Turner 1963. *See* Footprints.

Sandals
Amsden 1949. Charles Avery Amsden, *Prehistoric Southwesterners from Basketmaker to Pueblo* Published by Southwest Museum, Highland Park, Los Angeles, CA. Used with permission.
Schaafsma 1980. *See* Arrow.
Turner 1963. *See* Footprints.
Young 1988. *See* Breath.

Shaman
Grant 1978. *See* Arrow.
Grant, Baird & Pringle 1968. *See* Arrow.
Hedges 1985. "Rock Art Portrayals of Shamanic Transformation and Magical Flight." In *Rock Art Papers* Vol. 2. Editor: Ken Hedges. Published by the San Diego Museum of Man, San Diego, CA. Used with permission.

Shell
Hayden 1972. Julian D. Hayden, "Hohokam Petroglyphs of the Sierra Pinacate, Sonora, and the Hohokam Shell Expeditions." In *The Kiva*, Vol. 37., No. 2. Used with permission.

Mountjoy 1974. Joseph B. Mountjoy, "Some Hypotheses regarding the Petroglyphs of West Mexico." In *Meso-American Studies*, University Museum of Southern Illinois, University of Illinois, Carbondale, IL. Used with permission..

Schaafsma 1980. *See* Arrow.

Shields

Grant 1978. *See* Arrow.

Grant, Baird & Pringle 1968. *See* Arrow.

Lee & Bock 1982. Georgia Lee and A.J. Bock, "Schematization and symbolism in American Indian rock art." In *American Indian Rock Art*, Vol. 7+8. Editor: F.J. Bock. Published by ARARA. Used with permission.

Schaafsma 1980. *See* Arrow. Photograph by Karl Kernberger. Copyright © by Karl Kernberger 1980.

Waters 1963. *See* Butterfly.

Shrine

Schaafsma 1980. *See* Arrow

Sipapu

Mesa Verde Museum Association. *See* Eagle.

Waters 1963. *See* Butterfly.

Snakes

Michaelis 1981. *See* Butterfly.

Renaud 1938. Etienne B. Renaud, "The Snake among the Petroglyphs from North-Central New Mexico." In *Southwestern Lore* Vol. IV, No. 3. Used with permission.

Stephen 1936. *See* Beans.

Vuncannon 1977. *See* Diamond Chain.

Waters 1963. *See* Butterfly.

Solstice

Frazier 1986. Kendrick Frazier, *People of Chaco: A Canyon and Its Culture.* Published by W.W. Norton, New York and Colorado. Illustrations redrawn from The Solstice Project.

Williamson 1984. *See* Hourglass.

Speech

Brew 1979. J.O. Brew, "Hopi Prehistory and History to 1850" In *Handbook of North American Indians Volume 9: Southwest* edited by Alfonso Ortiz; series editor, William C. Sturtevant. Published by Smithsonian Institution Press. Copyright © Smithsonian Institution 1980. pp. 520. Used with permission.

Spider

Colton 1946. *See* Beans.

Michaelis 1981. *See* Butterfly.

Rafter 1989. John Rafter, "Spiderweb Petroglyphs" In *La Pintura*, Vol. XV, No. 4. Published by ARARA. Used with permission.

Waters 1963. *See* Butterfly.

Spirals

Benson & Sehgal 1987. *See* Centipede. Pen and ink drawing lower left done by Sheridan in "Drug Induced Hallucinations in Animals and Man" by Ronald K. Siegel and Murray E. Jarvik. In *Hallucinations: Behavior, Experience, and Theory* Editors: Ronald K Siegel and Louis Jolyon West. Published in 1975 by John Wiley & Sons, New York. Copyright © by Ronald K. Siegel. Used with permission.

Harris 1986. *See* Dragon Fly.

Waters 1963. *See* Butterfly.

Yellowman's Brother 1979. Yellowman's Brother, Navajo farmer, Rock Point, AZ. In *Navajo Farming.* Published by the Rock Point Community School, Chinle, AZ. Used with permission.

Young 1988. *See* Breath.

Spirits

Hultkrantz 1987. Ake Hultkrantz, *Native Religions of North America: The Power of Visions and Fertility* Published by Harper and Row, San Francisco, CA. Copyright © Ake Hultkrantz. Reprinted by permission of HarperCollins Publishers.

Mesa Verde Museum Association. *See* Eagle.

Voegelin 1938. Erminie W. Voegelin, "Tubatulabal Ethnology" In *Anthropological Records*, 2:1, University of California Press, Berkeley, CA. Copyright © 1938 Regents of the University of California. Used with permission of University of California Press.

Spirit Helpers

Grant 1978. *See* Arrow.

Schaafsma 1980. *See* Arrow.

Waters 1963. *See* Butterfly.

Squash
Mountjoy 1982. *See* Beans.

Staffs
Cole 1989. *See* Crook.
Harris 1981. *See* Emergence.
Hunger 1982. Heinz Hunger, "Ritual Coition as Sacred Marriage in the Rock Art of North America." In *American Indian Rock Art*, Vol. X. Editors: A.J. and Frank Bock. Published by ARARA. Used with permission.
Schaafsma 1980. *See* Arrow.

Star
Del Chamberlain 1977. Von Del Chamberlain, "Sky Symbol Rock Art" In *American Indian Rock Art* Vol. IV. Editors: E. Snyder, A.J. and Frank Bock. Used with permission.
Michaelis 1981. *See* Butterfly.
Stephen 1940. *See* Lightning.
Williamson 1984. *See* Hourglass.

Sun
Colton 1946. *See* Badger.
Ellis & Hammack 1968. *See* Concentric Circles.
Hudson & Lee 1984. *See* Comet.
Michaelis 1981. *See* Butterfly.
Rafter 1987. *See* Comet.
Schaafsma 1980. *See* Arrow.
Sims 1949. *See* Corn.
Stephen 1940. *See* Lightning.

Supernova
Eddy 1984. *See* Moon
Williamson 1984. *See* Hourglass

Swallower
Rohn et al 1988. *See* Bear.
Sims 1963. *See* Katcina–Cholawitze

Swastika
Stephen 1936. *See* Beans.
Turner 1963. *See* Footprints.
Waters 1963. *See* Butterfly.

T-Shaped
DiPeso (7) 1974. Charles C. DiPeso, *Casas Grandes—A Fallen Trading Center of the Gran Chichimeca* Published by the Amerind Foundation, Dragoon, AZ. Used through the courtesy of the Amerind Foundation, Inc., Dragoon, Arizona.
Nabokov & Easton 1989. Peter Nabokov and Robert Easton, *Native American Architecture* Published by the Oxford University Press, New York. Used with permission.
Viele 1980. *See* Rain.

Tablet, Tableta, or Tabla
Warner 1982b, Jesse Warner, "Concrete Concept Associations" In *Utah Rock Art*, Vol. 11. Editors: Phil Gray and Cindy Everett. Used with permission.

Thunderbird
Grant 1967. *See* Arrow.
Hultkrantz 1981. *See* Spirits.
Schaafsma 1980. *See* Arrow.

Turkey
Grant 1978. *See* Arrow.
Harris 1981. *See* Emergence.
Murie 1954. *See* Badger.
Schaafsma 1986a. *See* Bird-Headed Humans.

Twin War Gods
Harris 1981. *See* Emergence.
Schaafsma 1980. *See* Arrow. Photograph by Karl Kernberger. Copyright © Karl Kernberger 1980.
Williamson 1984. *See* Hourglass

Two-Headed
Grant, Baird & Pringle 1968. *See* Arrow.

Vulvax
McGowan 1978. *See* Female Figure.

Rafter 1987. *See* Comet.

Vastokas & Vastokas 1973. *See* Coitus.

Vuncannon 1985. Delcie H. Vuncannon, "Fertility Symbolism at the Chalfant Site, California" In *Rock Art Papers* Vol. 2. Editor: Ken Hedges. Published by San Diego Museum of Man, San Diego, CA. Used with permission.

Warriors

Schaafsma 1980. *See* Arrow.

Turner 1963. *See* Footprints.

Water

Harris 1986. *See* Dragonfly

Michaelis 1981. *See* Butterfly.

Waters 1963. *See* Butterfly.

Water Gourd

Sims 1949. *See* Corn.

Stephen 1936. *See* Beans.

Taube 1983. Karl A. Taube, "The Teotihuacan Spider Woman" In *Journal of Latin American Lore* Vol. 9, No. 2. Published by the UCLA Latin American Center.

Copyright © 1984 by the Regents of the University of California. Reprinted with permission from Karl Taube, "The Teotihuacan Spider Woman", *Journal of Latin American Lore*, Vol. 9, no. 2. pp. 107-189. Also 'Mural Painting, Teopanacazco, Teotihuacan.' After copy in color by Villagra. In *Handbook of Middle American Indians*, Vol. 10, Part 1, Robert Wauchope, General Editor. By permission of the University of Texas Press.

Water Skate

Colton 1949. *See* Beans.

Turner 1963. *See* Footprints.

Wright 1988. *See* Dragonfly.

Young 1988. *See* Breath.

Waving Person

Apostolides 1984. *See* Dumbbell

Vastokas & Vastokas 1973. *See* Coitus.

Waters 1963. *See* Butterfly.

Weeping Eye

Mountjoy 1982. *See* Beans.

Schaafsma 1971. *See* Head Hunting.

Whirlwind

Turner 1963. *See* Footprints.

Viele 1980. *See* Rain.

X-Incurved

Bentley 1988. *See* Butterfly.

DiPeso 1974. *See* Praying Person.

Warner 1982. Jesse E. Warner, "Figurines and their similarity to Rock Art Figures." In *Utah Rock Art*, Vol. II. Editors: Phil Gray and Cindy Everett. Used with permission.

X-Ray Style

Hedges 1985. *See* Patterned Bodied Anthropomorphs

Ritter & Ritter 1976. *See* Hocker.

Turner 1968. *See* Footprints.